Digital Sculpting with Mudbox

Digital Sculpting with Mudbox

Essential Tools and Techniques for Artists

Mike de la Flor
Bridgette Mongeon

Routledge
Taylor & Francis Group

LONDON AND NEW YORK

This book is dedicated to the community of artists and researchers whose creativity, hard work, and zeal for innovation push the technological envelopes to greater heights.

First published 2010 by Focal Press
This edition published 2014 by Focal Press

Published 2017 by Routledge
2 Park Square, Milton Park, Abingdon, Oxon OX14 4RN
711 Third Avenue, New York, NY 10017, USA

First issued in hardback 2017

Routledge is an imprint of the Taylor & Francis Group, an informa business

Library of Congress Cataloging-in-Publication Data
Application submitted

ISBN 13: 978-1-138-40069-6 (hbk)
ISBN 13: 978-0-240-81203-8 (pbk)

Typeset by: diacriTech, Chennai, India

Contents

Contents

Contents

Acknowledgments

We would like to thank the people whose talent and hard work made the production of this book possible. At Focal Press, we would like to acknowledge the superb editorial and production staff. We are especially grateful to Laura Lewin, Chris Simpson, and Anaïs Wheeler for their valuable direction, editorial expertise, and patient, but firm, reminders to get things done.

At Autodesk, we would like to thank Brittany Bonhomme who worked patiently with us on everything that we needed from Autodesk for this book and Ash Aiad for answering our technical questions about Mudbox. With much appreciation, we thank the Mudbox development team for producing an innovative digital sculpting and three-dimensional (3D) painting program that is intuitive, fun to use, and gets the job done.

A sincere thank you to Josiah Hultgren and Andy Runyon at Maxon Computer for answering our questions about Cinema 4D, and thanks to Steve Kondris and Bruce Hoins for their help with Carrara. We are also thankful to Dan Gustafson at Next Engine for providing a desktop 3D scanner that made writing Chapter 7 possible. At Synappsys, we would like to thank Allen Ray and John Pontari for their insightful input and technical review of Chapter 7. Many thanks to Bob Wood, at ExOne, who fielded numerous questions and found others to answer those questions he could not.

Special thanks to medical illustrator Scott Weldon for his valuable feedback and technical review of Chapter 4. We are grateful to Hollywood veteran Johannes Huber for his expertise and generous allotment of his time in writing the Mudbox to Maya and Mudbox to modo workflows and his technical review of Chapter 6. Warmest thanks to Amy, our model in Chapter 3, and her parents.

On a more personal level, I would like to thank my coauthor and wife, Bridgette, for sitting through long meetings, listening to my ideas, keeping things on track when it seemed like we would never finish, and writing and sculpting late into the night for months to get this book done. Her experience as a master sculptor in traditional figurative sculpture and her enthusiasm for digital sculpting were indispensable in making this book first and foremost about the joy and art of sculpting.

I would like to add a heartfelt thank you to my husband Mike who endured my many questions about 3D and prompted and supported me to make my work and research for this book into a graduate study. And thanks to those many people who encouraged me to document the process, labyrinth of information, and resources so that our readers could more easily take the journey.

No book is written without taking valuable time away from family and friends, even our pets. So, it is with our most heartfelt appreciation that we thank our families for their steadfast support during the production of this book.

About the Authors

Mike de la Flor is a freelance medical illustrator/animator, instructor, and writer. He is the author of several computer graphics titles including the popular *The Digital Biomedical Illustration Handbook*. Mike has written more than 75 articles, reviews, and tutorials for *3DWorld, Studio Monthly, Computer Arts, Computer Graphics World, MacFormat*, and *MacWorld* magazines. He has also been an adjunct instructor of computer graphics at Kingwood College, Kingwood, Texas.

Bridgette Mongeon is a master sculptor and sought-after instructor with more than 20 years of experience in commissioned figurative sculpture. Bridgette also enjoys speaking on a variety of topics including art and technology and marketing in the arts. She is a contributing writer for *Sculptural Pursuits* and *Sculptural Review* magazines and has written numerous articles on the arts. Bridgette enjoys bridging the gap between the traditional studio and new technologies through her lectures, this book, the podcasts that will be featured at www.digitalsculpture.net, and her ongoing graduate studies at Goddard College, Plainfield, Vermont. To learn more about Bridgette's work, visit www.creativesculpture.com.

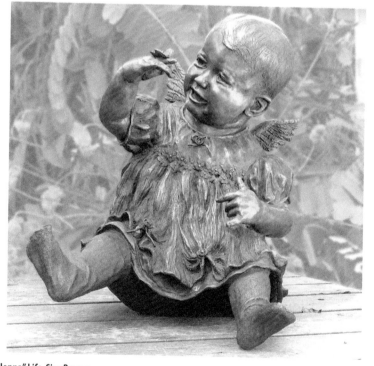

"Jenna" Life-Size Bronze.
Private Collection.

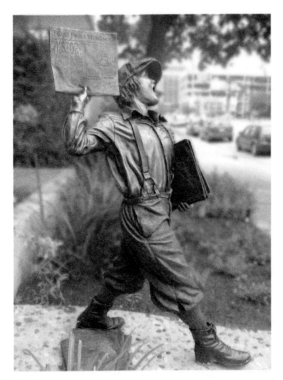

"Newsboy" Life-Size Bronze.
First Edition Owned by the Texas Press Association.

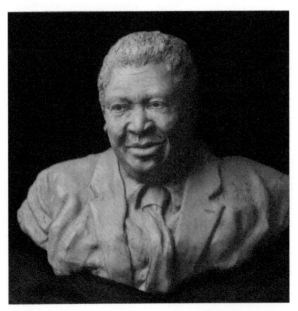

"B.B. King" Clay Portrait Bust.
Owned by the Artist.

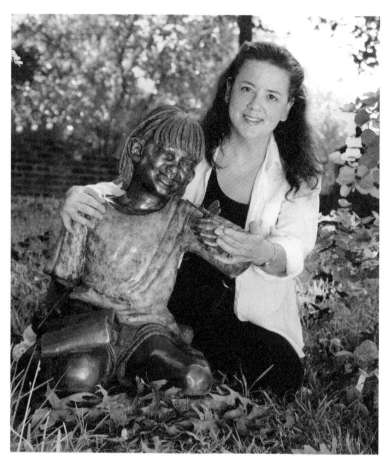

Life-Size Bronze Memorial of Ellie with the Artist.

Introduction

If you are browsing through this book, you are probably interested in computer graphics, art, design, or traditional and digital sculpting, or some combination thereof. You may be either a veteran three-dimensional (3D) modeler who has been chasing edges, vertices, and polygons and is ready for a transition to digital sculpting, or a traditional sculptor who has been elbow deep in clay, rubber, plaster, and wax for years and is curious about digital sculpting. We encourage you to keep looking through this book because we believe that you will find the information and encouragement that you are seeking within these pages.

The two main goals of this book are to teach you digital sculpting with Autodesk Mudbox and to review the fundamentals of the art of sculpture as applied to digital sculpting. These two goals are distinct, but complementary. We believe that simply achieving proficiency in using a computer graphics program is not enough to become an effective artist. No matter how much expertise one develops in the technical use of any program, without an understanding of basic design concepts, the results are lackluster. For this reason, throughout this book, we combine technical "know-how" with a fundamental understanding of art and design. By the time you are finished with the tutorials in this book, you will be proficient in Mudbox and have a core understanding of sculpting concepts and know how to apply them in digital sculpting.

The primary focus of this book is, of course, sculpting with Mudbox. In addition to sculpting, two workflows are covered. The first workflow goes something like this: Maya → Mudbox → Maya (Maya may be replaced with almost any other 3D program). In this scenario, a low-resolution model is imported into Mudbox, sculpted, and then the sculpted detail is exported back into Maya where the sculpting details are maintained with a combination of bump, normal, and displacement maps along with painted textures. The second workflow, reviewed in Chapter 7, involves Mudbox and technologies such as 3D scanning and printing. These workflows may look something like this: 3ds Max → Mudbox → 3D metal printing or Mudbox → digital milling or even 3D scanner → Mudbox → data direct to mold. No matter which way you look at it, once you are finished with this book, you will know how to use Mudbox and integrate it into different workflows.

Quick Preview of Chapters

To get an idea of what you can expect from this book, the following are the brief synopses of the contents in each chapter. For beginners, this book is organized in a bottom-up fashion. In other words, Chapters 1 and 2 begin with the basics and subsequent chapters build on. However, if you are a seasoned

sculptor or computer graphics artist, you can skip forward to any chapter as each chapter is a self-contained unit.

Chapter 1 introduces the concepts of composition, form, proportion, gesture, and anatomy, as well as an overview of expression and emotion in sculpture. Various traditional sculpture techniques are compared with the digital sculpting tools in Mudbox. This chapter lays the foundation for the following chapters.

Chapter 2 is a brief overview of the Mudbox tools and interface; but, more importantly, in Chapter 2, you will work through a brief Mudbox tutorial meant to familiarize you with its interface and workflow.

Chapter 3 features the first full-length sculpting tutorial. This chapter immerses you in Mudbox providing in-depth instruction on the Mudbox workflow. Also covered are the fundamental concepts in sculpting a human head. As a matter of interest, comparisons between the digital sculpture of Amy and traditional clay sculpture of Amy are made throughout the chapter.

Chapter 4 covers sculpting a full figure. The subject of the tutorial, in this chapter, is a humanoid creature. In this chapter, you begin with a low-resolution mesh imported into Mudbox and progress to a finished detailed sculpture. This chapter focuses heavily on understanding human anatomy as applied to art.

Chapter 5 introduces Mudbox's 3D painting system. This chapter features overviews of the paint tools, paint layers, and UV mapping. In this chapter's tutorial, you will paint in various styles to simulate skin on the humanoid creature sculpted in Chapter 4.

Chapter 6 covers the workflows between Mudbox and several other 3D applications. You will learn to extract displacement maps and export a model from Mudbox. This chapter features "how-to" tutorials on applying Mudbox displacement maps on models in 3ds Max, Maya, modo, and Cinema 4D.

Chapter 7 is one of the reasons this book is different from other digital sculpting books. In this chapter, you will explore ways in which Mudbox can be integrated into workflows that include 3D scanning, 3D printing, and digital milling.

What Is Mudbox?

Mudbox is a professional digital sculpting and production-level texture painting program. While this may be true in practicality, Mudbox is something different to everyone. To the character or creature designer, Mudbox could be a tool to quickly explore ghoulish variations on the human form. To the professional 3D modeler, Mudbox may be one of many tools used to build models for the film, games, or broadcasting industries. To the fine art sculptor, Mudbox may be a starting point for a one-of-a-kind sculpture that may be eventually be printed in resin or cast in metal. The possibilities are endless. However, no matter who is using Mudbox, they will all be sculpting with the best digital sculpting technology available, and this is where Mudbox is unmatched by any other program.

Why Mudbox?

Much of the work created in Mudbox could be done in standard 3D modeling programs. In fact, before the advent of programs like Mudbox, 3D modelers produced complex and finely detailed models using various modeling techniques. However, spending hours, if not days, manipulating countless vertices, edges, and polygons to create organic models is a counter-intuitive process that has no analogy to how artists create in the real world. In sharp contrast, Mudbox is a close analog to real world sculpting; it is a paradigm shift in how 3D modelers now create organic models. The days of tinkering with vertices and polygons are a thing of the past. Why Mudbox? It is because Mudbox provides an intuitive, artist-friendly environment where models are quickly sculpted, much like a traditional sculptor would do.

About This Book

The main goal of this book is to teach digital sculpting, sculpting concepts, and anatomy as applied to art. You may begin this book at any point because each chapter is a self-contained unit. However, if you are new to digital sculpting or new to Mudbox, we recommend that you first read through Chapter 2 and work through the brief introductory tutorial. This will provide you with a basic foundation for dealing with the more in-depth tutorials in the rest of the book.

We suggest you skim, if not read, through Chapter 2 as a sort of dry run before attempting the tutorials in Chapters 3 and 4. This will familiarize you with the concepts and workflows in the tutorials before sculpting and help you get the most out of each chapter. All of the support files required for each chapter are provided at www.digitalsculpting.net. Make sure to download all of the required files before starting each tutorial.

About the Tutorials

The tutorials in this book are designed to work on most Windows PCs and Apple computers configured for computer graphics. Although it is possible to sculpt models composed of tens of millions of polygons with Mudbox to produce extreme levels of fine detail, doing so requires high-end and often expensive computer hardware. To make the lessons in this book available to the widest possible audience, the models in this book have polygon counts that are within the capabilities of most computer graphics hardware.

Finally, this book was written with Mudbox 2010. However, barring a few differences, the sculpting and painting tutorials in this book also could be done with Mudbox 2009. The sculpting tutorials may also be done with Mudbox 2011, and though the painting tools are somewhat different in 2011, the painting tutorial in this books still applies.

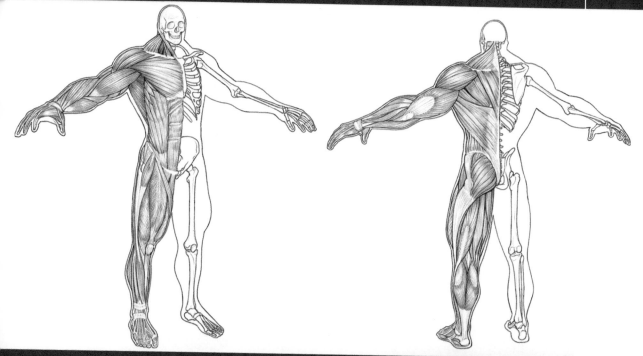

Sculpting Concepts

From the beginning, we want to draw strong correlations between traditional studio sculpting and digital sculpting in Mudbox as a foundation for the topics that will be covered in this chapter and parts of this book. So, we begin by reviewing traditional sculpting tools and techniques and comparing them with the digital sculpting tools and techniques in Mudbox. Then, we will briefly discuss topics, such as anatomy, form, proportions and measurements, gesture, and emotion and expression, as applied to sculpture.

Comparing Traditional and Digital Sculpting

Workspace

A traditional sculpture studio is a large workspace that affords the sculptor the room to sculpt and to step back and view the sculpture from all sides. When working on a traditional sculpture, the clay is placed on a stand with wheels that can be moved around the subject. Continuous viewing of the sculpture from different angles avoids problems such as having a sculpture end up looking flat. Also sculpting on an individual area and then pulling away to look at the entire subject is an essential routine or, for example, you may have

Digital Sculpting with Mudbox. DOI: 10.1016/B978-0-240-81203-8.00001-5

FIG 1.1 When Working with Mudbox, the Program's Interface Provides All the Space and Tools Required for Sculpting.

sculpted a perfect ear, but then you find that it is too small for the face. By pulling back and comparing the whole sculpture to the focused area, you will ensure that you are keeping things in proportion and not getting carried away with details too early – an easy thing to do when in a creative flow.

In Mudbox, the interface becomes the sculpture studio (Figure 1.1). Mudbox's camera navigation tools are analogous to the sculpture stand and the sculptor moving around in the studio. Navigating within the 3D scene allows the same relative movements of the sculptor to subject and sculpture. With a click, you can zoom out and view all of your work, rotate it to see it from different angles, or zoom in to create fine details.

Armatures

A traditional clay sculpture is created around an armature. The armature supports the clay during sculpting, and it is usually made of wire, wood, or other materials to which the sculptor will add the clay. In Mudbox, the initial polygonal model is analogous to the armature and clay. The polygonal model

is composed of polygons (faces), edges, and vertices, and these components, together, build the surface that will be sculpted. The model could either be one of the model templates that are included with Mudbox or a model created in another program and imported into Mudbox.

Lighting

A sculpture studio is equipped with movable lights that allow the sculptor to light the sculpture and subject in different ways to study forms, shadows, and details. Often, the look and feel of a sculpture changes with different lighting. It is said that Rodin would take a candle to his artwork in the dark to see the shadows more clearly. In Mudbox, the lighting is also very important. Using the default light or lighting presets in Mudbox accomplishes the same goals as the real studio lights. In fact, in Mudbox, you can add as many digital lights as you want and move them around as needed.

Sculpting Tools

The tools available in the traditional sculpture studio are numerous. Wooden modeling tools, metal clean-up tools, rasps, trimming tools, loops, spatulas, and dental tools are used (Figure 1.2). Each tool comes in various sizes and strengths depending on the density of the clay and the size of the project. Kitchen utensils, found objects, and straight pins are all usable. "Whatever works" quickly becomes an indispensable tool. Sponges, paint-brushes, and even nylon stockings are used in conjunction with either water or a solvent, depending on the type of clay, to help to smooth the clay. Cloth and other found items are useful tools, as they are pressed into the clay to create texture and patterns. Adding textures to a sculpture helps to give contrast to different sections, thereby producing an overall realistic and detailed appearance.

Mudbox has many of the same tools found in the traditional sculpture studio. However, in Mudbox, the tools are named based on their function. So, in Mudbox, you will not find a rasp, mallet, or brush, instead you will find the Scrape, Flatten, and Smooth tools. These tools can be customized by adjusting their properties such as size, strength, and falloff to create a myriad of tools that do different tasks. To create textures such as wrinkles or scales, there is a wide range of stamps and stencils that can be used in combination with the sculpting tools. So, as you can see, for just about every sculpting action found in the real sculpture studio, there is a tool or combination of tools in Mudbox that will create the same or similar effect (Figure 1.3).

Of course, there are differences between working with real clay and polygons, but with practice, those differences soon fade and sculpting in Mudbox becomes second nature. Although sculpting with real clay has its advantages, so does sculpting with Mudbox. For example, in Mudbox, you can use sculpt

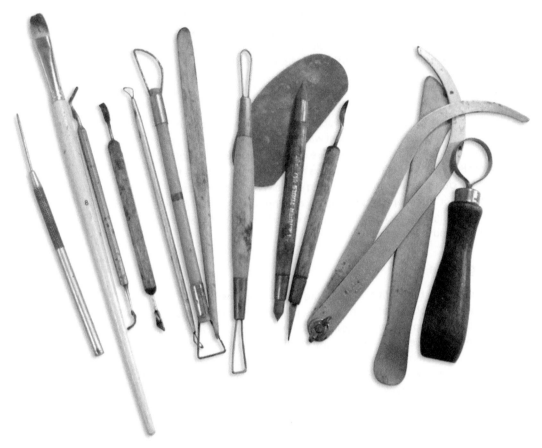

FIG 1.2 Traditional Sculpting Tools Come In a Variety of Sizes and Shapes.

FIG 1.3 Mudbox Sculpting Tools Produce the Same or Similar Sculpting Effects as Real Sculpting Tools.

layers either to organize levels of sculpting details or to simply experiment in a nondestructive manner – something that is impossible with real clay.

The traditional techniques of adding, blending, smoothing, scraping, pinching and pulling the clay to sculpt and add details vary, depending on the type of clay and size of the sculpture. For example, a small water-based clay sculpture that needs a change in shape may simply be pressed with the thumb, but a large life-size or monumental sculpture may require a rubber mallet. In Mudbox, the actions of the sculpting tools will also vary, depending on the resolution and size of the model. For instance, if you use the Sculpt tool on a mesh that is not sufficiently subdivided, the result will be a coarse and lumpy mess. However, with subdivided mesh, the same tool produces a beautifully sculpted stroke. The size of the mesh also plays an equally important role in how the sculpting tools work. Because Mudbox has an internal scale, sculpting on a small mesh produces different results than sculpting on a larger mesh, assuming all other variables are the same.

Mudbox is a close analogy of real clay sculpting as it provides the sculptor with a digital sculpture studio stocked with all of the sculpting tools and materials needed to produce just about any sculpture. Although Mudbox may not be an exact equivalent to real clay sculpting, the same sculpting techniques and concepts used in traditional sculpting apply when sculpting in Mudbox. In the next section of this chapter, you will review basic concepts like anatomy, proportions and measurements, form and gesture, and emotions as applied to sculpture.

Anatomy for Sculptors

To be a successful figurative sculptor, a fundamental knowledge of anatomy is required. In this case, anatomy refers to the skeleton, muscles, and skin and fat – also collectively known as *surface anatomy*. There are entire books written on this subject, so a comprehensive discourse is beyond the scope of this book. Nonetheless, the paragraphs that follow will review important information on these concepts, which we will revisit in Chapters 3 and 4.

Skeleton

The skeletal system is the armature on which the rest of the anatomy rests. Understanding the shapes of bones and the way joints articulate and move will help you create figures that are properly proportioned and naturally posed. The skeleton also forms natural bony landmarks on the surface of the body. For instance, the front of the torso is defined by the clavicles, the lower edge of the ribs, and the superior edges of the pelvis. The back of the torso is defined by the edges of the scapulas, the processes of the vertebrae, the sacrum, and the iliac crests. Because the skeleton is the underlying support and structure of the body, it dictates the form. Thus, it is important to be familiar with skeletal anatomy.

Muscles

Muscles are the underlying mass of the human body, especially in the arms and legs. Muscles are composed of microscopic fibers, which are collected into larger and larger bundles. The largest of these bundles are visible under the skin, especially when the muscle is doing work. Just take a look at a photograph of an athlete in action, and you will see these muscle bundles. When roughing in the primary forms on a figurative sculpture, add mass according to the underlying muscle groups and smooth the clay (or polygons) in the direction of the muscle bundles.

Skin and Fat

As the protective covering overlying all anatomy, the skin drapes over the shapes created by bones and muscles. However, the skin does not drape over the body like a sheet covering a piece of furniture. The skin is held in place by a network of underlying, loose, connective tissues. So, when a muscle moves, the skin moves with it to varying degrees. Like muscle, the skin also has a directional flow often referred to as cleavage or Langer's lines. These lines dictate how the skin moves over bones and muscles, and how folds, tension lines, creases, and wrinkles form. So, it is important to have a basic understanding of the properties of skin when sculpting.

Another important component of skin is the subcutaneous fat, which is found directly under the skin. Subcutaneous fat drastically affects the surface anatomy. For instance, the shape of a young person's face is largely dictated by the fat under the skin. Also, subcutaneous fat is distributed in predictable areas such as the chest, hips, and thighs. However, the location of subcutaneous fat varies between men and women. For example, men tend to deposit fat around the midsection, whereas women tend to deposit it in the hips, buttocks, and thighs. So, as with the skeleton and muscles, it is also a good idea to understand the anatomy of skin and fat.

Even though someone viewing your sculpture may not know human anatomy, they may naturally be aware of what looks "right" and can easily pick out an anatomical oversight. If you are going to be sculpting zombies, satyrs, lizard-men, or any other type of monstrous creature, then an understanding of human anatomy still applies because these creatures are humanoid. The sketch in Figure 1.4 shows the creature that is sculpted in the Chapter 4 tutorial. The creature isn't quite human, but the general principles of human anatomy still apply.

Proportions and Measurements

Proportions

Along with surface anatomy, a sculptor must know human proportions. Proportions can refer to size comparison between specific parts such as an ear in relation to the face or it can also refer to known ratios between

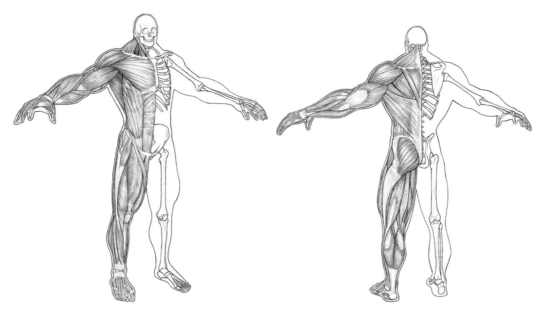

FIG 1.4 Sculpting a Natural Sculpture Begins with the Understanding of Anatomy.

the overall size of a figure and its parts. For example, the average man is seven and one half heads in height. Also common errors like squashing the top of the skull can be eliminated by knowing that the eyes are in the middle of head. Thoroughly understanding proportions will enable you to create accurate compositions and avoid time-consuming mistakes. Like anatomy, there are extensive resources available on proportions. However, the following is a list of important proportions you should know. As you read the list get a "hands on" lesson in proportions by feeling your face and body to verify the list. Keep in mind that there are individual variations.

- The back of skull attaches to the neck on the same plane as the ears.
- The nose falls on the same angle as the ears.
- The eyes are usually one eye-width apart.
- The ears are much longer than most people sculpt them and fit between the space of the brow and the space between the nose and upper lip.
- The centers of the pupils match up to the corner of the mouth.
- In a profile, the distance from chin to an eye is the same distance as from an eye to the back of ear.
- A particular favorite – when you place the wrist at the bottom of the chin, the middle finger will touch the hairline. This proportion assures that the hands are in proportion to the subject's face.

Study proportions both from books and from life, and you will find that your speed and accuracy as a sculptor will dramatically increase. Chapters 3 and 4 review more information on proportions and anatomy.

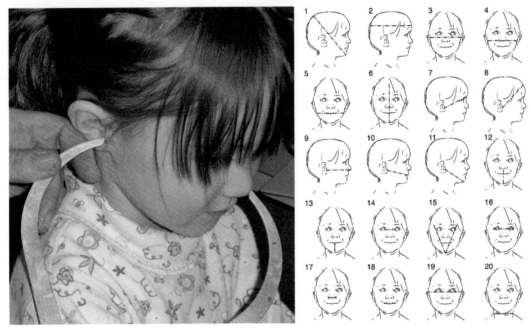

FIG 1.5 When Possible, It Is Advisable to Take Accurate Measurements of Your Subject to Assure Correct Proportions.

Measurements

When creating a portrait bust, there are 20 different proportional measurements of the face and head that are taken from the subject. Sculpting calipers are used to measure the various points on a subject, and then, those measurements are transferred to a diagram for use later while sculpting (Figure 1.5). The full figure has its designated points of measurement as well. Measurements help the sculptor confirm the proportions. In Mudbox, accurate proportions can easily be obtained by using reference images for proportional comparisons and working with Mudbox's internal scale for measurements. We will review these proportional measurements in the sculpture bust of Amy in Chapter 3 and the full-figure sculpture of the humanoid creature in Chapter 4.

Form, Negative Space, and Gesture

Form

Form encompasses the overall shape and composition of the sculpture. The form of your sculpture is perceived by how light, shadows, and the transitions in between are created by the underlying shapes. This interplay of light and shadow is often referred to as the value. By manipulating how the shapes on your sculpture relate to one another, you control how highlights, transitions,

FIG 1.6 The Interplay of Light and Shadows on the Surface of a Sculpture Dictates Its Perceived Form. Life-Size Clay Sculpture by Bridgette Mongeon.

and shadows are formed, thus creating interest and mood in the composition. Ultimately, form is often dictated by your own style, the medium, and the final use of the work.

Form is intimately tied to proportions because basic forms correspond to the initial proportions of the sculpture. Forms can also be broken down into planes. For example, the basic form of the head can be reduced to a few planes such as the forehead, nose, brow, nose, chin, and so on. By reducing the sculpture to its corresponding planes, it is easy to see the relationships between forms and proportions (Figure 1.6).

Negative Space

An important but often overlooked aspect of form is the negative space. *Negative space* is the space around and between a part of the subject or even the entire subject. For example, when sculpting an arm, you would focus on the shapes created by the negative space between the arm and the body. By also focusing on the negative space while sculpting, you can avoid being

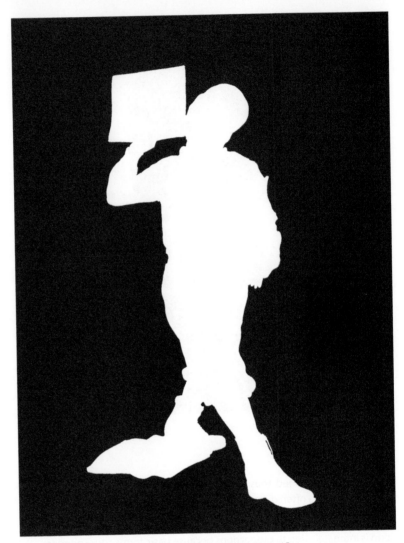

FIG 1.7 Negative Space Is Useful In Preventing Problems with Proportions and Form.

distracted by the details and anticipate problems such as incorrect proportions. In Mudbox, you can view the negative space around your sculpture by displaying it as a silhouette (Figure 1.7).

Gesture

Gesture refers to the flow of lines in the figurative sculpture. More precisely, gesture describes the rhythm, weight, and balance in the design of the sculpture. Gesture is what makes a perfectly still sculpture appear to be alive and in motion.

FIG 1.8 Establishing Gesture Early In the Process Ensures an Appealing Sculpture that Has Motion and Balance. In This Photograph, You Can See the Lines that Establish Its Gesture. Life-Size Bronze Sculpture by Bridgette Mongeon.

From the initial sculpting stages, gesture must be incorporated into the process because ignoring it will result in a stiff, lifeless sculpture. Some sculptors begin creating gesture by shaping the armature before any clay is applied. In this way, a strong gesture is ensured from the start (Figure 1.8).

Unlike anatomy or forms, which are tangible things, gesture is an abstract concept. Unfortunately, this can make gesture difficult to master. However, you can develop a sense of gesture by practicing with gesture sculptures and drawings. Gesture sculptures are loose quick sketches in clay that lack detail

but capture the motion and rhythm of the subject. Equally, gesture drawings are also very loose quick studies that do not focus on the details but rather focus on the impression or movement of the subject. In either case, quick gesture sculptures and drawings help you to get a feel for motion, balance, and rhythm in composition. Good gesture sculptures and drawings tell a story, evoke emotion, and show expression.

Expression and Emotion in Sculpture

It is expression and emotion that draws us to a sculpture, and capturing that emotion is an art, as well as a science. Psychologist Paul Eckman, one of the leading emotion researchers, created an entire process for documenting how the muscles in the face express emotion. This documentation is known as the Facial Action Coding System (FACS). In recent years, FACS has been increasingly used by many 3D modelers and animators to create lifelike emotions in digital characters. FACS measures the facial actions of expression in Action Units (AUs). Often an AU is produced by more than one facial muscle at a time. For example, a natural smile incorporates many specific facial muscles. As a result, the AUs of a smile as compared with that of a grin or grimace are very different.

To understand how much the face and the body can change during an emotional response, place both hands lightly over your face as you try to express different emotions. First, think about sadness and really feel it, become aware of what your face and body do during the emotion of sadness. You will most likely find that brows move down, your lips pout, your entire face pushes forward, but you will also notice that your shoulders will sag and your body most likely will pull into itself. Try another emotion like surprise or excitement: notice how your eyebrows raise, your eyes widen, your mouth drops open, and you will feel your shoulders will push back and chest push out. Try the same experiment, this time looking in a mirror. It is a great idea to keep a mirror by your computer when sculpting for this very reason.

Researchers have also discovered that when we watch someone expressing an emotion, it initiates empathy in us in two ways. First, our own facial muscles will often mimic the expression that we are viewing. Second, mirror neurons in our brains cause us to "feel" the observed expression. Thus, the simple act of viewing an emotion being expressed can invoke that same emotion in the viewer. Therefore, having a thorough understanding of how emotion is expressed on the face and in the body will help you produce sculptures that are more natural, attractive, and that emotionally involve the viewer.

Summary

As you have learned from this chapter, successful sculpting is far more than just having the right tools or the right software. Creating unique figurative sculptures that are appealing and that engage the viewer requires

a fundamental knowledge of anatomy, form, proportions, gesture, and emotion. Throughout this book, we will continue to reference these concepts and help you learn to apply them. However, if you haven't already, it is important that you embark on the process of mastering these important topics. In the next chapter, you will be introduced to Mudbox's interface, tools, and workflow, and you will also attempt your first Mudbox sculpture.

Introduction to Mudbox

If you are familiar with Maya, 3ds Max, Cinema 4D, or any other three-dimensional (3D) program, you will be right at home in Mudbox and will begin sculpting in a matter of minutes. However, if you are new to 3D and digital sculpting, Mudbox is still the perfect choice because of its artist-friendly interface, shallow learning curve, and intuitive sculpting and painting workflows. In the first part of this chapter, you will briefly review important parts of the Mudbox interface like menus, tools, windows, and camera navigation. After the interface overview, you will be reviewing the basics of 3D computer graphics. Then, you will complete the first tutorial in this book that will introduce various sculpting tools, layers, and provide you with hands-on experience with Mudbox.

Interface Overview

Upon launching Mudbox, you will see the Welcome window, which provides quick access to the Learning Movies, the models that come with Mudbox, and any recent Mudbox files worked on. You may turn off the Welcome window by checking the "Do not show this Welcome window again" option in the lower left corner. If you choose to turn it off, you will still have access to all of the

Digital Sculpting with Mudbox. DOI: 10.1016/B978-0-240-81203-8.00002-7

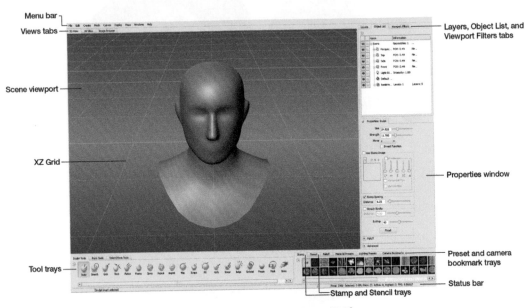

Menu bar
Views tabs
Scene viewport
XZ Grid
Tool trays

Layers, Object List, and Viewport Filters tabs
Properties window
Preset and camera bookmark trays
Status bar
Stamp and Stencil trays

FIG 2.1 Mudbox Has a Standard, Intuitive Interface and Straightforward Sculpting and Painting Workflows.

same data through the menus. For now, select the Basic Head model from the "Start a new sculpture section" in the Welcome window. You should see the Basic Head model in the scene as shown in **Figure 2.1**.

By default, you should be looking through the perspective camera into the scene, which is contained in the 3D View. The 3D View is one of three main views in Mudbox. The other two are the UV View and the Image Browser. The 3D View is where you do sculpting and painting work, and it is analogous to viewports in other 3D programs. In most standard 3D modeling programs, you can view the scene through multiple cameras or viewports, but in Mudbox, there is one viewport. Nonetheless, you may use Mudbox's camera bookmarks, which you will learn about later, to quickly switch between the camera views. Next to the 3D View tab is the UV View, which displays the UV coordinates of the selected model. The third tab is the Image Browser, which allows you to preview and organize images and assign them to various tools. For example, you could browse to an image on your hard drive, load it into the Image Browser for inspection, and then assign it to be used as a stencil to detail a model. The Image Browser is also useful for viewing specialized types of files such as image-based lighting files and displacement maps.

At the bottom of the interface, you will find a collection of customizable trays that organize the Sculpt, Paint, and Select/Move Tools along with an assortment of trays for storing stamps, stencils, bookmarks, and various presets. The Sculpt, Paint, and Select/Move Tools comprise the three leftmost trays (**Figure 2.2**). Faces and Objects are selection tools, and the Translate, Rotate, and Scale tools are collectively known as the *transform tools*. You may customize any of the tool trays by adding, deleting, or renaming tools, as well as building custom

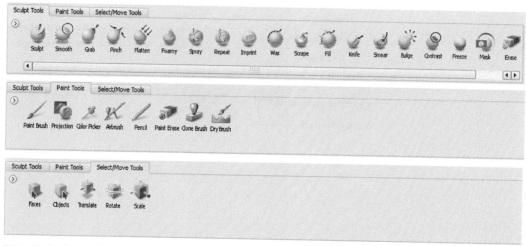

FIG 2.2 Mudbox Features a Comprehensive Set of Sculpting and Painting Tools. The Main Selection Tools Are Faces and Objects, and the Translate, Rotate, and Scale Tools Comprise the Select/Move Tools.

trays with your favorite tools for quick access. The first nine sculpting tools may be accessed by simply pressing the numbers 1 through 9 on your keyboard.

The first two trays on the right organize images that can be used as stamps or stencils in conjunction with various sculpting and painting tools. Mudbox ships with an assortment of stamps and stencils, but you can create your own tools and add them to the trays. Next is the Falloff tray, which stores presets that manage sculpting and painting tool profiles. At this point, it is worth mentioning that the falloff parameter is an important property of the Mudbox tools because falloffs dictate the shape of the stroke created by the tool. In other words, the same tool with different falloffs will create different effects. The last three trays on the right are the material presets, lighting presents, and the camera bookmarks.

The next important area in the Mudbox interface is the tabs and windows to the far right of the interface. Starting at the top, there are the Layers, Object List, and Viewport Filters tabs. The Layers tab is composed of the Sculpt and Paint layers. You may add, delete, merge, and restack the sculpting layers as needed. These may also be locked, hidden, or have their effect attenuated by adjusting the layer opacity. Much of the work you will do in Mudbox is directly tied to managing the sculpting layers efficiently. The tutorial in the chapter will introduce you to layer basics, and the tutorials that follow will cover layers in detail (Figure 2.3).

To switch to the paint layers, press the Paint button in the Layers tab. The paint layers organize the various texture types that may be painted on a model. For instance, you may paint several diffuse textures, as well as specular, gloss, bump, and reflection textures. Like the sculpt layers, the paint layers may also be restacked, locked, hidden, or have their opacity adjusted (Figure 2.4).

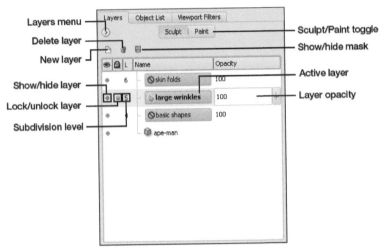

FIG 2.3 To Effectively Sculpt In Mudbox, You Must Learn to Manage the Sculpt Layers.

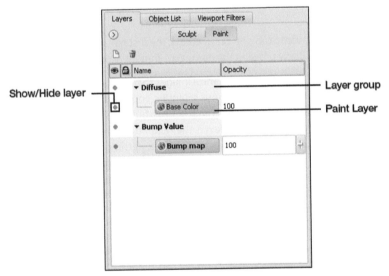

FIG 2.4 Paint Layers Organize the Different Types of Textures, Such as Diffuse, Bump, and Specular, that Mudbox Can Paint.

The Object List organizes, manages, and displays information about all of the objects in the scene including lights, cameras, and materials (Figure 2.5). For instance, you may choose a different camera to look through, as well as select, rename, or delete objects from the scene. Last in this set of tabs is the Viewport Filters. The first three Viewport Filters simulate various render environments through controls for lighting, depth of field, and ambient occlusion. The Screen Distance filter displays a gray scale depth map of the model based on the distance from the camera. The Normal Map filter previews the normal map, and the Non-photorealistic filter simulates a sketchy render.

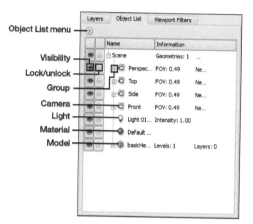

Object List menu
Visibility
Lock/unlock
Group
Camera
Light
Material
Model

FIG 2.5 The Object List Is the Central Hub Where You Can Find Information about Any Object In the Scene.

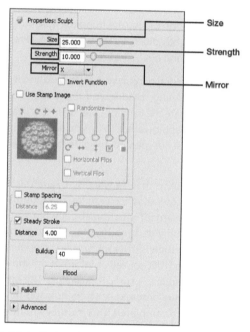

Size
Strength
Mirror

FIG 2.6 The Properties Window Displays Information about the Active Tool or Selected Object. The Strength, Size, and Mirror Properties Are Highlighted because They Are Often Used to Adjust the Mudbox Tools.

Below the Layers, Object List, and Viewport Filter tabs is the Properties window (**Figure 2.6**). The Properties window is context sensitive in that it will display attributes of selected objects or tools. For instance, if you select the Foamy tool, all of the properties for that tool will be displayed in the Properties window; if you then select a camera from the Object List, then the properties for the camera are displayed. It is important to highlight the Size, Strength, and Mirror properties of the sculpting and painting tools. You will be referring to these properties a lot in the following tutorials.

The menu bar is located along the top left corner of the interface (see Figure 2.1). These menus organize different commands by task. The File and Edit menus organize standard file-management commands, as well as selection commands. The Create menu sorts all of the different objects that may be created, and the Mesh menu provides quick access to subdivision commands. For now, we will skip over the Curves menu and move on to the Display menu. The top one-third of the Display menu holds the commands to hide and show objects, and the bottom two-thirds features commands for customizing how objects are displayed and how the scene looks. You may access the commands in the bottom two-thirds of the Display menu by right-clicking anywhere in the scene. Next, the Maps menu has the commands for extracting displacement maps, which will be covered in Chapter 6. And finally, the Windows menu allows you to display different tabs as floating windows. Some users may prefer to have specific windows handy all the time – by selecting them from the Windows menu, the selected window persists in the interface. The Preferences command in the Windows menu allows you to customize just about every part of Mudbox. If you are using the Macintosh version of Mudbox, the menus are slightly different. For example, the Preferences will be located in the Apple menu and not in the Windows menu.

Camera navigation is an integral part of working in Mudbox; it involves moving around the scene by panning, rotating, and zooming the camera. See Table 2.1 for hotkeys to navigate the camera. Later on in this chapter, you will be prompted to set up your graphics tablet. Once you have finished, you will use the buttons on the tablet's stylus (pen) to navigate the camera throughout the scene.

A couple of last interface items that we will discuss are the Heads-Up Display (HUD) and the Status bar. When working in Mudbox, you will often see the HUD display important information about what you are doing. For instance, when you subdivide a model, the HUD will display the new number of polygons and subdivision level. Certain error messages are also displayed through the HUD, as well as information about different tools, like instructions when using stencils (Figure 2.7). The far left end of the Status bar displays a blue progress bar that indicates how much of a specific operation has been completed. This is usually noticeable when performing operations that can be time consuming like when extracting displacement maps. On the right side of the Status bar is information about the scene and, occasionally, you will see the far right end of the Status bar flashing to remind you to save your work (you can turn that off if you find it annoying).

In this section, you have briefly reviewed the Mudbox interface, so that you can effectively work through the tutorial, later in this chapter. However, there is much more to the Mudbox interface that is not specifically covered here, but you will eventually come across many of those features later in this book. If you are curious now and want to know more, go to the Help menu

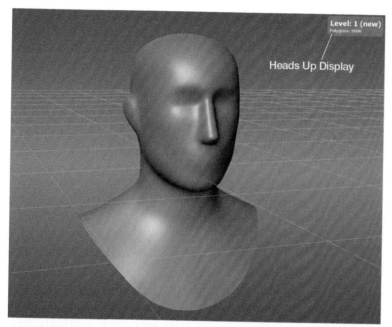

FIG 2.7 The HUD Displays Important Information about Current Operations.

and select Mudbox Help and choose User Interface to learn more about the Mudbox interface.

What You Will Need to Work In Mudbox

To get the best results from Mudbox's sculpting tools and painting brushes, you will need a pressure-sensitive graphics tablet. We recommend that you use a Wacom tablet. In fact, Autodesk lists a Wacom tablet as part of the system requirements for Mudbox. Wacom produces a wide variety of graphics tablets for all levels of experience and budgets. Before starting work on the tutorials, launch Mudbox, go to the Help menu, select Mudbox Help, and complete the Tablet Setup instructions. The reason we are not guiding you through the tablet set up process is that set up for different tablets may vary and you can customize how your tablet works.

Mudbox was developed to be used by a wide spectrum of users, including students, hobbyists, and professionals. Each type of user will require different configurations of computer hardware, depending on how they use Mudbox. For the tutorials in this book, your computer should meet the minimum hardware and operating system requirements listed for Mudbox on the Autodesk website. The reason your computer must have at least the minimum requirements is that to effectively sculpt in Mudbox, you will be working with models composed of hundreds of thousands and, sometimes, millions of polygons.

Although Mudbox is optimized to efficiently manage very large polygon datasets, you will still need the computer hardware that can handle the data. The tutorials in this book were designed so that almost anyone can complete the work with a standard computer that meets the minimum requirements.

A 3D Primer

Because Mudbox is a true polygonal modeler, it is important to understand some of the basics of 3D computer graphics. If you have experience working in programs like Blender, XSI, or 3ds Max, then you probably are already familiar with these concepts and may skip to the tutorial later in this chapter. However, if you are either new to 3D computer graphics, or a traditional sculptor curious about digital sculpting, this section will introduce you to several of these important topics.

Understanding 3D Space

Like most standard 3D programs, Mudbox uses x, y, z coordinates to plot the location of objects within its virtual 3D world space also know as the *scene*. Everything from the location of models, lights, and cameras, even how some of the sculpting tools work depends on the x, y, z coordinate system. The center of the coordinate system is called the *origin*. At the origin, the value of x, y, and z is 0. So, if an object that is located at the origin is moved 5 units along the z axes, the value of the z axis for that object changes from 0 to 5. In Mudbox, the x axis describes the horizontal plane (left/right), y axis describes the vertical plane (up/down), and z axis describes the depth plane (front/back).

To see the coordinate system at work, try the following quick exercise. Launch Mudbox, and from the Welcome window, select the Basic Head model to insert it into the scene. Next, click on the Select/Move Tools tab in the bottom tray and choose Rotate. You should see the Rotate manipulator appear within the model. If you look closely at the Rotate manipulator, you will see the rotation axes labeled x, y, and z, as seen in **Figure 2.8**. In the Properties tray, you will see three input fields (one for each axis) next to the label Rotate. Now, click anywhere in the scene and drag. Notice that the model is rotated as you drag but also notice that the values in the Rotate field change. By dragging the mouse, you are interactively changing the x, y, z Rotate values. Finally, type a 0 in each Rotate input field. The model should go back to its original position. The Translate (move) and Scale tools work in a similar fashion. It is important to understand the underlying coordinate system because it describes the 3D space within Mudbox and affects just about everything within the scene.

Polygon Basics

Mudbox is a polygonal modeler, which means that the sculpting tools move the polygons that make up a model to change its shape. But what exactly

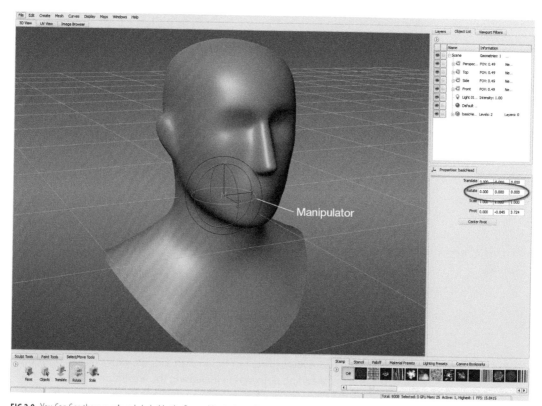

FIG 2.8 You Can See the x, y, z Axes Labeled In the Rotate Manipulator. Also Notice the x, y, z Coordinate Input Fields In the Properties Window.

is a polygon? A *polygon* is a virtual 3D object that is composed of at least three vertices and three edges forming a triangle. However, a polygon that is composed of just vertices and edges is empty and usually invisible. To become visible, a polygon must be filled so that it can interact with virtual lights. Once filled, a polygon has a front face and back face. Typically, it is the front face of a polygon that can interact with virtual lights. This type of polygon is called a single-sided polygon, and it is the type of polygon that Mudbox displays. If a single-sided polygon is flipped, with the back face pointing toward the light, it becomes invisible again. To see the edges of the polygons that make up a model in Mudbox, referred to as the *wireframe*, press W (**Figure 2.9**).

When many polygons share their vertices and edges, a polygonal model is constructed. A polygonal model can be open like a plane or a closed volume like sphere. When working in Mudbox, you only need to be aware of polygon faces. Mudbox does not have any tools to directly manipulate vertices or edges. Mudbox works best with polygons that have four vertices and four edges, otherwise known as a *quadrangle* or *quad* in short.

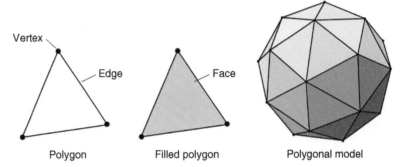

FIG 2.9 Polygons Are Composed of Vertices and Edges. Filled Polygons Interact with Virtual Light, and When Many Polygons Share Vertices and Edges, a Polygonal Model Is Constructed.

Resolution

Another concept that is important to understand is resolution. In computer graphics, resolution can mean many things like how many pixels make up an image. However, in digital sculpting, the resolution of a model is determined by how many polygons make up the model. For example, a model with half a million polygons has a lower resolution than a model with a million polygons. The process of adding polygons or increasing the resolution is called *subdivision*. Try the following quick exercise. With the Basic Head model in the scene, press W to display the wireframe. In the lower right corner status bar, you should see the number of polygons that make up the Basic Head model as 2002. Now, press Shift + D to subdivide. Notice the total is now 8008 polygons and the wireframe is denser. Each time a model is subdivided, the number of polygons is multiplied by four. You can see how it would be easy to increase the resolution of a model into the hundreds of thousands if not millions of polygons with just a few subdivisions. To sculpt fine details, a high-resolution model is often required, but the higher the resolution, the more computer resources are needed to display the model (**Figure 2.10**).

UV Mapping

UV mapping is a coordinate system that specifies how an image texture is applied to a polygonal model. UV mapping uses the U and V axes to assign the pixels in an image to specific locations on a model. In Mudbox, a model does not have to be UV mapped to use the sculpting tools, but it must be UV mapped to effectively use Mudbox's paint brushes. Mudbox can display UVs, but it does not have any tools to edit UVs. Consequently, if a model is imported into Mudbox for painting, it must be UV mapped in a separate program like modo. If you want to see a UV map, insert the Basic Head model into the scene and click on the UV View tab. Notice that the UV map is a flattened 2D representation of the model packed into the UV tile or space (**Figure 2.11**).

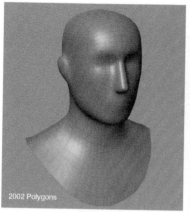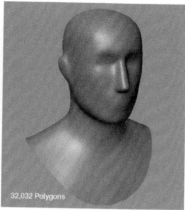

2002 Polygons

32,032 Polygons

FIG 2.10 The Resolution of a Model Depends on How Many Polygons Compose the Model. The Model on the Left Has a Lower Resolution than the Model on the Right.

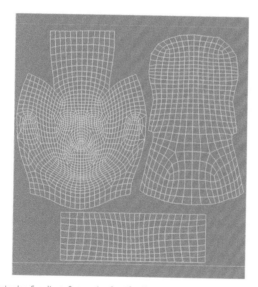

FIG 2.11 UV Mapping Is a Coordinate System that Specifies How a 2D Image Is Applied to a 3D Model.

Digital Images

A digital image is a 2D grid or dataset that stores information as pixels (pixel is short for picture element); see Figure 2.12. For example, a picture taken with a digital camera is a digital image composed of pixels. Pixels store information like color (RGB or CMYK), bit-depth (8, 16, or 32 bits), and transparency. Mudbox uses digital images in several ways. For instance, when painting a texture on a sculpture, Mudbox is creating a digital image. The stencils and

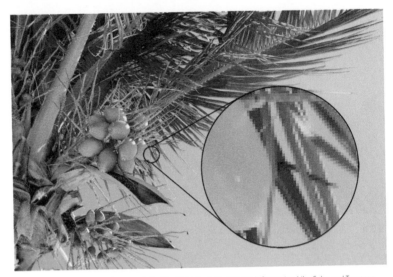

FIG 2.12 Digital Images Are Composed of a Pixel Grid. Each Pixel Stores Information Like Color and Transparency. Mudbox Uses Digital Images as Stencils and Stamps and Creates Digital Images When Painting Textures. *Photography by Christina Sizemore.*

stamps are digital images, and Mudbox can also save screenshots of the scene as digital images of various formats.

Mudbox Hotkeys

You should become familiar with the following important keyboard shortcuts referred to as hotkeys. These hotkeys increase productivity and usability by allowing you to quickly access common commands or tasks while working (Table 2.1). There are many more Mudbox hotkeys, but for now, you need to know the ones in the list below. If you would like to see a complete hotkey list, go to the Help menu and choose Mudbox Help.

Quickstart Tutorial: Sculpting a Bell Pepper

The purpose of this tutorial is to introduce you to the basics of sculpting with Mudbox. This tutorial is designed for someone who has little or no experience with Mudbox, so it assumes that you don't know anything about Mudbox or digital sculpting. If you have experience with Mudbox, you may want to skip to the sculpting tutorial in Chapter 3. This tutorial will cover fundamentals like camera navigation, several of the sculpting tools, sculpting workflow, layers, and stencils.

The subject of the sculpture in this tutorial is a bell pepper. This may seem like an odd choice for the subject of the first tutorial, but the reason we chose a bell pepper is because it has a simple but recognizable shape that is forgiving

TABLE 2.1 Hotkeys

Action	Windows Hotkeys	Mac OS X Hotkeys
Rotate camera	Alt + left mouse button	Option + left mouse button command + left mouse button
Pan or Track camera	Alt + middle mouse button	Option + middle mouse button command + middle mouse button
Zoom or Dolly camera	Alt + right mouse button	Option + right mouse button command + right mouse button
Roll camera	Shift + middle mouse button	Shift + middle mouse button
Focus	Place cursor on the area of interest and press F	Place cursor on the area of interest and press F
Frame all	A	A
Adjust tool size	B + left mouse button	B + left mouse button
Adjust tool strength	M + left mouse button	M + left mouse button
Toggle Smooth tool	Shift	Shift
Invert Sculpting tool	Ctrl	Control
Add subdivision level	Shift + D	Shift + D
Step up subdivision level	Page Up	Page Up
Step down subdivision level	Page Down	Page Down
Invert Freeze	Shift + I	Shift + I
Unfreeze all	Shift + U	Shift + U
Undo	Ctrl + Z	Command + Z

enough to allow you to focus on learning the sculpting workflow without worrying too much about details. You will sculpt the sphere model that comes with Mudbox into a bell pepper, so everything will be done within Mudbox without any imported models.

Setting Up the Scene

After launching Mudbox, you will see the Welcome window. In the "Start a new sculpture section," scroll down until you see the Sphere and click to insert it into the scene. The default Mudbox scene displays a grid along the x and z axes and a gradient background. For the purposes of this tutorial, turn off the grid and gradient by right-clicking anywhere in the scene (but not on the sphere), and from the contextual menu, uncheck Grid and Gradient Background (Figure 2.13).

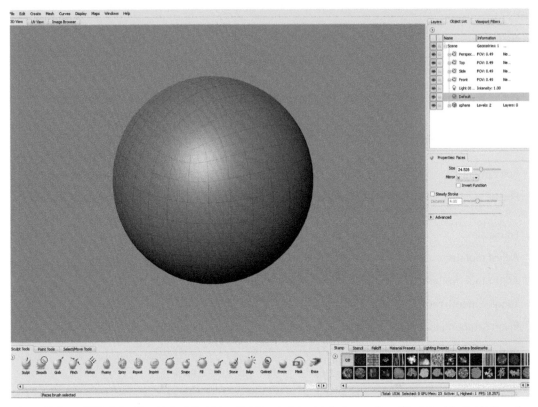

FIG 2.13 The Pepper Will Be Sculpted from Mudbox's Stock Sphere Model. Insert a Sphere into the Scene and Turn off the Grid and Gradient Background.

Selecting and Scaling a Model

Next, you will select the sphere in the scene and scale it down (make it smaller). You may select the sphere either by clicking on its icon in the Object List or by choosing the Objects tool from the Select/Move Tools tray and clicking on the sphere in the scene, and once selected, the sphere will turn yellow. Next, choose the Scale tool from the Select/Move Tools tray. Notice that the Scale manipulator is displayed within the sphere. At this point, you may scale the sphere by clicking and dragging on any of the manipulator's squares. However, clicking and dragging on the green, blue, or red squares will scale the sphere along one axis, resulting in an oval. In this case, the sphere should be uniformly scaled so that it retains its spherical shape. Click on the manipulator's white middle square and drag until the sphere is about half of its original size (Figure 2.14). An alternate method to scale the sphere is to do it numerically. To scale the sphere numerically, make sure that it is selected, choose the Scale tool from the Select/Move Tools tray, and in the Properties tray, enter the numerical value in the Scale input fields. In this case, you would enter .5 for each field to scale down the sphere by 50%.

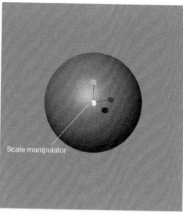

Scale manipulator

FIG 2.14 Scale Down the Sphere by about 50%. You May Scale a Selected Object by Clicking and Dragging the Scale manipulator or by Numerically Changing the Values of the Rotate x, y, z Input Fields.

Creating a Layer and Subdividing

Next, you are going to create the first sculpting layer and subdivide the sphere in preparation for sculpting. A layer in Mudbox is an important tool that manages the sculpting process. For example, you could rough in the basic shape of the pepper in one layer and then add details in another layer. If you don't like the work you have done in the layer in which you sculpted the details, you can delete it, create a new layer, and try again without disturbing any of the work done in the first layer in which you roughed in the basic shape. Mudbox's layers are in many ways similar to layers in programs like Photoshop. As mentioned earlier in this chapter, subdividing the model means increasing the resolution or number of polygons that makes up the model. The reason the model is subdivided is to have enough polygons to effectively sculpt. You will learn more about layers and subdivision as you work through this tutorial; for now, follow these next steps to add a new layer and subdivide the sphere.

To add a new layer, click on the Layers tab, then click on Layers menu (the small, circular button with the arrow pointing to the right), and select New Layer. A new layer is created above the object-labeled sphere. Double-click on the layer to make the layer name editable and name the layer as Basic Shape.

Press Shift + D twice to subdivide the sphere two times. As you subdivide, notice that the HUD in the upper right corner of the scene displays the active subdivision level and number of polygons in the model. You should be in level 3 and the model should have 24,576 polygons. If you missed the HUD display (it flashes by quickly), look for labels "Total:" and "Active:" in the status bar at the bottom of the interface, and they should read Total: 24,576 and Active: 3 (Figure 2.15). A key Mudbox feature is that you can move between subdivision levels. In this case, press the Page Down key to go down to level 2; now press Page Up to go back up to level 3.

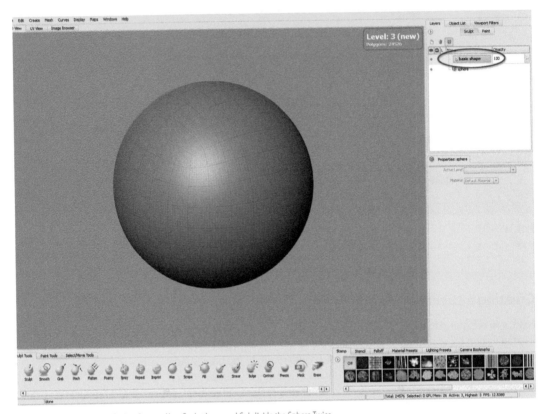

FIG 2.15 Before Starting to Sculpt, Create a New Sculpt Layer and Subdivide the Sphere Twice.

An important feature about layers and subdivision levels is that layers only work with one subdivision level. In other words, if you are at subdivision level 3 and begin sculpting in the layer Basic Shapes, then that layer is locked at level 3. So, if you subdivide again to level 4, you cannot sculpt in the layer Basic Shapes anymore and you would have to create a new layer to work at level 4.

Roughing In the Shape

At this point, the scene and sphere are set up, a new layer has been created, and the sphere has enough polygons to begin sculpting – so let's get started. Make sure that you are working in the layer named Basic Shape by clicking on it once to make it active. Now, rotate the camera so you can see the top of the model. Select the Grab tool from the Sculpting Tools tray and set the Size of the Grab tool to about 50 and the Strength to 65. Position the Grab tool above the sphere (at the North pole) and move the Grab tool down to flatten the sphere as seen in **Figure 2.16**. Repeat the process for the bottom of the sphere.

In this next step, you will mark the sections of the pepper. Peppers can have many sections, but to keep things simple, our pepper will have four. Rotate the camera so that you are looking down on the sphere and select the Bulge

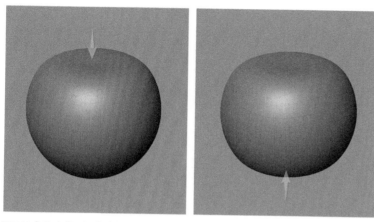

FIG 2.16 To Begin Shaping the Sphere into a Pepper, Use the Grab Tool to Quickly Flatten the Top and Bottom.

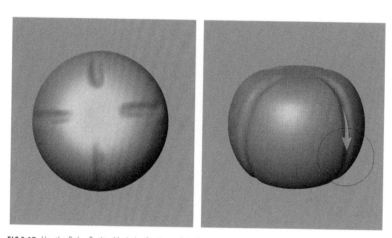

FIG 2.17 Use the Bulge Tool to Mark the Sections of the Pepper. However, In This Case, You Will Invert the Bulge Tool by Pressing Ctrl While Sculpting to Sculpt Indentions.

tool. Set the Size to about 20 and the Strength to 65. But, before applying the Bulge tool, press Ctrl (Mac Control) and then create four indentations. Certain sculpting tools like the Bulge tool can be inverted by pressing the Ctrl key. This means that instead of pulling out when sculpting, the tool pushes in. Rotate the camera around to see the sides of the model and use the inverted Bulge tool to continue the indented marks to the bottom of the model (Figure 2.17). Don't worry too much about making the indentions perfect; these are just guides for sculpting the sections of the pepper.

Now, you will shape the sections so that the sphere is even squattier. With the Grab tool set to about Size 50 and Strength 65, push in each end of the sphere. Reduce the Strength of the Grab tool to about 30 and shape the top as in Figure 2.18. Select the Bulge tool, set its Size to about 40 and Strength to 60, and sculpt the bumps at the top of each section. To delineate grooves between

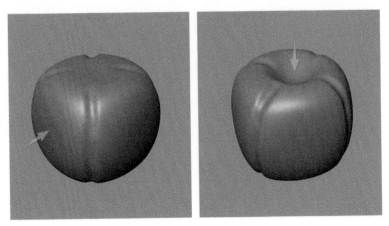

FIG 2.18 With the Grab Tool, Push in the Sides of the Sphere Then Indent the Top.

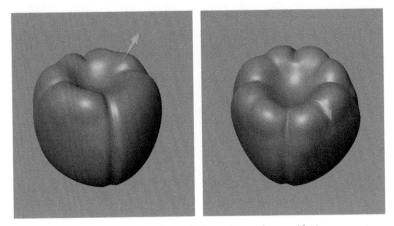

FIG 2.19 Use the Pinch Tool to Delineate or Tighten the Grooves between Bumps and Sections.

the bumps, invert the Bulge tool, set it to a small size of about 15, and sculpt the grooves as seen in **Figure 2.19**. Focus on getting a feel on how the sculpting tools work; don't fret too much over details. You may use the Smooth tool to soften or smooth out any bumps or lumps you don't want. The Smooth tool may be accessed by selecting it from the Sculpt Tools tray or by pressing Shift to toggle to the Smooth tool while working with any other sculpting tool.

Rotate the camera so that you are looking at the bottom of the sphere. Use a combination of the Grab and the Bulge tools to create the features seen in **Figure 2.20**. At this point, the sphere should resemble a pepper, so we'll refer to it as a pepper from now on. Rotate the camera so that the pepper is right-side-up. Use the Grab tool to pull out the sides at the top of the pepper and push in the sides at the bottom. See **Figure 2.21**. You can do as little or as much reshaping as you like. Remember that peppers come in all shapes, so you can't

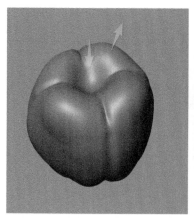
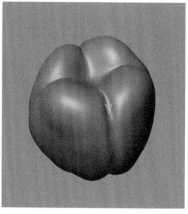

FIG 2.20 Use a Combination of the Grab and Bulge Tools to Shape the Bottom of the Sphere. By This Point, You Should Be Getting a Feel of How the Sculpting Tools Work.

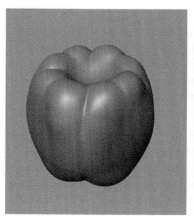
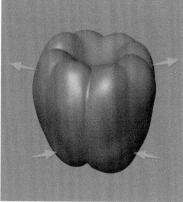

FIG 2.21 Use the Grab Tool to Give the Pepper Its Characteristic Bell Shape.

get it wrong. Once you are finished shaping the pepper, use the Pinch tool to emphasize the grooves between each section. The Pinch tool moves polygons closer together, so when the tool is run along a groove, it makes the groove tighter. Select the Pinch tool and set its Size to about 10 and Strength to 30. In the tool properties, check the Steady Stroke option. Steady Stroke makes it easier to follow along a path. Run the Pinch tool along all of the grooves on the pepper to make them tighter and more distinct.

Sculpting Details

So far, you have sculpted a sphere into the general shape of bell pepper using the Grab, Bulge, Smooth, and Pinch tools. You have learned that some sculpting tools may be inverted by pressing the Ctrl key (Control Mac) so they push in instead of pulling out, and that the Smooth tool can be toggled on

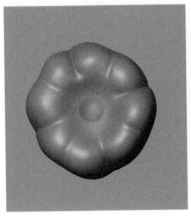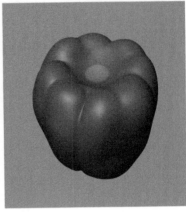

FIG 2.22 Use the Freeze Tool to Paint the Area Where the Stem Will Be Sculpted. Then Invert the Freeze Tool to Freeze the Rest of the Pepper and Leave the Stem Spot Unmasked.

by pressing Shift while working with any other sculpting tool. You have also learned to manage the size and strength of the sculpting tools to get the desired amount of sculpting effect. In the next section of this tutorial, you will sculpt the floret and stem of the pepper with new tools like Freeze, Flatten, and Fill, and continue to practice with the sculpting tools that you have already been working with.

Before moving on to sculpting the floret and stem, add a new layer and name it Stem. In this way, you can practice sculpting the stem without disturbing the work you have already done to shape the pepper. If you mess up the stem, delete the Stem layer, create a new layer, and try again. After you have created a new layer, subdivide (Shift + D) the pepper twice to level 5. At this level, the pepper has 393,216 polygons. The added polygons will allow you to sculpt with the smaller details of the floret and stem.

In the following steps, you will use the Freeze tool to create a mask that will allow you to sculpt the stem. The Freeze mask will protect the masked areas, allowing the sculpting tools to work only in the unmasked areas. Rotate the camera so you are looking down at the pepper. Select the Freeze tool from the Sculpting Tools tray, set its Size to about 10 and Strength to 100, and paint the area shown in Figure 2.22. Now, press Shift + I to invert the Freeze. Make sure that you are working in the new Stem layer by clicking on it once to make it active.

With the Grab tool set to Size 20 and Strength 65, pull out the stem as shown in Figure 2.23. The Freeze mask is not necessary any more, so turn it off by pressing Shift + U. Next, use the Smooth tool to smooth the base of the stem if necessary. You can shape the shaft of the stem by using any combination of the Grab, Bulge, and Smooth tools. Try experimenting with different tools to see how they work together. The top of the stem can be shaped with the

Flatten tool. If you like, you may turn off the wireframe by pressing W. At very high subdivision levels, there are so many polygons that the wireframe is not useful.

The floret of the pepper is made up of very small, lumpy leaves. In the following steps, you are going to suggest the floret without really sculpting all of the details. Use the Fill to fill in the area around the sections of the pepper and the stem, as shown in **Figure 2.24**. You may have to determine the appropriate Size and Strength for the Fill tool because your pepper and stem will probably be different than what is shown in the figures. However, a Size of about 30 and Strength of 25 is a good starting point. Next, use the Bulge and Wax tools to sculpt the lumps and bumps of the floret and use the Pinch tool around

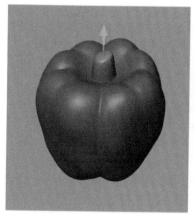
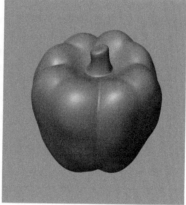

FIG 2.23 Use the Grab Tool to Pull Out the Stem. Once Finished, Turn Off the Freeze Mask and Shape the Stem.

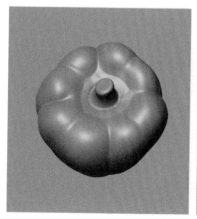
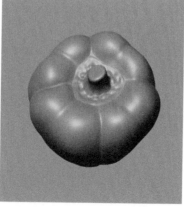

FIG 2.24 Use the Fill Tool to Fill In the Area around the Stem. This Will Give You a Base to Sculpt the Floret. Then Use the Bulge and Wax Tools to Sculpt the Lumpy Leaves and, Finally, Use the Pinch Tool around the Edges to Delineate the Floret.

the edges of floret to separate it visually from the body of the pepper, as seen in **Figure 2.24**. At this point, you should have a recognizable sculpture of a bell pepper.

Adding Texture with a Stencil

Although the skin of a pepper may appear perfectly smooth, if you look closely, it has a slight texture. So, in these last few steps, you will add a texture to the skin of the pepper, using the Sculpt tool along with a Stencil. But first things first, create a new layer and name it Texture. As with the other two layers, adding this layer just for sculpting the texture preserves any work you have done so far and allows you to experiment without worry.

Select the Sculpt tool and set its Size to about 20 and Strength to about 5. Then, from the top row in the Stencils tray, choose the third image to the right by clicking on it once. If you hold the mouse over the stencil images, the file name is displayed; the one you want to choose is named bw_finestonedetail.png. As soon as you select the stencil, it is displayed in the viewport along with a HUD that has instructions on how to manipulate the stencil image. In this case, the stencil should be smaller, so press S + RMB and drag to scale it down (**Figure 2.25**). Next, click on the Sculpt tool once more to display its properties in the Properties tray and turn on mirroring across the *x* axis by selecting X from the Mirror menu. Mirroring allows the Sculpt tool to texture both sides of the pepper at the same time.

Now that everything is ready, start brushing with the Sculpt tool along the surface of the pepper. You should see a texture appear underneath the sculpted area. Rotate the camera so that you can apply the texture on all of the pepper's skin. Don't worry if the texture appears very rough; apply the texture to all of the pepper's skin, but try to avoid the stem and floret (**Figure 2.25**). Once you

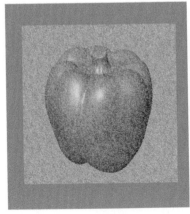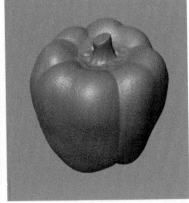

FIG 2.25 Use the Sculpt Tool with a Stencil to Add a Texture to the Pepper's Skin. When Finished, the Texture Will Appear Very Rough.

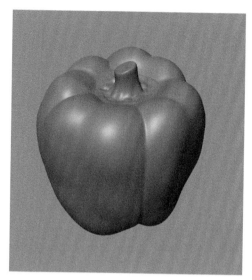

FIG 2.26 Use the Opacity Property of the Texture Layer to Reduce the Skin Roughness.

are finished applying the texture, click on the Off button in the Stencils tray. At this point, the pepper has a very rough skin. To remedy this problem, go to the layer named Texture and in the Opacity field change the value from 100 to 10. You should see the texture become very subtle as in Figure 2.26. The opacity property of the layer may also be changed by using the Opacity slider.

Summary

Congratulations on completing the first sculpting tutorial. By this point, you should be familiar with the Mudbox interface and be able to locate the sculpting tools, the Layers tab, the Properties window, and navigate the scene using the mouse or stylus. In this tutorial, you used many of the sculpting tools and managed layers and subdivision levels to sculpt a bell pepper. That is quite an accomplishment for a beginner. And you have probably figured out that there are many possible ways to sculpt a bell pepper. Becoming proficient with Mudbox requires practice, but the great thing about Mudbox is that it makes practice fun. In the next chapter, you will sculpt a portrait bust. You will take everything you have learned in this chapter and apply it to a more challenging sculpture.

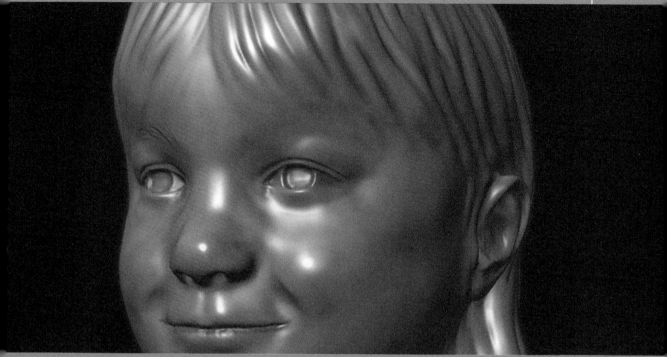

Sculpting a Portrait Bust

In this chapter, you will sculpt the portrait bust of a young girl named Amy. The focus of this tutorial is to sculpt the head and facial features such as the nose, mouth, eyes, and ears. For traditional sculptors who are transitioning to digital sculpting, comparisons between digital sculpting and traditional sculpting techniques will be made. When working through this tutorial, you will learn to set up reference images to guide sculpting, create camera bookmarks for quick camera navigation, and, of course, become very familiar with Mudbox's sculpting tools. This tutorial will suggest sculpting tools, tool settings, and a general workflow to sculpt a likeness; however, you are encouraged to experiment and try the different sculpting tools as you gain experience. Once you have completed the work in this chapter, you will have enough familiarity with Mudbox to create your own digital sculptures.

This tutorial is written with the assumption that either you have worked through the tutorial in Chapter 2 in which the basics like layer management and several of the sculpting tools were introduced, or you have some experience with Mudbox. If you are new to Mudbox, it is a good idea to first work through the tutorial in Chapter 2.

Digital Sculpting with Mudbox. DOI: 10.1016/B978-0-240-81203-8.00003-9

Sculpting a Likeness

Sculpting a likeness may seem intimidating, but when broken down and taken one step at a time, it becomes a doable endeavor. Keep in mind that your task is to sculpt a likeness, not an exact duplicate. Resist the tendency to get caught up with the minutia of details, but instead sculpt the essence of the subject. Remember that you have artistic license and some room for interpretation in creating your sculpture. Here are quick tips on sculpting a likeness:

- Don't sculpt what you assume something should look like. Check the reference materials.
- Continuously study reference materials while sculpting. Keep all the reference materials organized and handy.
- When you make a change in one area, check how that change has affected other areas of the sculpture.
- Continuously compare the sculpture to the reference materials.

Collecting Reference Material

Sculpting a portrait is dependent on capturing form and proportions to produce a good likeness. You could do this by sculpting while the subject is posing in front of you, but more often, sculpting is done from photographs. So, it is important to have a good photograph reference of the subject. If possible, the photograph reference should show both neutral facial expression and the final expression to be sculpted. Take photos all the way around the subject on the same plane (Figure 3.1). Also take photographs from the front, sides, three-quarter view, and looking up and looking down on the subject. It may be difficult to get an absolute straight front or side photographs, especially when working with children, but do your best. You may also want to find photographs of the subject that are not posed. It is these candid shots that often show that "special" expression. All of the photograph reference that you will need to complete this tutorial is available at www.digitalsculpting.net. The following are some tips on getting good photograph reference:

FIG 3.1 It's Important to Take Good Reference Photographs All the Way around the Subject on the Same Plane and from Different Angles.

- Photograph the subject against a simple background to eliminate distractions.
- Light the subject to get good shadows and contrast as this will provide good reference for proper depths.
- Use a photograph-editing program to change the contrast if the photographs don't provide good contrast.
- Take photographs all the way around on the same plane preferably at the eye level with your model, and from different angles like from above and below.

Facial Expressions

Understanding how expressions affect and change the face is important in sculpting a natural likeness of an individual. Different facial expressions can drastically change the face. For example, a full smile changes the shape of the mouth, the cheeks, forehead, and even the eyes. As you progress through the sculpting process, you will move away from the neutral facial expression to the final facial expression that the subject will express. In this project, Amy will have a subtle smile (Figure 3.2).

Measurements

Remember, from Chapter 1, that form and proportions are important in sculpting a good likeness. In traditional clay sculpture, physical measurements of the subject are taken to assure accurate form and proportions. Specific measurements of the subject are often taken from the notch of the ear as a reference point, for example, from the ear to the tip of the chin, from the ear to the tip of the nose, and so on. Many measurements are very similar and can help you remember proportions. For instance, the measurement from the ear to the nose is the same as across the face, and from the chin to the eyebrows (Figure 3.3).

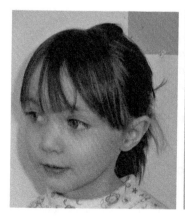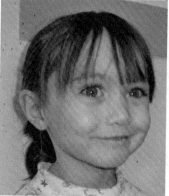

FIG 3.2 In This Project, the Sculpture Will Have a Subtle Smile, but In the Photo Sitting, Amy Exhibits Quite a few Expressions. Expressions Noticeably Change the Shape of the Face.

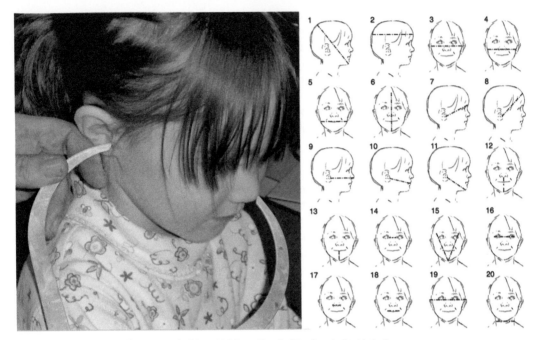

FIG 3.3 In Traditional Sculpture, Measurements Are Taken with Calipers. Many Are Taken from the Notch In the Ear.

If when working on your own digital sculptures, you have an opportunity to take measurements of your subjects, it's a good idea to do so. Even though Mudbox does not have measuring tools at this point, the measurements you take will provide you with a solid reference for the correct proportions of your subject. In Mudbox, you will use reference sketches placed into the program to assure proper form and proportions.

Getting Started

You will sculpt the Basic Head model that comes with Mudbox into a likeness of Amy. The Basic Head model is a great starting point because it is the correct scale for the Mudbox environment, and it is made up of quads (polygons with four sides) that are all about the same size, which is perfect for predictable subdivisions. To guide the sculpting process, you will use many reference photographs and reference sketches loaded into Mudbox's cameras.

Sculpting In the Neutral Position

Although it is important to know the final pose of the subject in the sculpture or the ultimate use of the model such as animation or three-dimensional (3D) printing, it is equally important to first work on the sculpture in the neutral

FIG 3.4 Sculpt First In the Neutral Position to Avoid Time-Consuming Mistakes.

position, otherwise its form and proportions could become skewed (Figure 3.4). When sculpting a clay portrait bust, the facial features are often sculpted while the sculpture is in the neutral position and then the sculpture is posed by bending the underlying armature.

Symmetrical Modeling

Throughout much of this tutorial, the mirroring property of the Mudbox sculpting tools will be enabled. Mirroring (also known as *symmetrical modeling*) makes it possible to simultaneously sculpt on opposites sides of the sculpture. You will be sculpting with mirroring enabled across the *x* axis, thus sculpting the left and right sides at the same time. Mirroring helps to prevent errors in proportions, speeds up the sculpting process, and makes it difficult to skew the facial features. However, mirrored sculpting should be used with caution because humans and other creatures are not symmetrical. Creating symmetrical sculptures without introducing some natural asymmetry to the facial features will produce a stale and unrealistic sculpture.

Loading the Basic Head Model

Launch Mudbox, and from the Welcome dialog, select the Basic Head model by clicking on it once (Figure 3.5). An alternate method to load the Basic Head model or any stock model that comes with Mudbox is to go to the Create menu, and from the Mesh submenu, select the model you want. The figures in this tutorial show the grid and the background gradient turned off.

Setting Up Reference Sketches

In the following steps, you will set up the reference sketches that will guide you in sculpting a likeness of Amy. In Mudbox reference, images are loaded into the Image Plane associated with each camera. To load the front reference sketch into the Front camera, click on the Object List tab, right-click on the Front camera object, and select Look Through (Figure 3.6). You should now be looking at the scene through the Front camera. Then, while still

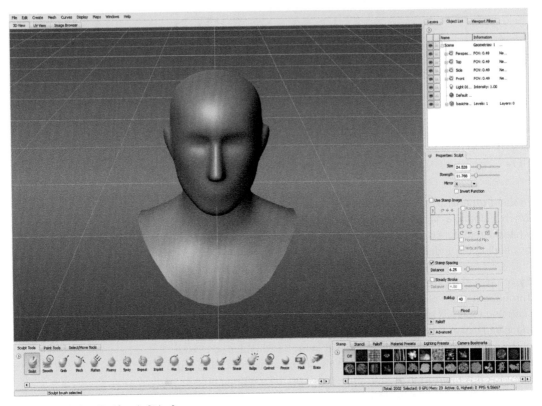

FIG 3.5 Select the Basic Head from the Dialog Box.

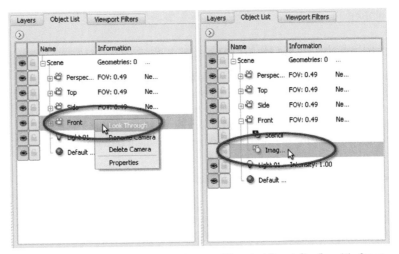

FIG 3.6 In the Object List, Right-Click on the Front Camera and Choose Look Through. Then Expand the Camera Tree and Select Image Plane. In the Properties Window, Click on Import to Load the Reference Sketch.

in the Object List, click on the plus (+) symbol next to the Front camera to display the Image Plane, and click on the Image Plane. The Image Plane properties will display in the Properties window. Click on the Import button and browse to the file front_sketch.jpg that you found at www.digitalsculpting.net to import it. The reference sketch will appear in front of the model; so, for the moment, you will not see the model in the scene, but only the sketch (Figure 3.6).

To see the model again, you could do one of two things: either you could move the sketch back in the scene behind the model, or you could change the visibility (transparency) of the sketch. In this case, you will change the visibility. Make sure that the Image Plane is still selected in the Object List, expand the Advanced tab in Properties window, and set the Visibility amount to about 0.30 by moving the slider or typing the value. Leave the Depth set to 0 (Figure 3.7).

Next, you will align the model with the front reference image by moving the camera – not by moving the model. At no point, in this tutorial, will you be asked to move the model by using the Translate, Rotate, or Scale tools located in the Select/Move Tools tray. Although it is possible to move the model around the scene, it is best to leave it in the middle of the scene, so that your work will match with the instructions and figures in this tutorial and instead,

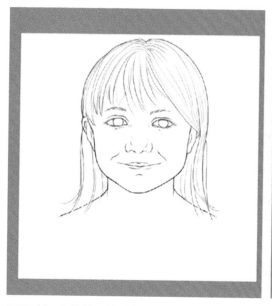

FIG 3.7 Adjust the Visibility of the Reference Sketch to See the Model.

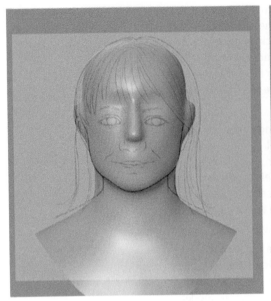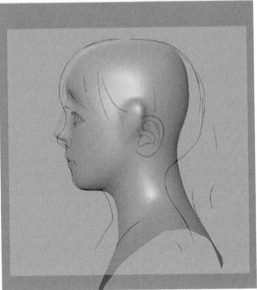

FIG 3.8 Align the Model with Front and Side Reference Sketches.

move the camera. While still looking through the Front camera, zoom until the chin and top of the head of the model match with the reference image as best as possible. Then, pan to align the nose of the model with the reference image (Figure 3.8). Repeat the process you just completed for loading the front reference sketch into the Front camera and aligning the front reference sketch to the model; but this time, do it for the Side camera. The reference sketch for the Side camera is side_sketch.jpg.

Adding a Camera Bookmark

Camera bookmarks allow you to record camera positions, so that you can recall them at a later time. This feature is very useful because it makes it possible to compare your sculpture with the reference sketches or photographs from the same point of view, at any time. To create a camera bookmark for the Front camera view, look through the Front camera, then in the Camera Bookmarks tray, click on the small arrow in the upper left corner, and select Add Camera Bookmark. In the Camera Bookmark dialog, name the bookmark as Front (Figure 3.9). Repeat the process to create a bookmark for the Side camera view.

You have now completed setting up the scene by loading the model you will sculpt, importing the reference sketches, aligning the model with the reference sketches, and creating the first couple of camera bookmarks. This would be a good time to save your work as an incremental copy. In the next part of this tutorial, you will rough in Amy's basic proportions.

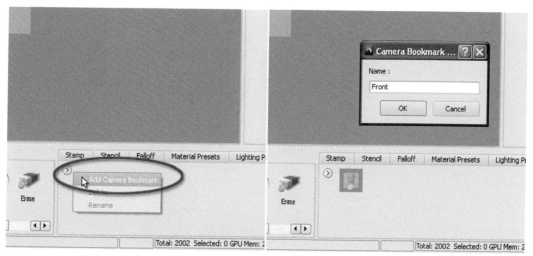

FIG 3.9 Create Camera Bookmarks for the Front and Side Cameras.

Best Digital Sculpting Practices

- Organize the reference materials so that they are handy when needed.
- Save often and save incremental files at important milestones (i.e., sculpt01.mud, sculpt02.mud …).
- Move the scene light (L + MMB) to check forms by examining shadows.
- View the model with different materials. Lighter materials bring out details hidden by dark materials.
- Rough in larger shapes first to build up general forms first, and then add details later.
- Rotate around the model often to inspect it from all angles while working.
- Use the lowest subdivision level that will hold the desired forms. Subdivide only when adding more details. Working at very high-subdivision levels unnecessarily produces lumpy sculptures and wastes computer resources.
- Most important, when building up forms, blend them into the surrounding areas with the Smooth tool. Then, build up and smooth again. Repeatedly using the Smooth tool with the other sculpting tools will create smoother less lumpy forms.

Changing Proportions from Adult to Child

Amy's features and proportions are very different from the features and proportions of the Basic Head model. This is because the Basic Head model has the proportions of an adult, and there are marked differences between the proportions of an adult and a child. The following are key things to know

FIG 3.10 The Proportions of a Child Are Very Different than an Adult's Proportions.

about the differences between an adult's head and face and a child's head and face (**Figure 3.10**):

- A child's face is squattier and more rounded than an adult. Adults tend to have longer faces.
- A child's chin is farther back than an adult's chin.
- The back of the head and the forehead is more round in a child than in an adult.
- As the upper and lower jaws increase in size, it changes the proportions of the face.
- The size and shape of teeth affect the shape of the mouth and lower face.
- The eye sockets are round in a child but gradually become more rectangular in an adult.

Creating a Sculpt Layer and Subdividing

In the Layers tab, create a new layer and name it something that will indicate what it contains, such as Proportions. Next, subdivide the model twice by pressing Shift + D two times. As you subdivide, you should see the Heads Up Display (HUD) displaying the subdivision level and number of polygons in the model. After subdividing the model twice, you should be at level 2, and the

model should have 32,032 polygons. Remember, from Chapter 2, that layers work only with one subdivision level and that the number of subdivisions or resolution affects how the sculpting tools work. As a result, it is important to keep track in which layer and what subdivision level you are working and also how many polygons the model has at that level. If you haven't already turned on the model's wireframe, do so now by pressing W. This will allow you to see how you are changing the model's geometry.

Adjusting the Proportions of the Chest, Back, and Shoulders

The Basic Head model has broader shoulders and a larger chest than Amy. So, your first sculpting task will be to change the adult proportions of model's shoulders and chest into the proportions of a child. You will use a combination of the Smooth and Grab tools to accomplish this task. Make sure that you are looking at the model through the Perspective camera. From the Sculpt tools tray, select the Smooth tool and in the Properties window, set the size to about 20 and strength to about 40, and turn on mirroring across the x axis by selecting X from the Mirror menu. Now, begin brushing over the lower edge of the chest, and you should see the chest getting smaller on the left and right sides because mirroring is turned on. Use short controlled strokes to slowly reshape the model. If you don't get the desired result, simply press Ctrl + Z (Mac Command + Z) to undo and try again. You may switch to the Front camera and use the front reference sketch as a guide. If necessary, switch to the Grab tool and set it to about the same size and strength as the Smooth tool and carefully move any areas of the chest and shoulders that need to be adjusted (Figure 3.11). Use the Grab and Smooth tools to make the back a bit smaller also. The goal is to make the chest, back, and shoulders

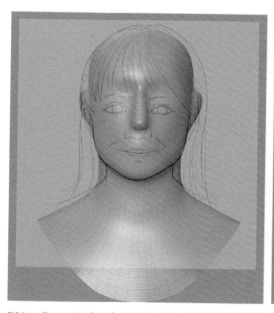
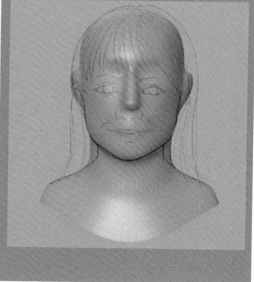

FIG 3.11 Changing the Chest, Back, and Shoulders of the Adult Model to Match with Amy's Smaller Proportions.

smaller and more in scale with a child's proportions. However, you don't have to make it perfect because this is not the focal area of the sculpture.

Changing the Proportions of the Head

Next, you will change the shape of the model's head and neck to match with Amy's proportions. Use the Grab tool (size 60, strength 60) while looking through the Front camera and move the outer edges of the model's neck to align with Amy's neck. Then, move the model's jawline, temples, and cheeks to match with the front reference sketch. Also move the eye sockets, brows, and bridge of the nose to match with the front reference sketch (Figure 3.12). You will have to vary the size of the Grab tool as you work from a large amount to a smaller amount of strength.

Switch to the Side camera and use the Grab tool to adjust the model's profile, as seen in Figure 3.13, so that the model matches with the side reference sketch. The reference sketches were drawn and edited, so that the size and facial features align almost perfectly between the front and side views. However, because these sketches were drawn from photographs, there are going to be some slight differences. If you find that what you sculpt in the front view changes the model's alignment in the side view (or visa versa), make sure that you are using the camera bookmarks when looking through the Front or Side cameras. If there are still some slight differences, just split the difference between the views when sculpting, and remember that the goal is just to sculpt a good likeness of Amy.

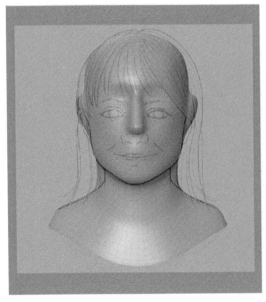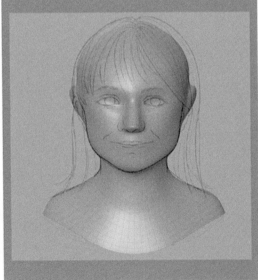

FIG 3.12 Use the Grab Tool to Adjust the Model's Features as Seen from the Front.

FIG 3.13 Adjust the Model's Features as Seen from the Side.

It's important to note that your sculpture may not look exactly like the sculpture in the figures – and that's okay. Expect that there will be some differences between your work and the figures because things like how you initially aligned the model with the reference sketches could be slightly different than what is shown in the figures. If you see some slight differences, don't be discouraged, just keep sculpting. When you are finished, you will still end up with a good likeness.

At this point, you should have the correct proportions and general shape of Amy's head. Switch to the Perspective camera and take time to inspect the model from all angles. Make sure that the head is round as seen from the top and sides. If you notice any artifacts such as dents and bumps, correct them now. One artifact that may occur is a crease that is down the midline of the mode. This is caused by working with the Grab tool in the side view. This artifact can be deleted by going over it with the Smooth tool. As you work, switch back to the Front and Side views to make sure that you are not changing the basic proportions. This is a good time to save an incremental copy of your work.

Refining the Shape of the Face

In this section, you will begin using the photograph reference to refine the overall shape of the face. You will rely on the photographs for the rest of the tutorial, so please make sure that you have downloaded all of them from www.digitialsculpting.net (Figure 3.14). There are eight photographs in total, including a front and side view and additional photographs taken from around Amy's head. Once you are finished with this section, you will sculpt the nose, mouth, eyes, and ears.

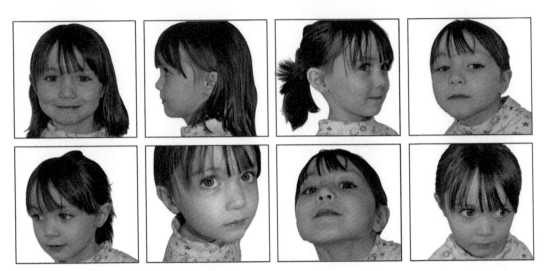

FIG 3.14 Download All Reference Photographs.

Roughing In the Eye Sockets

In the next steps, you will rough in the areas where the eyes will be sculpted by positioning the eye sockets. If the eye sockets are not in the correct place, it will make refining the face and creating the eyes more difficult later. This may be a challenging step, so take your time. First, check the Side camera sketch to see how far back the eyes are on the model compared with the position of the eyeballs on the sketch. This helps in repositioning the eye sockets. Then, switch to the Perspective camera and rotate the camera to see the front of the sculpture. Select the Bulge tool (size 35, strength 10) and make sure mirroring is enabled across the x axis. Keep mirroring on for all sculpting tools from now on, unless instructed to turn it off. Then, press Ctrl (Control on the Mac) to invert the Bulge tool and slowly push in the eye sockets. Continue the stroke to the outside corner of the eye sockets with less pressure as you move along the outside of the face. The indentation created by continuing the stroke to the side of the face will help to define the cheek area (Figure 3.15). After pushing back the eye sockets, use the Grab tool to sculpt the cheek and forehead.

In traditional clay sculpture, the sculptor would put her thumbs at the bridge of the nose and dig out the clay to position the eye sockets and continue digging out clay to just before the temples. Roughing in the eye sockets and the indentation on the sides of the head will make the next steps much easier. Check the side camera sketch again to see where the sockets are in the model compared to where the eyeball is on the sketch.

Shaping the Face

What follows is a suggested workflow to sculpt the basic shape of Amy's face, using the reference photographs. You will position the Perspective camera to match with the views as seen in specific reference photographs and make

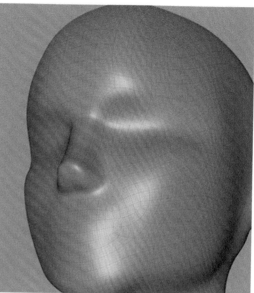

FIG 3.15 Repositioning and Roughing In the Eye Sockets and Sculpting the Forehead and Cheeks.

camera bookmarks. Then, you will sculpt the model to match what you see in the photographs. You will repeat this process for several of the reference photographs. For now, sculpt in the same layer that you created earlier and keep the subdivisions at level 2. Remember that your model may differ to varying degrees from what you see in the figures – which is fine – just keep sculpting. As you progress, your model will begin to resemble Amy.

Look at photo1.jpg; notice that you can barely see Amy's right ear. Now, rotate the Perspective camera so that the view is similar to photo01.jpg. When you position the camera to match with the photograph, you can see most of the model's right ear. This difference occurs because the model does not have Amy's chubby cheeks (Figure 3.16). Take a minute to make a camera bookmark. This will help you refer back to this viewpoint as needed. Then, with the Grab tool, pull the model's cheeks to match with the photograph. Notice that, in this view, you can also see that the forehead needs to be rounded and the chin and jawline need to be sculpted to look like the reference photograph. To sculpt the jawline, use the Grab tool to push up under the jaw, and use the Bulge tool to define the edge of the jaw. Take time to make these adjustments and any others that you see while studying photo1.jpg and comparing it with the model. Remember to smooth the model as you sculpt.

You do not have to sculpt in the same position as the reference photographs at all the time; this would be impossible to do. At some point, you will need to rotate the camera to see other parts of the model even though you are still working from a specific reference photograph. Move the camera around the model as

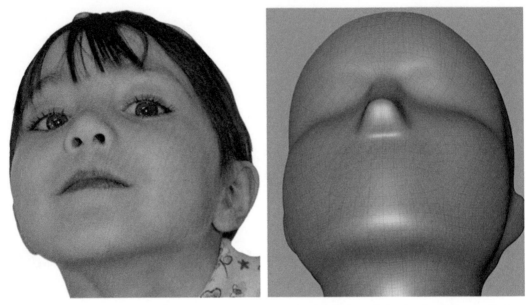

FIG 3.16 Position the Camera to Match with Photo01.jpg and Sculpt What You See. As You Work, Use Camera Bookmarks to Save the Views that Match with the Reference Photographs.

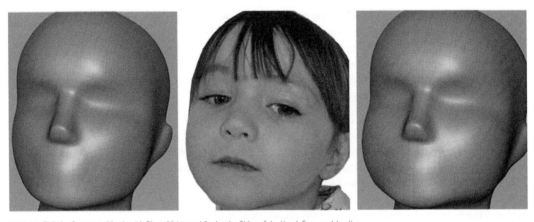

FIG 3.17 Roll the Camera to Match with Photo02.jpg and Sculpt the Sides of the Head, Face, and Jawline.

needed to sculpt, and then use the camera bookmarks to reposition the camera back to the same view as the reference photograph to check your work.

When you are finished with photo1.jpg, move on to photo02.jpg. Remember to make a camera bookmark when you have the scene view in a position similar to that of photo02.jpg (**Figure 3.17**). To match with the view in photo02.jpg, roll the camera by pressing Shift + MMB. In this view, sculpt the top and sides of the head, fill in the sides of the face, and begin to sculpt the jawline. As you sculpt, check your work with the reference sketches in the Front and Side camera.

Use a combination of the Bulge, Grab, Wax, and Smooth tools at varying sizes and strengths to continue sculpting. However, experiment with other tools such as the Sculpt and Flatten tools to see how they work. Recall from the tutorial in Chapter 2 that each tool has a different feel and produces varying results. As you gain experience with Mudbox, you may discover that you prefer different tools or tool combinations than the ones we are suggesting – use the sculpting tools that work best for you.

Study the remaining reference photographs to continue sculpting the model. Make camera bookmarks for all reference photographs like you did with the first two. Continue to sculpt the cheeks, jawline, chin, forehead, sides of the head, and neck based on what you see in the photographs. Once you have worked your way through all reference photographs, review the model by looking at it through the first camera bookmark. How did the changes you made in one view affect the others? You may find that you have to resculpt certain areas to get them to match with the reference photographs. Remember that sculpting is a push–pull dance until you find the happy medium where the model begins to resemble Amy.

Refining the shape of the head and face, using the reference photographs, was challenging, but certainly it's worth the effort. The steps that you have taken, so far, have laid down the foundation needed to sculpt the main facial features like the nose, mouth, and eyes. At this point, you should have a model that is beginning to resemble Amy (**Figure 3.18**).

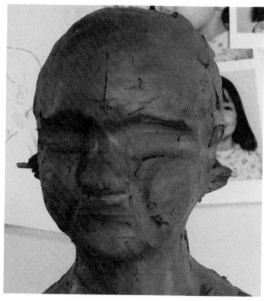

FIG 3.18 Traditional Sculpture Roughed In.

Sculpting the Nose

Now that you have camera bookmarks for several angles of the face and have sculpted the basic shape of Amy's head, face, and neck, you can begin sculpting the facial features – the first one will be the nose. Create a new layer and name it as Nose, then press Shift + D to subdivide the model to level 4. You may want to turn off the wireframe (press W) because at this subdivision level, the wireframe lines can be distracting. The tool sizes and strengths indicated are approximations, and feel free to change the settings to fit your sculpting style.

While reshaping and sculpting the head in the previous section, you actually sculpted some of the nose anatomy. When you pushed and pulled on the face and forehead and aligned the tip of the nose with the reference sketches, you defined the bridge and length of the nose. Without even knowing it, you have already come a long way in sculpting the nose. For you to follow along with this section of the tutorial, you will need to know the following nose anatomy (Figure 3.19). The following are some important things you should know about a child's nose:

- There is very little bridge to a child's nose, and the bridge is less defined as seen from the front because it blends into the cheeks.
- A child's nose is usually more bulbous and tipped up than an adult's nose. While looking from the top, the bulbous look is less apparent.
- The nostrils are smaller.

Widening the Bridge of the Nose

The first task is to widen the bridge of Amy's nose. Use the Grab tool (size 10, strength 9) to pull the sides of the bridge of the nose. Next, use the Fill or Wax tools to sculpt the skin that connects the bridge of the nose to the face

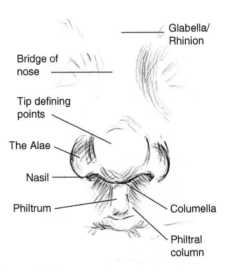

FIG 3.19 The External Anatomy of the Nose.

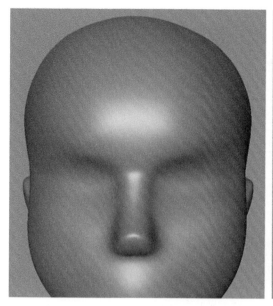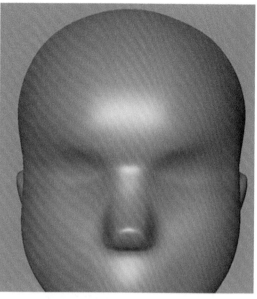

FIG 3.20 Widen the Bridge of the Nose and Sculpt the Sides of the Nose as They Blend into the Cheeks.

(Figure 3.20). Switch to the Side camera to compare your work with the side reference sketch to make sure that the bridge of the nose generally follows the sketch.

Sculpting the Alae and Tip of the Nose

If you are unsure of how wide to make the nose, it is wider than you think. Look at a front-view photograph, and if you measure the width of the nose from the edge of one alae to the edge of the other, you will find that about 1⅓ nose widths will fit between an alae edge and the edge of a cheek (Figure 3.21). These types of comparative measurements help with proportional sculpting.

Now that you know about how wide to make the nose, select the Foamy tool (size 10, strength 10) and apply short strokes to slowly build up the alae as seen in Figure 3.22. Remember to smooth as you sculpt. Switch to the Front camera and compare your work with the front reference sketch. A few attempts may be required to create the alae as seen in the reference materials. Once you are finished, see if your model's nose is the right width by comparing it with the measurement that you got from the photograph.

Refining the Tip of the Nose

You are probably getting better at positioning the camera, switching between cameras, and using camera bookmarks to get the best view to sculpt a specific feature. So, place the camera in a position where you can easily see the tip of the nose. Select the Foamy tool and begin sculpting the part of the

FIG 3.21 Comparing the Width of the Nose to the Width of the Cheek.

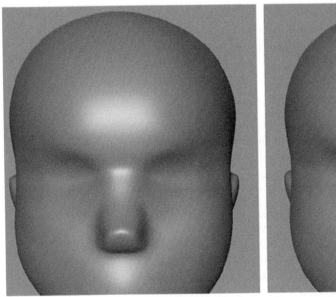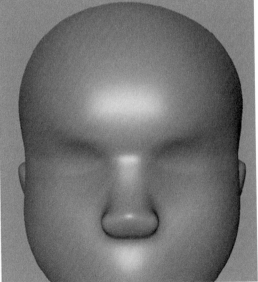

FIG 3.22 Roughing In the Alae.

tip that is below the bridge of the nose but just above the tip itself. These areas are the tip-defining points (**Figure 3.23**). Be sure to view the nose from different angles to ensure that it is being correctly sculpted. You may even look down at the nose from above or up from below to make sure that it is not flat. Constantly compare the model with the photographic reference. You may also use the Grab tool to move parts of the tip into position as you

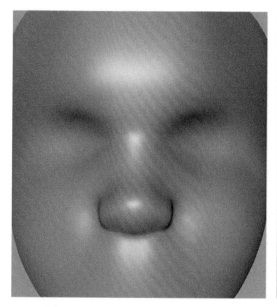

FIG 3.23 Refining the Alae and the Tip of the Nose.

sculpt with the Foamy tool. Once again, check the width of the nose with the 1⅓ measurement and also with the front-view reference sketch to ensure correct proportions.

Adding Nostrils

What is a nose without nostrils? In these next few steps, you will sculpt the nostrils. Rotate the camera until you can see the bottom of the nose. Refer to the reference photographs in which you can see the bottom of the nose. Select the Freeze tool (size 5, strength 100). Paint the area shown in **Figure 3.28**. Press Shit + I to invert the freeze. Then, with the Bulge tool inverted (size 5, strength 5), push in the nostrils (**Figure 3.24**). Alternate between the Bulge and Smooth tools to control sculpting the nostrils and sculpt from different views. When you are finished, press Shift + U to delete the Freeze and use the Smooth tool to soften the edges of the nostrils.

Refining the Alae

The next task is refining the alae so that the groove or transition from the tip of the nose to each alae is more distinct. Refer to the reference photographs often as you sculpt the alae. Rotate the camera so that you can see a side or a three-quarter view of the model. Select the Freeze tool (size 12), carefully paint the area shown in the first panel of **Figure 3.25**, and then invert the freeze. With an inverted Bulge tool (size 5, strength 10), lightly sculpt the alae facial groove, and smooth as you sculpt. Now with the Grab tool (size 5,

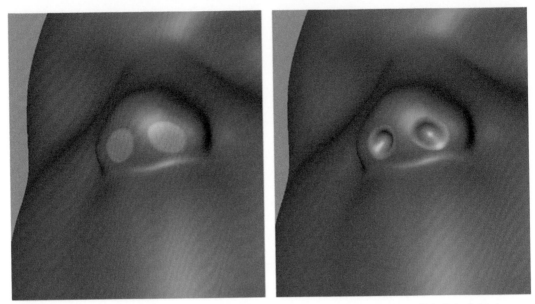

FIG 3.24 Use the Freeze Tool to Mask the Area Where the Nostrils Will Be Sculpted. Invert Freeze and Then Use an Inverted Bulge Tool to Push In the Nostrils.Use the Smooth Tool to Get Rid of Any Unwanted Artifacts.

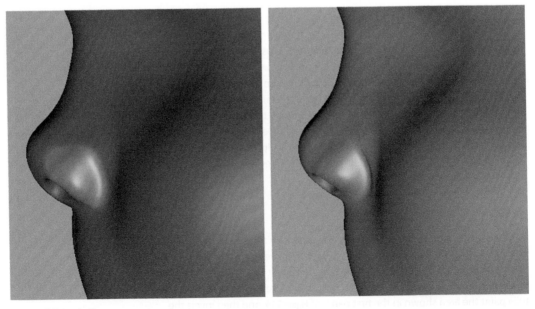

FIG 3.25 Refining the Alae.

strength 25), move the alae back toward the cheek and also down a bit. Undo the freeze and smooth both the groove and alae being careful not to smooth out the groove that you have just created. Just remove the jaggedness within the groove if there is any. Should you find that you need more mass at the columella, the structure between the nostrils, use the Foamy tool (size 10, strength 7).

After sculpting the features of the nose, remember to check the model against the reference sketches in the Front and Side cameras. Should you discover that the nose does not align with a reference sketch, then use the Grab tool to reposition it as necessary.

Sculpting with Negative Space

Sometimes, looking at a structure in a different way helps to highlight its shape and its relationship with its surrounding structures. For example, the bottom of the alae and the columella form the nostrils. In essence, the nostrils are negative space between these structures. To help get the right shape of the alae, the columella, and by default the nostrils, try the following: Look at a side view of the nose in one of the reference photographs. From the left side, as the outer edge of the alae makes its way around to the columella, it forms a backward S (on the right side, it's a normal S). Look at this S shape to help you gauge the shape of the nostril and surrounding structures (Figure 3.26). The space between the alae and the columella or the nostrils forms a negative space.

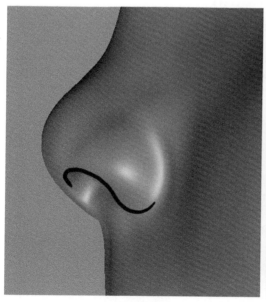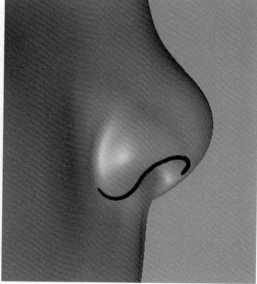

FIG 3.26 Sculpt the Negative Space Created by the Nostrils and the S Shape Created by the Alae and the Columella to Get the Right Shapes.

Sculpting the Philtrum

Once you have completed the bridge, alae, nostrils, and bottom of the nose, you are almost finished. However, you are sculpting more than just a nose stuck on a face. Each part of the face is dependent on the shapes surrounding it. To complete the lower portion of the nose, you have to take the philtrum and philtral columns into consideration. The philtrum is the dip everyone has between the nose and the upper lip and the philtral columns are the ridges on either side of the philtrum. The philtrum blends into the columella and the philtral columns into the nostrils. Therefore, the edges of the nostrils do not complete a circle all the way around the bottom of the nose. In Amy's nose, the philtrum and philtral columns are more subtle than in an adult's nose, but they are there and have to be sculpted.

To sculpt the philtral columns, use the Wax tool (size 5, strength 5) and slowly build up the shapes shown moving downward and outward as to create the triangular mass as seen in **Figure 3.27**. Check your work with the reference sketches to make sure that everything is still in place and that you are not making this portion of the lip too thick.

Up to this point, you have done a lot of work to sculpt proportions, the shape of the head, and now the nose. This is a good time to save an incremental copy of your work. By sculpting the philtrum, you have already begun to sculpt the mouth.

Sculpting the Mouth

In this section, you will sculpt the mouth and continue to work on surrounding features like the chin and cheeks. Novice artists tend to draw or sculpt the mouth as if it were on a flat plane when, in fact, it is the 3D structure that is influenced by the contours of the jaws, face, muscles, and fat. To sculpt the mouth and surrounding structures, convincingly, you must understand the

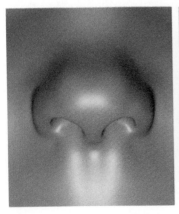
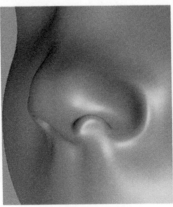
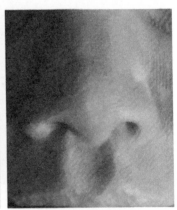

FIG 3.27 Sculpting the Philtrum and Philtral Columns In Mudbox and the Completed Nose In a Traditional Sculpture.

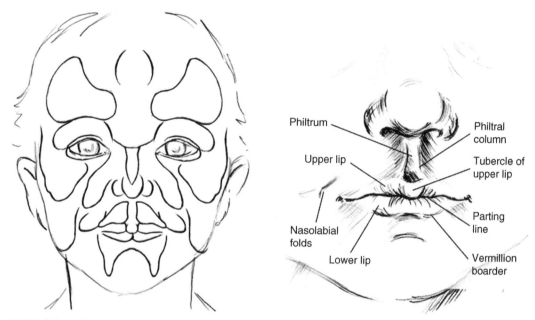

Philtrum

Philtral column

Upper lip

Tubercle of upper lip

Nasolabial folds

Parting line

Lower lip

Vermillion boarder

FIG 3.28 Understanding the Anatomy of the Mouth as Well as the Masses of the Face Will Help In Properly Sculpting the Mouth.

underlying anatomy and the relationships between the structures of the face (Figure 3.28). The following are some things that you need to know about the mouth.

- As seen in profile, the lips and mouth are on a downward angle between the nose and the chin.
- The upper lip is composed of three masses and the lower lip is composed of two masses.
- The lips and mouth follow the round contours of the jaw and face.
- The teeth influence the shape of the lips.
- The underlying fat and muscle dictate the shape of the lips and mouth.

Take time to study the reference photographs to get a general understanding of how Amy's mouth is formed. Be aware that different emotions and expressions will change the shape of the mouth.

Hiding Part of the Model

Sometimes, when you work on one area of the model, other areas can be distracting. In this case, as you are working on the lower half of the head, the upper half can draw your attention away. In traditional sculpting, some artists will wrap a cloth around the top half of the head to hide the eyes and other features to avoid distractions (Figure 3.29). In Mudbox, you can hide parts of the model so that you can focus on what you are sculpting. Also hiding the part of the model you are not working on helps the computer work faster

FIG 3.29 Hiding Part of the Model In Mudbox and Hiding Part of the Sculpture In Traditional Sculpting.

because Mudbox has fewer polygons to display. Go to the Select/Move Tools tray. Select the Faces tool, and in the Properties window, enable Mirroring across the *x* axis. Then, begin to paint over the top half of the model including the eyes, top of the ears, and the back of the head. The selection you are creating will turn yellow. Now, go to Display menu and choose Hide Selected. When you are ready to see the entire model again go to the Display menu and choose Show All.

Marking the Location of the Lips

Before getting started on the mouth, create a new layer and name it as Mouth. The correct placement of the facial features like the mouth, eyes, and ears can be challenging. Sometimes, the fear of making an error in placing the facial features can stifle your progress. To avoid time-consuming errors, the first thing you will do is mark the location of the mouth. Use the front reference sketch as a guide and the Knife tool or an inverted Bulge tool to trace the part of the lips. Try using the tools with Steady Stroke on, as this feature helps to trace details. The lip parting line is not a straight line across, but curves up toward the corners and has a bit of a dip in the middle (Figure 3.30).

The Upper Lip

Next, you will sculpt the general shape of the upper lip. When studying the reference photographs, it may be easy to be confused by the color of the lips when trying to figure out the shape of the lips. This happens because the edge of the vermillion, or the color of the lips, does not necessarily follow the edge of the lip. Focus on the shape and mass of the lips instead of just the color.

The upper lip is composed of three masses two on either side and one in the middle. To rough in these masses, you can try either the Wax or Bulge tools set to a small size and strength or a combination of both tools. Smooth as you

FIG 3.30 Sketching the Parting Line In the Lips.

FIG 3.31 Sculpting the Upper Lip and Blending It into the Philtrum.

fill in the upper lip. Experiment with the Falloff profiles to determine which one works best to shape the lip. Falloff profile 6 worked well in shaping the upper lip. As you rough in the upper lip, connect the top edge of the lip to the philtrum and philtral columns to blend the upper lip into this area. Check your work with the reference sketches (**Figure 3.31**).

Falloff profiles determine how a stroke from a sculpt tool blends from its center to its outer edge. Certain falloff profiles blend the stroke smoothly, whereas others may create hard edges. In certain circumstances, you may want to change the falloff profile to get a different effect. For example, while sculpting the lips, you may want to use a profile that has a smoother blend (like profile 6). Mudbox ships with a half a dozen falloff brushes ready to be used, but you can change the falloff of the brush on the fly by adjusting the falloff shape in the Falloff section in the Properties window. You may also save your new falloff profile.

The Lower Lip

Freeze the upper lip to avoid accidentally changing it while working on the lower lip. Then, slowly, build up the shapes that make up the lip with the Wax and Bulge tools (Figure 3.32). Avoid making huge changes all at once. Check with the side reference sketch to see if the lips line up. If necessary, push back the lower lip according to the side reference sketch. Look at the model from the top down or from the bottom up and make sure that the shape of the lower lip/mouth is round. If you find that the line that parts the lips disappears while you sculpt, just go over it with an inverted Bulge tool and use the Pinch tool to keep it distinct.

Sculpting the lips is a balance between adding the masses, smoothing, pushing and pulling, and defining the parting line between the lips. Continuously check the model from all angles and compare your work to the reference materials. You may have to go back and forth for a while making changes in one area and then adjusting another until the lips begin to take the appropriate shape. Using Freeze and Invert Freeze tools will aid you in working on each lip, individually, without affecting the other (Figure 3.33).

The masses on each side of the lower lip extending down toward the chin help to shape the mouth and naturally blend the lower lip into the surrounding

FIG 3.32 Sculpt the Masses of the Lower Lip. Check with Side Reference Sketch to Make Sure the Lips Line Up.

FIG 3.33 Work with Freeze and Invert Freeze to Adjust Lips.

areas. Use the Wax tool to build up these masses. Also note that the roundness of the chin combined with the masses on either side of the lower lip creates a noticeable indentation right under the lower lip. Finally, you may have noticed that Amy's chin has a subtle, barely noticeable dent or dimple in the middle. Invert the Bulge tool, set it to a small size and low strength, temporarily turn off mirroring, and carefully push in to create the dimple.

Refining the Mouth

After working on the upper and lower lips, compare the model to the reference photographs and sketches again to make sure that the general proportions are still good. Use the camera bookmarks that you created earlier to check how the model compares with the reference photographs. Inspect the model from all angles and revise anything that looks off. Remember that in this sculpture, Amy has a subtle smile so you will have to take that into account when looking at photographs where she has a different expression. Look at the model from the bottom up and top down to make sure that the mouth is round and as seen from these views. You may have to push back the corners of the mouth or move the cheeks to get the right look. The upper lip is a bit farther forward than the lower lip, even at the corners. So freeze the upper lip and push back the corners of the lower lip (Figure 3.34).

Amy's smile makes the nasolabial folds prominent and creates small dimples at the corners of the mouth. To sculpt the nasolabial folds, Freeze the area shown in Figure 3.35 and use an inverted Bulge tool to accentuate the fold. When finished, release the freeze and use the Grab tool to make any necessary adjustments.

FIG 3.34 With the Upper Lip Frozen Push Back the Corners of the Mouth.

FIG 3.35 Defining the Nasolabial Folds Will Help In Shaping the Corners of the Mouth.

Refine the mass in the middle of the upper lip; this is formed by a subtle protrusion. Use the Bulge tool and set to a small size and low strength to add this mass to the upper lip (Figure 3.36). To control where you sculpt, you may need to freeze the surrounding areas. This feature of the upper lip is very subtle, so use the Smooth tool to blend it into the rest of the lip.

Lips have a noticeable texture created by folds or furrows in the thin skin of the lips. These folds run from the inside of the mouth toward the edge of the lip following the curve of the lip. It's possible to sculpt these folds with different sculpting tools or even with a texture. But, in this case, try an inverted Bulge or Foamy tool set to a very small size and low strength to create the

FIG 3.36 Add Small Mass, Tubercle of Upper Lip, to the Middle of the Upper Lip and Pull Down over Lower Lip.

FIG 3.37 Add Texture to the Lips by Sculpting Subtle Folds and Furrows. The Traditional Sculpture In Clay.

folds (**Figure 3.37**). Once you have finished working on the mouth and surrounding structures, you can unhide the top part of the head by going to the Display menu and choosing Show All.

Do not forget to work on the areas of the face around the lips. Accentuating the cheeks will help to make the lips look like they belong to the face, and

FIG 3.38 Defining Cheeks and Jawline Will Aid In Blending the Mouth to the Rest of the Face.

further define the smile. Defining the jawline between chin and cheeks will also help to increase the smile and add to the contour of the face (Figure 3.38).

By now, you should be comfortable with Mudbox's sculpting tools and even have favorites that you like working with. You will want to spend a bit more time on the lower face. It is up to you to decide on which sculpting tools to use; remember that you can use the Freeze tool to protect certain areas from being changed accidentally. Refer to the reference photographs, the anatomy, the masses of the face, and the references sketches as you finalize the mouth. Also don't forget to save your work as an incremental file.

Sculpting the Eyes

In this section, you will sculpt the eyes and surrounding features. Sculpting eyes can feel intimidating and indeed they are one of the most challenging features to sculpt on the face. But, if you study the reference materials, learn the basics of eye anatomy (Figure 3.39), and continue to practice with Mudbox, you will do just fine. The following are important things to know about eye anatomy and proportions, which will help you to sculpt the eyes more effectively.

- The eyeball is larger than you think about 2.5 cm in length. By 2 years of age, the eyes have reached their full size, so they appear disproportionately large in children.
- The eyes sit in sockets in the skull surrounded by fat and muscles.
- The eyes are not on a flat plane across the face but instead follow the round, 3D contour of the skull.
- The eyelids are draped over the eyeball, so the eyelids follow the round contour of the eyes.
- When viewed from the front, the outer corner of the eye is higher than the inner corner. Different expressions can lower the outer corner, but it will typically never be lower than the inner corner.

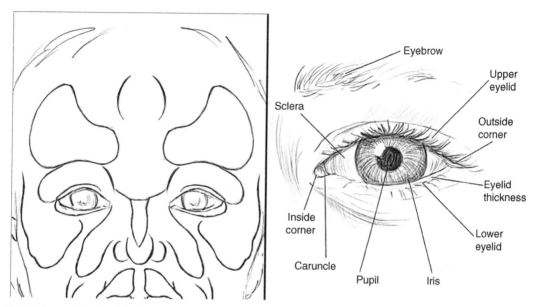

FIG 3.39 Anatomy of the Eye and the Masses of the Upper Face. Eyelids Have Thickness and Come over the Eye.

- When viewed from the bottom, the inner corner of the eye is farther back in the head than the outer corner. The inner corner should not be visible from a side view.
- Depending on where the eye looks, the highest portion of the upper lid will be over the pupil. This is caused by the bulge created by the cornea.
- When viewed from the front, eyes are usually one eye-width apart.
- When viewed from the side, the lower eyelid and the upper eyelid are on an angle and should not be sculpted vertically on the same plane.
- Eyes are in the middle of the head.
- In most cases, when viewed from the front, the center of the eye is in line with the corners of the mouth.
- If the eyes are too far apart, the nose will look too big.
- If the eyes are placed too low on the face, the nose will look short.
- If the eyes are placed too deep in the face, the nose will look too long.

Although you will be focusing on sculpting the eyes, you will also have to take the surrounding areas of the face into consideration. Sculpting a facial feature like the eyes is not an isolated process but is part of a larger process that depends on continually sculpting the surrounding features. There is no way to avoid this "jumping around" process in sculpting. It may seem easier to just focus on the eyes and ignore everything else, but the fact is that the surrounding features like the bridge of the nose, the forehead, and the cheeks affect how you sculpt the eyes. Remember that you are not just sculpting the parts but are trying to bring cohesion to the face.

Step back and take a wide view of the face. When sculpting the eyes, study the masses and forms in the upper part of the face just as you did with the lower part of the face. The masses form distinct planes. Becoming aware of these planes will help you sculpt a better likeness. The masses that make up the upper face are the front of the forehead, the two shapes above each of the eyes, the fatty upper part of the upper lid and the brow, the upper lid, the lower lid, the masses on each side of the nose, and the masses that run along the upper part of the cheeks (Figure 3.39).

Make sure that you have the reference photographs and other materials readily available. Double check the Front and Side camera reference sketches to make sure that everything still lines up. Remember that depending on the smile chosen, your lips may or may not line up in the side view. Pay close attention to the location of the eyes on the head as you study the photographs and sketches.

The eyes will be sculpted on their own layer, so create a new layer and name it Eyes, and for now, stay at subdivision level 4. You may wonder why you have not subdivided the model since you started sculpting the facial features. When working with the Basic Head mesh that comes with Mudbox, you should be able to sculpt features like eyes, nose, mouth, and so on, at subdivision level 4 with no problems. Subdividing the model beyond what is necessary wastes the valuable computer resources.

Sculpting the Eyeball

You will use mirroring when sculpting the eyes, so both eyes will be sculpted at the same time. This will create symmetrical eyes that are unnatural; but later on, you can introduce some asymmetry to the model. Look through the Front camera and trace the edges of the eyelids like you traced the location of the lips. This will help you to be confident about the placement of the eyes on the head (Figure 3.40).

Next, you will rough in the basic shape of the eyeball. What you are doing here is sculpting a semispherical shape for the eyeball so that you can sculpt the eyelids. Don't become too concerned about making this initial shape perfect in any way. Use your favorite sculpting tool to pull out the eyeball. We suggest the Bulge or Foamy tool, set to a small size, but medium strength. Pull out the eyeball in several steps. Don't try to do it all at once. Make sure to smooth as you sculpt. You can determine the width of the eyeball by staying within the outline you traced earlier (Figure 3.41). Check your work in the Side camera to be sure that you do not pull the eyeball too far forward. Focus on the negative space between the eyeball and the bridge of the nose as seen from the side to determine the correct location of the front of the eye. You may also need to revise the upper cheek a bit so that it does not throw off sculpting of the eyelids and eye. Using the Grab tool, you can push and pull the eyeball to be sure of the proper placement.

FIG 3.40 Outline the Eyes to Ensure Correct Placement.

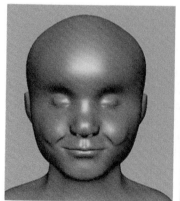
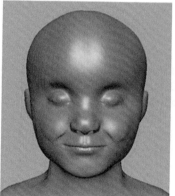
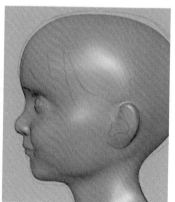

FIG 3.41 Use the Bulge and/or Foamy Tools to Sculpt the Eyeball.

Sculpting the Lower Eyelid

It's important to keep in mind the eyelids drape over the eyeballs. To rough in the basic shape of the lower eyelid, you may use the Wax tool set to low setting like size 5 and strength 4 using Falloff preset 6 to lay in the main mass of the lower eyelid and use the Bulge tool set to very low values to define the upper border and then smooth (Figure 3.42). Remember to check the reference materials often; if you have to reposition the entire eye, use the Grab tool to properly align it with the reference sketches.

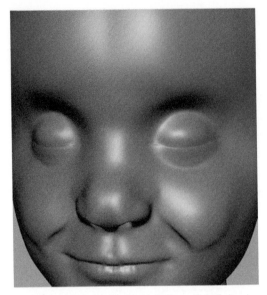

FIG 3.42 Rough In the Lower Eyelid with the Wax and Bulge Tools and Then Smooth.

FIG 3.43 Eyelids Have Thickness.

Eyelids have thickness, and they are much thicker than you probably think (**Figure 3.43**). To create the eyelid's thickness, first freeze the eyeball and parts of the upper eye socket. Use the Wax tool to add mass to the edge of the eyelid, and with the Grab tool, pull up on the top part of the eyelid to form an edge. While looking down on the model, use the Flatten tool to flatten the inner part of the edge. Use the Pinch tool to cinch up the edge between the eyeball and the inner edge of the lower eyeball. Now, rotate the camera so you are looking up at the model, and use the Grab tool to make sure that the lower eyelid is round (**Figure 3.44**).

Now that you have the lower eyelid roughed in, step back again and see how your work compares with the rest of the face and to the reference materials. If something seems off, then there is probably a problem somewhere. Rotate around the model and carefully inspect it to see what the trouble may be and correct anything that you find. However, what may cause you concern may not have anything to do with the areas around the eyes, so look everywhere on the face to make sure that the features are in proportion. One important feature, which you may want to inspect, is the angle created on the side of the face and upper cheek, when looking at the face from the front. If this angle is off, it may make the eyes appear to be in the wrong place. To correct any problems, use the Grab tool to modify the side and angle of the cheeks and chin (**Figure 3.45**).

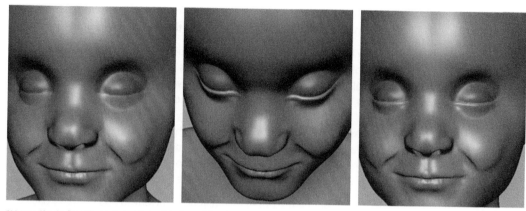

FIG 3.44 Use the Freeze Tool to Protect Parts of the Eye and Then Sculpt the Thickness of the Lower Eyelid. Use the Flatten Tool to Define the Eyelid Thickness. Then Rotate the Camera to View the Model from Underneath. Use the Grab Tool to Make Sure That the Eyelid is Round.

FIG 3.45 Take a Moment to Inspect the Model to Make Sure Its Proportions Are Correct. Inspect the Shape of the Face as Seen from the Front.

Sculpting the Upper Eyelid

The upper eyelids are partially tucked under the brow when the eyes are open, so it is only a thin strip of skin draped over the eye, especially in young children. The upper eyelid is sculpted in a similar way as the lower eyelid. But before sculpting the upper eyelid, you may need to make room for it by

moving the brow up a bit. This may not be needed in your model, but the point is to make sure that you have space above the eye to add the upper eyelid.

Study the reference materials to get a good idea of what the upper eyelid looks like. Look for the shapes it makes as it follows the contour of the eyeball. Use the Freeze and Invert Freeze while you are working on the upper eyelid. Then use the Wax, Bulge, and Smooth tools to add the upper eyelid as in Figure 3.46. Don't be afraid to try it several times until you feel that it looks good. Then, refine the edge and thickness of the upper eyelid with the Wax, Grab, and Flatten tools as you did with the lower eyelid. Once the upper eyelid is sculpted, use the Pinch tool to sharpen the edge between the eyeball and the eyelid. Finally, add the fatty pad above the upper eyelid.

To further define the upper eyelid, it is important to add the fatty pad between the upper eyelid and brow. Slowly build this using the Wax tool (Figure 3.47). One feature that may be challenging is the crease between the upper fatty pad in the upper eyelid and lower part of the upper eyelid. Sculpting this feature is not only a matter of carving out a line but also carefully sculpting the path of the crease and positioning the upper eyelid to appear as it is tucked underneath the fatty pad. These structures help to define the eye's overall appearance. You will have to use the Freeze tool to freeze most of the eye and carefully define this crease with tools like the Pinch tool and an inverted Bulge tool. To help steady your stroke as you sculpt, turn on the Steady Stroke option in the Properties window (Figure 3.48).

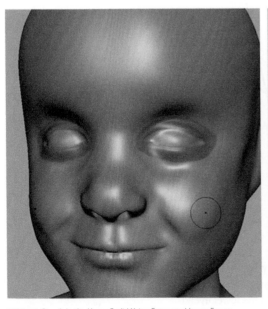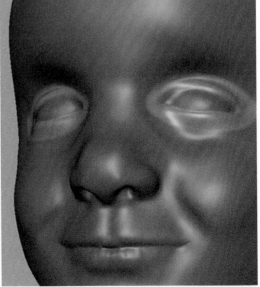

FIG 3.46 Rough In the Upper Eyelid Using Freeze and Invert Freeze.

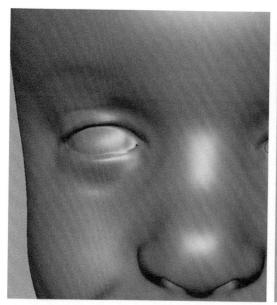

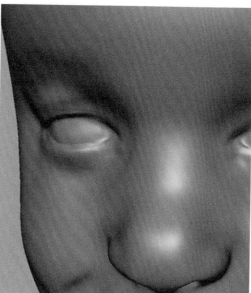

FIG 3.47 Add the Fatty Pad between Upper Eyelid and Brow.

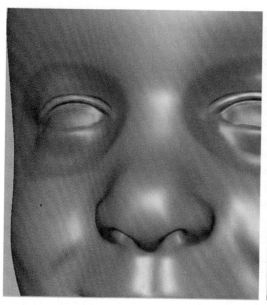

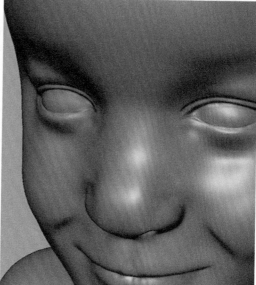

FIG 3.48 Sculpt the Crease between the Upper and Lower Parts of the Upper Eyelid.

Because the visible part of the upper eyelid is draped over the eyeball and tucked under the upper fat pad, it is not vertical but is angled back. To sculpt this, freeze all of the eye and eyelids and surrounding areas except the crease. Now, with the Grab tool, set to a large size but medium strength, pull the crease back into the head.

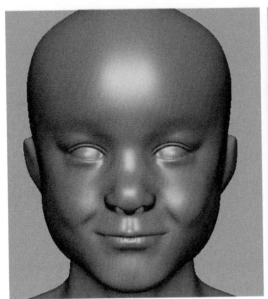

FIG 3.49 To Add More Contours to the Eye, Push the Inside and Outside Corners of the Eye Back.

The eye is almost complete. Rotate the camera so you are looking at the model from the bottom up and make sure that the eyelid is round and not flattened; while in this view, use the Grab tool to push the inside corner of the eye back, as well as the outside corner (Figure 3.49).

Refining the Eye

At this point, the eye should look anatomically correct, be in proportion to the rest of the face, and resemble Amy's eyes. However, don't be alarmed if you have a bit of trouble seeing Amy in your model yet. The model does not have any eyelashes, eyebrows, or a hairline, and these are important features that give the face personality and unique characteristics. This is where using the reference sketches and comparing the model with the reference photographs will assure you that you are on the right track. In the next few steps, you will refine the eye and add details.

You can never check the proportions and anatomy enough, so first take a close look at the eye and compare it with the reference materials and make any changes that are necessary. Remember to include the surrounding areas of the face in your inspection. Once you are satisfied that your model is correct, you can move on. The first item you will add is the caruncle lacrimalis, otherwise known as the *little fleshy bump* in the inside corner of the eye. As with most young children, in Amy, the caruncle is hidden somewhat by the skin at the inner corner of the eye. Rotate the camera so that you can see into the inside corner of the eye and add a very small caruncle. The Bulge tool set to a very small size and strength should do the trick. The caruncle should not be overtly visible from the front (Figure 3.50).

FIG 3.50 Adding Details to the Eyes Like the Caruncle.

Add character to the eye by sculpting some of the small wrinkles and lines in the lower eyelids. Because Amy is very young, these are difficult to see, but the wrinkles are present. Study the references photographs, and then with the Knife tool or an inverted Bulge tool, which is set to a very small size, carefully sculpt the wrinkles. With these details, completely check the overall anatomy and proportions once again by comparing it with the reference sketches in the Front and Side cameras and the reference photographs.

Creating the "Sculpture" Look

This part of the tutorial is optional. In traditional sculpture, the irises are carved out of the clay. The depth that is carved out indicates the eye color. For instance, blue eyes are not as deep as brown eyes. If you carve the iris, it will make the model look more like a traditional sculpture, but carving out the iris is not something that you should do if you are exporting the model to another program for animation. However, you can experiment with the sculptured look by doing the following steps on a separate layer. In this way, the model will not be permanently altered if you decide that you don't like the sculptured look.

A couple of important items to note about the iris are that the top and bottom of the iris is usually covered by the eyelids, and the center position of the iris typically lines up with the corners of the mouth. Switch to the Front camera and use the front reference sketch to outline the iris. Now back in the Perspective camera, use the Freeze tool to freeze the eyelids and the other parts of the eye, and be sure to freeze the inner surfaces that create the thickness of the eyelids. Use an inverted Bulge tool set to a large size and medium strength and slowly push in the iris. Remember to smooth often (Figure 3.51).

You can sculpt the eyebrows also to continue to give your model the sculptured look. Eyebrow hair grows in a distinctive pattern, so study the reference photographs to become familiar with Amy's eyebrows. Then, with the Bulge tool set to small size and low strength, draw the hairs of the eyebrow. However,

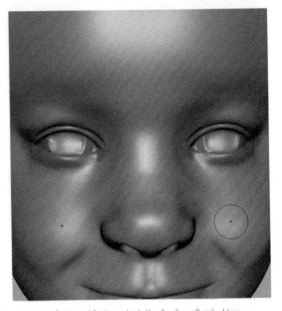

FIG 3.51 To Give the Model a Traditional Sculpture Look, You Can Carve Out the Irises.

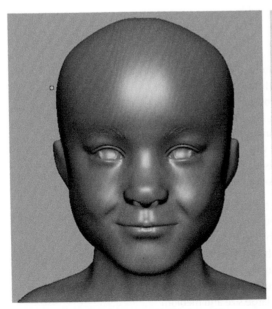

FIG 3.52 Completed Eyes of Amy and Traditional Sculpture of Amy.

alternate between the Bulge tool and the inverted Bulge tool so that some hairs are raised and some are carved into the model. For many people, the highest point of the brow will usually align with the outside of the iris (Figure 3.52).

With the nose, mouth, and eyes sculpted, you should have a model that resembles Amy. Step back from the model and look at the whole face and compare it with the reference materials. Rotate the camera to get a good look at the model from different angles. Use the camera bookmarks to see how well your model resembles the reference photographs. Turn off mirroring and tweak each eye to make it match with Amy's eyes. This will help to gain a likeness. In the next section, you will refine the back of the head and sculpt the ears.

Sculpting the Ears

The correct placement of ears is very important because if they are misplaced, the proportions of the face will be thrown off. If you recall from earlier in this chapter, in traditional sculpture, many facial measurements are taken from the ear. The ears act like landmarks from which the rest of the face can be measured. The following are guidelines for placement and size of the ear:

- If the ears are placed too far back, the head will look narrow.
- If the ears are placed too close to the front, the head will look flat from the front.
- If the ears are placed high, the lower half of the head will look too long.
- If the ears are placed low, the lower half of the head will appear too short.
- From the side view, the orientation of the ear is not completely vertical, but instead follows the slant of the bridge of the nose.
- The highest point of the ears is usually aligned with the eyebrows.
- The lowest part of the ears is usually in alignment with the underside of the nose.
- The ears are not flat against the head but are angled away from the head. If they are not angled enough, the face will look too thin.

We never really pay attention to our ears, but these little fleshy folds of skin and cartilage sticking out from the sides of our heads have a specific structure and anatomy. Take a moment to learn the structures of the ear because they will be referred to in the next section (Figure 3.53). Also study the variations in ears by looking at photographs, looking at people's ears, or by simply feeling the shape of your own ears.

Shaping the Back of the Head and Positioning the Ears

Create a new layer and name it as Ear and keep the subdivision level at 4. Like you did when sculpting the eyes, you will use mirroring across the x axis to sculpt both the ears at the same time. Because the model already has a very basic ear, make sure that it is in the right place on the head by checking the reference sketches in the Front and Side cameras (Figure 3.54).

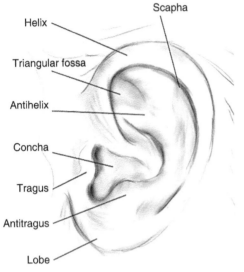

Scapha

Helix

Triangular fossa

Antihelix

Concha

Tragus

Antitragus

Lobe

FIG 3.53 Anatomy of the Ear.

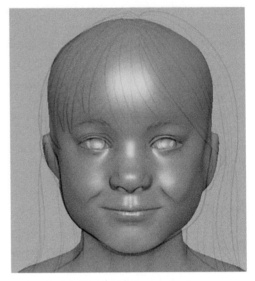

FIG 3.54 Check the Sketch for the Alignment of the Ears.

Use the Grab tool to position the outer edges of the ears until they match with the reference sketches. Pay special attention to the jawline in front of the ear. Look at the model from above and push in the sides of the head just in front of the ear. Smooth and shape this area so that it is round and continuous with the cheeks. Sculpting the area in front of the ear will help with sculpting the ear and will also make the head look more natural. If you are not quite sure about this step, try this: put your hands on your own cheeks, with wrists toward your lips and fingers to the ears. Notice how your fingers curve back around your face past the cheeks, before touching your ears (Figure 3.55).

Now that you have shaped the head in front of the ears, you will shape the head behind the ears. Use the Grab tool to make the back of the skull more round as seen from the top. And, if necessary, refine the shape of the neck so that it is more proportional to the head. These steps are important to create the correct distance between the ears and the back of the head (Figure 3.56). Switch to the Side camera and use the reference sketch as a guide to draw the general structures of the ear.

Sculpting the Back of the Ear

In this next step, you will carve away the space between the ear and the head. The back of the ear has two main shapes: the back of the helix and the back of the concha. With an inverted Bulge tool, slowly push in this space so that the back of the helix and the concha are suggested. Remember that you can use the Freeze tool to control which areas are sculpted. If for some reason

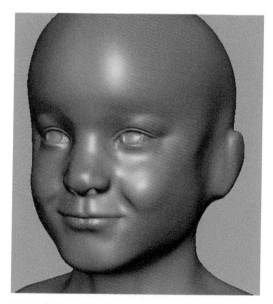

FIG 3.55 Push In the Sides of the Head In Front of the Ears.

FIG 3.56 Shape the Back of the Head to Make Sure It Is Round and Refine the Shape of the Neck if Necessary.

the shoulders and chest get in the way of viewing and sculpting the ear from below, simply select and hide them as you did with the top of the head in the mouth section (Figure 3.57).

Take time to verify that the ears are still in the correct position by comparing the model with the reference sketches in the Front and Side cameras. Also use the photographic references to ensure proper placement and proportions. And just as you did with the nose, mouth, and eyes you may find that you need to continue to define other features on the face and head around the ear. For instance, look at the relationship of the jaw, the neck, and the back of the head as compared with the ear and revise these areas if necessary.

Sculpting the Ear

For these next few steps, it is important that you know the anatomical terms of the ear, so review Figure 3.52. Using the reference sketch in the Side camera and outline the basic shapes of the ear, such as the helix, antihelix, tragus, and concha, just as you did with the parting lips of the mouth and the outline of the eyes. Now, you will give dimension to the ear structures (Figure 3.58).

Use an inverted Sculpt or Bulge tool to create the furrow between the helix and the antihelix. Then, use the Wax tool (with Steady Stroke turned on) and fill in the helix around the outer edge of the ear. With an inverted Bulge tool,

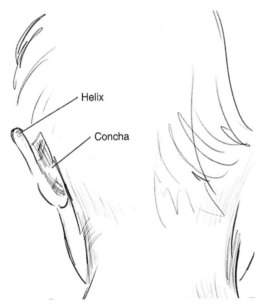

FIG 3.57 The Shape of the Concha and Helix as Seen from the Back of the Head.

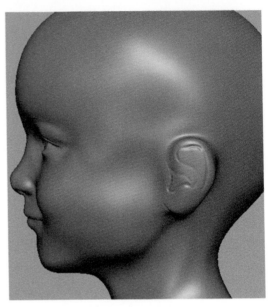

FIG 3.58 Outline the Parts of the Ear.

FIG 3.59 Roughing In the Helix, Antihelix, Antitragus, Tragus, and Concha.

rough in the concha as it goes into the inner ear. Notice the shape that looks like a question mark. Carve that shape out. Then, with the Bulge or Wax tools create the antihelix down to the antitragus. Next begin roughing in the tragus on the other side of the ear (across from the antitragus) (Figure 3.59).

As a reminder, do not sculpt the ear from only one direction or plane when carving out deep structures like the concha or the scapha. Rotate the camera so that the sculpting tools can carve deep and so that you can clearly see what you are doing. Also remember to sculpt and smooth as you work.

Add some definition to the antitragus and tragus using the Bulge tool and an inverted Bulge to indent the area in front of the ear. Notice that when viewing Amy from the front view, the antitragus extends out farther than the helix. While viewing the model from the front and back, use the Grab tool to pull the antitragus out. If when viewed from the front, the ears stick out too much or not enough, use the Grab tool to adjust their position, but don't flatten the ears against the head.

When sculpting the intricate shapes of the ear like the scapha or if you are to emphasize areas like the concha, remember that you can use the Freeze and Invert Freeze to freeze parts of ear while you sculpt on others. This will help you to indent and pull out specific areas without changing the surrounding structures (Figure 3.60).

Once the basic structures are roughed in, it is now only a matter of continuously refining those shapes. At this point, you should be able to decide which tools work best for what you are trying to do. Continue to check the Front and Side camera references to make sure that the ears are in the correct position. Also use the reference photographs to ensure that your model's ears look like Amy's ears as best as possible. If you find that you need to move the ear or reposition areas once again, use the Freeze tool and reposition the ear with the Grab tool on a high setting (Figure 3.61).

FIG 3.60 Refine the Shapes of the Ear by Continuing to Sculpt Its Inner Structures Using the Freeze Tool Liberally.

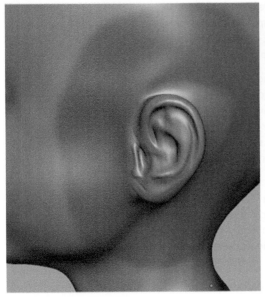

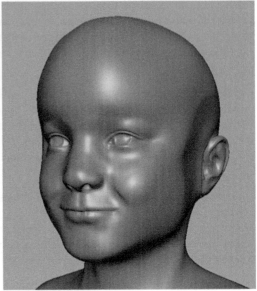

FIG 3.61 If Necessary, Reposition the Ear or Areas of the Ear to Fit Your Reference.

FIG 3.62 Traditional Sculpture of Amy's Ear and Sculpted Profile.

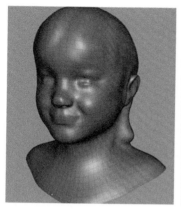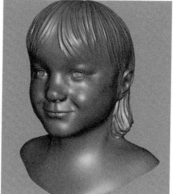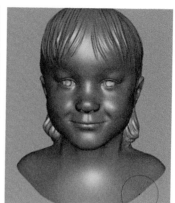

FIG 3.63 Adding Hair to the Mudbox Model.

Adding Hair

You can continue with the sculptural look by adding hair to Amy. Create a layer named Hair at a subdivision level of 1. At this level, you can add mass to the skull and neck area using the Foam tool. This mass should resemble the mass of hair. Pay close attention to how the hair grows and falls on the skull, neck, and face to simulate a natural look. Once the mass is added at a lower level, subdivide your sculpture to level 4 and add a layer called Hair Detail. Add detail using the Sculpt tool set at size 4–5 and strength 28. Alternate between Sculpt and inverting Sculpt tools to create the details of the hair. Smooth when necessary. Creating hair is limited as your topology on your hair layer will begin to change as you bring out more mass, making details in hair difficult, although starting at a lower subdivision will help, as well as creating simple hairstyles. Adding hair has its advantages: you may find that after adding hair, you notice other areas of the face that need to be modified (Figure 3.63).

Summary

It has been said that Leonardo da Vinci once exclaimed, "Art is never finished, only abandoned." This means that you could continue to refine your model for hours or days and keep finding areas to work on. Remember that the original goal was to sculpt a likeness of Amy and not an exact duplicate. If the anatomy and proportions are correct and your model resembles Amy, then you have completed the task for this tutorial and learned a good deal about facial structure and anatomy. In the next chapter, you will take what you have learned and apply it to creating a full figure.

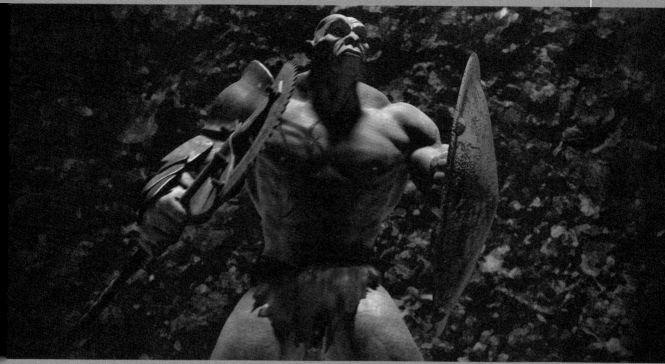

Sculpting a Figure

The tutorial in this chapter has two purposes: to improve digital sculpting proficiency through practice and to introduce human anatomy as applied to art. Although this tutorial is self-contained, in that you could probably work through it without reading any other part of this book, it is a good idea to at least review the basics and work through the Quickstart tutorial in Chapter 2. However, if you have already worked through Chapters 2 and 3, then you will practice what you have already learned and become more proficient in digital sculpting with Mudbox.

The great masters of past ages knew the importance of anatomical knowledge, and their grasp of human anatomy is reflected in the quality of their masterpieces. So it is with modern artists; every successful figurative sculptor, creature designer, and character designer should understand the fundamentals of human anatomy. Unfortunately, learning anatomy alone can seem dull, so in this tutorial, you will sculpt a humanoid creature and at the same time, learn the basics of surface human anatomy.

Digital Sculpting with Mudbox. DOI: 10.1016/B978-0-240-81203-8.00004-0

Anatomy Primer

Human anatomy as applied to art is critical to sculpting believable human figures and humanoid creatures. Even if your subject is a creature that bears little resemblance to normal humans, people viewing your work will intuitively notice incorrect proportions or faulty anatomy. Although the viewer may not, specifically, know what is wrong, the creature will seem abnormal or unbelievable. In the spirit of traditional life drawing and figurative sculpture, the appropriate names and proper relationships, locations, and correct shapes of superficial muscle groups and other anatomical landmarks will be emphasized in this tutorial.

Navigating Anatomical Space

To navigate or locate positions in three-dimensional (3D) space, coordinates along the x, y, and z axes are used. In the same fashion, to navigate anatomical space, directional terms are used to describe the location, orientation, and relationships among anatomical structures. For instance, to describe the location of the triceps, you could say that the triceps are inferior to the deltoids and posterior to the biceps. Using standard directional terms avoids lengthy complicated descriptions (Figure 4.1). Although there are many directional terms, Table 4.1 defines the common terms used in this tutorial.

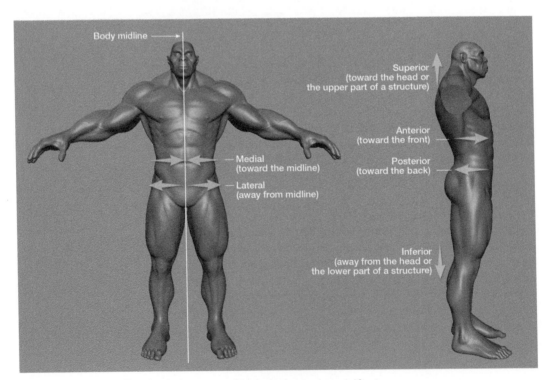

FIG 4.1 Anatomical Directional Terms Describe the Locations and Relationships between Anatomical Structures.

TABLE 4.1 Anatomical Directional Terms

Terms	Definition	Example
Anterior (ventral)	Toward the front of the body	The stomach is anterior to the kidneys.
Posterior (dorsal)	Toward the back of the body	The heart is posterior to the sternum.
Superior	Toward the head or referring to the upper part of a structure	The arms are superior to the legs.
Inferior	Away from the head or referring to the lower part of a structure	The elbow is inferior to the shoulder.
Medial	Toward the midline of the body or a structure	The pectoralis major is medial to the deltoid.
Lateral	Away from the midline of the body or structure	The fibula is lateral to the tibia.
Distal	Away from the point of origin	The ulna is distal to the humerus.
Proximal	Closer to the point of origin	The femur is proximal to the tibia.
Deep	Farther from the surface of the body	The heart is deep to the muscles of the chest.
Superficial	Nearer to the surface of the body	The skin of the arm is superficial to muscles in the arm.

Quick Overview of Muscle Anatomy

Surface anatomy is governed by how skin and fat drape over bone and muscles and how muscles work with the underlying skeleton. Thus, it is important to understand the anatomical relationship between the muscles and the bones they move. Skeletal muscles always span a joint and attach by means of tendons to two or more bones to produce movement. This tutorial often refers to the origin and insertion points of muscles to describe their relationships with the surrounding structures. The origin of a muscle is attached to a fixed bone (relative to the joint), and the insertion of a muscle is attached to the freely moving bone. In the first panel of Figure 4.2, you can see that the deltoid spans the shoulder joint and has an anterior origin at the clavicle and a lateral insertion at the humerus. When the deltoid contracts, it helps to abduct, flex, and extend the arm. As a matter of interest, skeletal muscles always work in groups to coordinate movement.

Skeletal muscles are classified according to their shape and fiber arrangements, such as fusiform, covergent, multipennate, parallel, and bipennate,

FIG 4.2 Understanding How Skeletal Muscles Work, the Different Types of Muscles, and Their Three-Dimensional Relationships Will Help You to Sculpt More Natural and Organic Figures.

among other types. Although it is not critical to memorize the names of the different muscle classifications, it is very important to become familiar with the orientation of the fibers in the major muscle groups. This will help you to easily sculpt more organic and natural figures. In the first panel of **Figure 4.2**, the Pectoralis major is an example of a covergent muscle because its fibers converge at the insertion on the humerus. In the second panel, the biceps brachii is classified as fusiform because it has two proximal heads that fuse together to form a central belly. In contrast, the coracobrachialis is an example of a parallel muscle because its fibers run parallel to the length of the muscle.

Because the skeletal muscles are arranged in 3D space, it is critical to understand their anatomical positions and relationships with one another. For example, in the third panel of **Figure 4.2**, you can see that the biceps brachii emerges from underneath the deltoid and the pectoralis major. As it emerges, it is not on the same plane as the surrounding structures. It is difficult to grasp 3D anatomical relationships by viewing drawings or photographs, so it is important to study the figure in life.

Superhero Proportions

The subject of this tutorial is a humanoid creature of superhero proportions (**Figure 4.3**). This means that the subject has exaggerated human proportions, is more muscular, has longer limbs, larger hands and feet, and is taller than the average human. Although the subject has exaggerated proportions, much of normal human anatomy still applies in terms of the location and relationship of its anatomical framework.

FIG 4.3 Heroic or Superheroic Proportions Are Different Than Average Human Proportions; However, Normal Human Anatomy Still Applies.

Getting Started

To get started, download the file ch04_01.mud from www.digitalsculpting .net/mudbox_book and open it in Mudbox (Figure 4.4). The model in the scene was modeled in a separate 3D modeling program and then imported into Mudbox as an OBJ file, but Mudbox can also import other file formats like FBX files. The model is composed of 2608 polygons that are about the same size and it is UV mapped; to see the UV map, select the model in the Object List and click on the UV View tab. Although UV mapping is not critical to sculpting in Mudbox, it is important to properly extract displacement maps and painting textures. It is better to UV map models before importing into Mudbox, but UVs can be imported later also.

Except Figure 4.4, the figures used in this tutorial have their XY grid and gradient background turned off. You may turn these features off by right-clicking anywhere in the scene (but not over the model) and unchecking those options from the contextual menu. Also you may display the wireframe of the model by toggling W. Displaying the wireframe is a good idea to check the model's topology as you work; but in general, it's better to hide it while sculpting.

Reference sketches and photographs were provided as sculpting guides for the model in Chapter 3. However, in this tutorial, the model already has all of the correct proportions and basic shapes in place. Your task will be to sculpt

FIG 4.4 Download the File ch04_01.mud from www.digitalsculpting.net/mudbox_book to Get Started.

surface anatomy details such as muscle masses, refine the hands and feet, and sculpt the head and face. The figures in this tutorial should be sufficient to guide you through the sculpting process. Nonetheless, it is a good idea to gather good reference sources on anatomy for artists such as books, websites, or even models that you can handle.

Making Things the Right Size

Because the sculpting tools in Mudbox are calibrated to an internal scale, an imported model has to be of the correct size. If the model were too small or too large, then the sculpting tools may not work predictably. The model in the file ch04_01 is already of the correct size for sculpting in Mudbox, so you don't need to scale it. However, when you import your own models, one way of checking whether the size of an imported figure is of the correct size is to compare it with the default human that ships with Mudbox. In other words, import your model and then insert Mudbox's default human; if your model is about the same size as the default human, then it's safe to proceed. If your model is not the same size, use the Scale tool to resize it. Another way to check for correct size is to use the scene XY grid. By default, each grid square is equivalent to half a meter (50 cm). So your figure should be about 1.5–2 m for the tools to work as expected.

If you are working in Mudbox 2009 or 2010, there is a known issue with scaling a model. When scaled, a model has to be exported at its new size and then reimported. Otherwise, the paint tools, specifically when painting bump maps, will not work properly.

Subdividing and Adding a New Layer

Press Shift + D twice to subdivide the model you just imported two times. The polygon count should now be 41,728 and the active level should be 2. You can see this information in the lower right corner of the interface in the status bar. The 41,728 polygons may seem like a lot of polygons, but it really isn't, when you consider that with Mudbox, you can sculpt millions of polygons in real time. Although it may be tempting to subdivide the model as much as possible right from the start, there are good reasons to keep the subdivision levels low at the beginning. First, keeping the subdivision level low at the start allows the computer to work faster because it does not have to display more polygons than what is necessary. Second, if the subdivision level is too high, then sculpting larger muscle masses becomes tedious, and you may be tempted to focus on details too soon, instead. In the initial stages of sculpting, your primary task is to rough in the general forms and masses, not details.

After you have subdivided the model, go to the Layers tab and create a new layer. Name it something that makes sense to you like Basic Muscles. In this tutorial, layers are initially used to manage levels of detail but they will be, eventually, used to manage sections of the model. For instance, the first layer will hold the roughed-in muscles; the next layer will hold more muscle details. Eventually, layers will be used to hold sculpting detail of sections like the hands, feet, and head.

Much like subdivision levels, sculpting layers have to be carefully managed. Remember, from previous chapters, that a layer is locked to the subdivision level in which sculpting occurs. For instance, if the model is subdivided to level 2 and you begin to sculpt in a new layer, then that layer is now locked to subdivision level 2. So, if you subdivide again to level 3, you must create a new layer to sculpt in. Also remember that layers may be deleted, so in the event that you don't like your work, you may simply delete the layer, create a new one, and try again. There is no right or wrong way to use the layers in Mudbox; in fact, you don't even have to use layers at all. However, layers help to manage the sculpting process, so it's a good idea to learn to efficiently work with them.

Sculpting Muscle Masses

Sculpting is not a linear process. In other words, various areas of the model are quickly sculpted moving from one area to another adjusting as needed. So, while this tutorial is organized in sequential sections, you should continuously

look at the model from all angles and sculpt as needed. For now, keep things simple and small details to a minimum; all you are doing is sculpting general masses and forms. Keep in mind that while you are sculpting a heroic, muscular, humanoid creature, he still has skin and some fat. Avoid sculpting the muscles so detailed that the creature appears to have no skin or looks like an écorché.

Through out this tutorial, various sculpting tools will be suggested to complete each tasks. To build up general masses and sculpt forms, you will generally use a combination of the Wax, Sculpt, and Bulge tools set to about size 10–15 and strength set to 5–15. As you gain experience, you may either add other tools or use different tool settings. Use the Smooth tool to smooth and blend shapes as you sculpt. Use the Contrast and Pinch tools to refine structures such as divisions between muscles, skin folds or creases, and other details. The Grab tool is useful for repositioning and to push and pull on sections of the model. Mirroring will be used to model symmetrically through out most of this tutorial, so when working with the sculpting tools, make sure that Mirroring is enabled across the x axis in the Properties window. It is a challenging task to tell you which tool to use for each sculpting task because many of the sculpting tools overlap in what they do, and the tool settings along with how you use your graphics tablet will vary what a specific sculpting tool does. However, start with the tool suggestions made in the tutorial and then experiment to see what works for you (**Figure 4.5**).

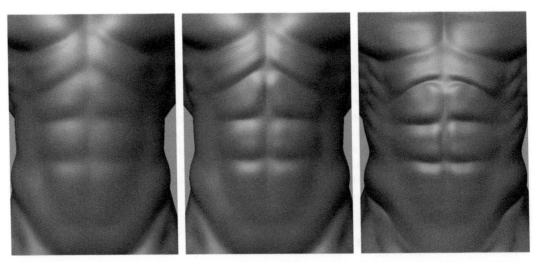

FIG 4.5 Use Various Sculpting Tools Like the Sculpt and Wax Tools to Build Shapes, Then Use the Smooth Tool to Blend, and Finally Use the Contrast and Pinch Tools to Define Edges and Details.

The Upper Torso

The upper torso is formed by the large pectoralis major muscles on the chest and the trapezius and deltoids on the shoulders and upper back (Figure 4.6). Start by building up the pectoralis major muscles, the anterior deltoid, and the trapezius muscles as shown in Figure 4.7. The Sculpt and Wax tools are good for this task. Rotate around to the back and add mass to the posterior deltoid and

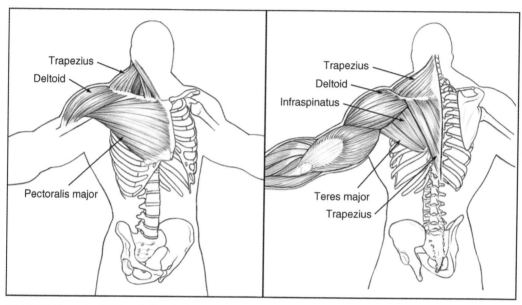

FIG 4.6 In This Section, You Will Shape the Upper Body by Sculpting the Trapezius, Deltoid, and Pectoralis Major Muscles.

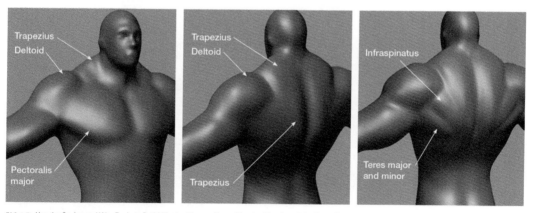

FIG 4.7 Use the Sculpt and Wax Tools to Build Up the Masses Created by the Muscles of the Upper Torso. Sculpt the Infraspinatus and Teres Muscles. Use the Pinch and Contrast Tools to Accentuate the Separations between the Muscle Groups.

trapezius (**Figure 4.7**). Work your way down to the middle of the back, delineating the edges of the trapezius. Over the scapulas, rough in the infraspinatus and the teres major, which are lateral to the trapezius and inferior to the deltoid. Use a combination of the Pinch and Contrast tools to accentuate the separations between the muscles (**Figure 4.7**).

The Sternocleidomastoid

The sternocleidomastoid muscle is a part of the neck, not the upper torso; but go ahead and rough it in now. The sternocleidomastoid begins behind the ear at the mastoid process of the skull and has two inferior insertions on the clavicle and on the sternum. Using the Wax tool, rough in the sterno-cleidomastoid (**Figure 4.8**). For now, sculpt the sternocleidomastoid from the mastoid process to the sternum – the lateral insertion at the clavicle will be sculpted later.

The Upper Limb

The upper limb is composed of the shoulder, upper arm, forearm, and the hand. The trapezius, deltoid, pectoralis major, infraspinatus, and teres muscles that you sculpted in the upper torso section also form parts of the shoulder and upper arm. It is not always possible to neatly separate muscles into sections because they blend from one part of the body to another. For instance,

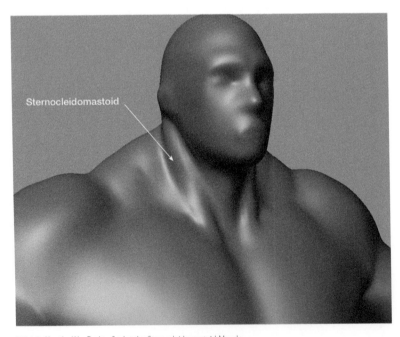

Sternocleidomastoid

FIG 4.8 Use the Wax Tool to Sculpt the Sternocleidomastoid Muscle.

the pectoralis major originates at the rib cage and inserts at the upper arm and the deltoid forms the shoulder, as well as the upper arm. As a result, you may sculpt different aspects of the same group of muscles when working on different areas of the sculpture.

The Upper Arm

The upper arm is shaped by the large masses of the deltoid, the triceps, the brachialis, and the biceps brachii muscles (Figure 4.9). Begin by adding mass with a combination of the Sculpt and Wax tools to define the biceps brachii. The biceps brachii emerge from underneath the pectoralis major and distal deltoids, run along the anterior or front of the arm, and end at the proximal radius. When finished with the biceps brachii, move around to the outside of the arm and sculpt the distinct masses formed by distal deltoid as it inserts into the humerus and the brachialis as it comes out from underneath the biceps brachii (Figure 4.10). Continue around to the back and rough in the lateral head and long heads of the triceps, which form the posterior arm. The medial or inside of the arm is shaped by the short head of the biceps brachii, the coracobrachialis, and the medial and long heads of the triceps. To keep things manageable, the inside of the arm may be sculpted as two groups: one for the medial biceps and the other for the coraco-brachialis and triceps as in Figure 4.10. At this point, you could indicate the olecranon of the ulna, which is the bony bump you can feel on the outside of your elbow.

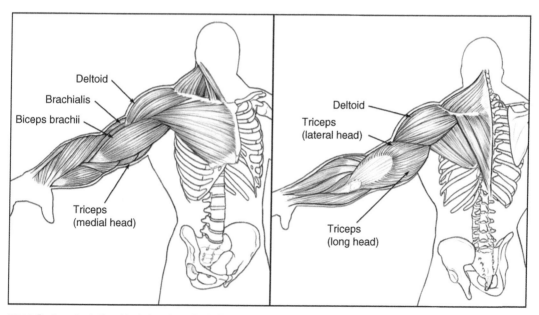

FIG 4.9 The Upper Arm Is Shaped by the Large Biceps Brachii, Triceps, and Deltoid. However, the Brachialis Is Also Visible In the Lateral Upper Arm.

99

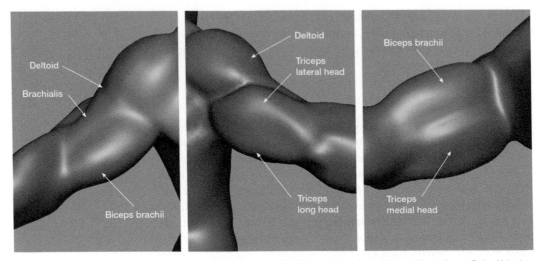

FIG 4.10 Use the Wax and Sculpt Tools to Shape the Upper Arm. Remember to Blend Shapes with the Smooth Tool and Use the Contrast Tool to Make the Groups Distinct.

The Forearm

The forearm is a complex arrangement of dozens of muscles that move the arm, wrist, hand, and fingers (Figure 4.11). Many of these muscles are deep in the forearm, and although these deep muscles are not part of the surface anatomy, they still shape the forearm. The forearm muscles may be arranged into three large superficial groups that facilitate sculpting. Like the upper arm, use the Wax and Sculpt tools to build up the muscles masses. Blend with the Smooth tool and then use the Contrast and Pinch tools to delineate muscle groups. Do the best you can at subdivision level 2 and don't worry about small details, but instead, focus on the large masses created by the muscles of the arm.

For the sake of brevity, only the largest or most prominent forearm muscles are named in each group. The first group of forearm muscles to be sculpted is formed mainly by the large brachioradialis muscle and the smaller extensor carpi radialis longus muscle (Figure 4.12). Notice how this group originates at the back of the upper arm posterior to the brachialis but anterior to the triceps and wraps around the radius to the thumb-side of the hand.

Moving around to the back of the forearm, the second group is shown in Figure 4.12. This group is formed mainly by three muscles, the extensor carpi radialis brevis, extensor digitorum, and the extensor carpi ulnaris. Superficially, these muscles appear near the elbow and run along the ulna to the dorsal side of the hand. Use the Bulge tool to sculpt the bump on the medial side of the wrist created by the head of the ulna.

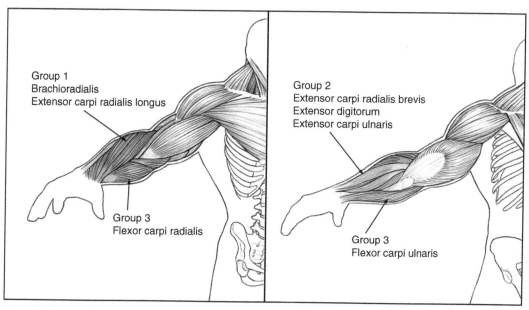

FIG 4.11 The Forearm Is Composed of Many Muscles That Move the Arm, Hand, and Fingers.

Group 1
Brachioradialis
Extensor carpi radialis longus

Group 2
Extensor carpi radialis brevis
Extensor digitorum
Extensor carpi ulnaris

Group 3
Flexor carpi radialis

Group 3
Flexor carpi ulnaris

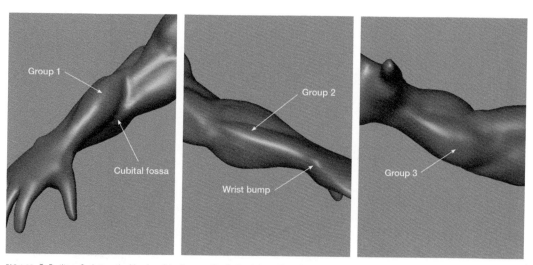

Group 1

Cubital fossa

Group 2

Wrist bump

Group 3

FIG 4.12 To Facilitate Sculpting, the Muscles of the Forearm May Be Divided into Three Groups.

The third and last group of muscles is very large and begins at the medial side of the elbow and ends at the palm of the hand. This group consists of several flexor muscles, the largest in the medial aspect is the flexor carpi radialis muscle, and in the lateral aspect, it's the flexor carpi ulnaris. When the forearm is seen from an anterior view, the first group of muscles consisting of the brachioradialis and extensors and the third group of flexors form the cubital fossa (Figure 4.12).

The Hand

The palm, dorsum (back of the hand), fingers, and the thumb form distinct groups that help with sculpting the hand (Figure 4.13). Rotate the camera so that you can see the dorsal side of the hand. Use the Bulge tool to rough in the four large knuckles and tendons leading to the forearm. The fingers are a challenge, but these also can be broken down into smaller groups formed by the three phalanges that make up each finger. Use the Wax, Smooth, and Flatten tools to loosely shape each finger section (Figure 4.14). Use your hand as reference or locate pictures of hands to get a good idea of how fingers are shaped.

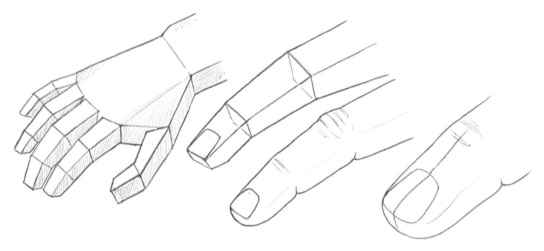

FIG 4.13 It Is Helpful to Break Down the Shapes of the Hand into Simpler Forms.

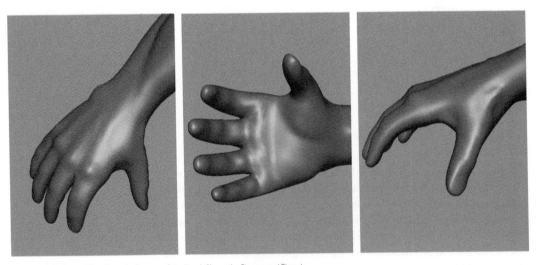

FIG 4.14 Add General Details to the Dorsum of the Hand; Shape the Fingers and Thumb.

Details on the palm of the hand are simple at this point; add a ridge of flesh at the distal palm to separate it from the fingers. Then, add masses at the base of the thumb and the ulnar side of the palm (Figure 4.14). The thumb has its own unique shape as shown in Figure 4.14. Sculpt the main tendon that comes from the forearm into the dorsal side of the thumb, sculpt the knuckle between the two thumb phalanges, and shape the tip of the thumb.

The Anterior and Lateral Torso

The main features on the anterior torso are the rectus abdominis muscles. Then, coming around from the back to the lateral aspect of the torso are the latissimus dorsi muscles. Anterior to the latissimus are the serratus anterior muscles and the external oblique in the lower lateral torso (Figure 4.15). Use the Sculpt, Wax, and Smooth tools to build up and blend the rectus abdominis muscles, as shown in Figure 4.16. Then, use the Contrast and the Pinch tools to define the intersections between the rectus abdominis muscles and the linea alba. Although the rectus abdominis is often referred to as a six-pack, there are usually eight sections, four on either side. The proximal aspect of the rectus abdominis originates at the inferior edges of the fifth or sixth ribs and the sternum and inserts inferiorly at the pubis (pelvis). Because the most proximal section of the rectus abdominis overlays a few of the ribs, it is not smooth but, instead, follows the contours or the ribs.

Using the Grab tool, pull out the latissimus laterally, and then, push in the torso in front of the latissimus. At the current subdivision level, you will be able to

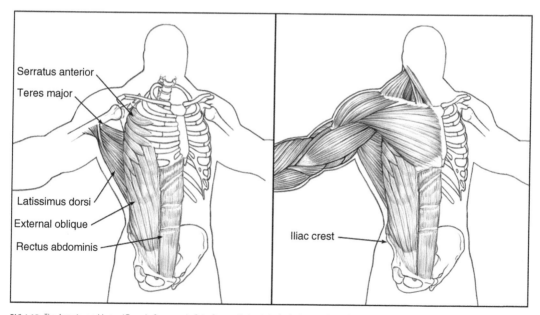

FIG 4.15 The Anterior and Lateral Torso Is Composed of the Rectus Abdominis, the Latissimus Dorsi, Serratus Anterior, and External Oblique.

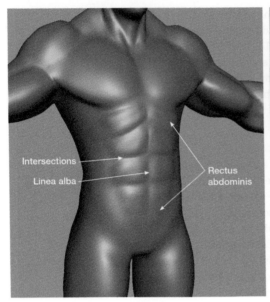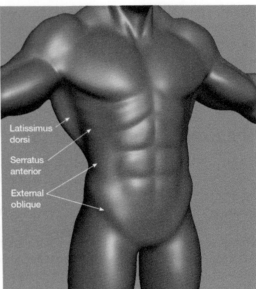

Intersections

Linea alba

Rectus
abdominis

Latissimus
dorsi

Serratus
anterior

External
oblique

FIG 4.16 Build Up the Muscles of the Torso with the Wax and Sculpt Tools, Blend with the Smooth Tool. Then Use the Contrast and Pinch Tools to Make the Muscle Groups Distinct. Use the Grab Tool to Sculpt the Latissimus Dorsi.

suggest the serratus anterior muscles, but not much more detail. Nonetheless, use the Wax tool to build up the serratus as shown in Figure 4.16. Typically, there are three to five visible digitations or sections of the serratus anterior muscle. The uppermost and longest visible digitation of serratus anterior is tucked under the pectoralis major and the subsequent lower digitations are shorter.

The inferior aspect of the external oblique inserts along the anterior half of iliac crest of the pelvis. Sculpt this muscle as shown in Figure 4.16. After further subdivision, more detail will be added to the serratus anterior and external oblique muscles and the torso, overall. Next, you will sculpt the general shapes of the posterior lower torso.

The Posterior Lower Torso

At the beginning of this section, you sculpted the general shapes of the posterior deltoid, trapezius, infraspinatus, and the teres muscles. Together, these muscles shape the shoulders and upper back, and now you will sculpt the muscles of the lower back. The largest muscle in the mid-lower back is the latissimus dorsi. This muscle originates and fans out from the middle of the back to its insertion at the medial aspect of the humerus. Note that the superior medial aspect of the latissimus is covered by the trapezius (Figure 4.17). Use the Wax tool to build up the shape of the latissimus as shown in Figure 4.18, and then try freezing the surrounding anatomy with the Freeze tool and use the Grab tool to pull the muscle out, slightly. Next, using the Contrast and Pinch tools, define the edges of the back muscles.

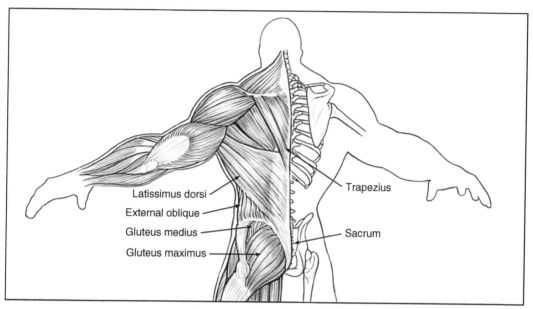

FIG 4.17 The Surface of Posterior Lower Torso Is Made Up of the Inferior Aspects of the Trapezius, the Latissimus Dorsi, and the External Oblique.

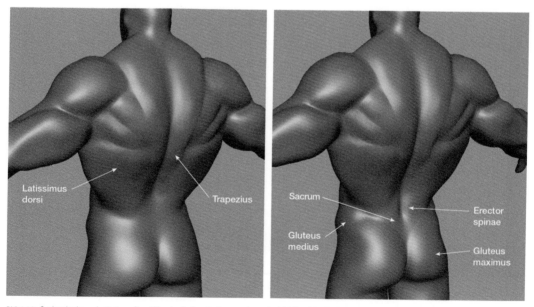

FIG 4.18 Sculpt the Large Latissimus Dorsi Muscle, Define the Furrow along the Middle of the Back, and Then Shape the Gluteus Medius and Gluteus Maximus Muscles.

Along the midline of the back, there is marked furrow formed by the skeleton (spine and ribs), the deep muscles of the back, and on the surface by the trapezius and latissimus. Make sure to accentuate this midline furrow with an inverted Bulge and Smooth tool to blend. Above the buttocks, the midline furrow is formed by erector spinae muscles. Once you are done with the back, take a moment to shape the gluteus medius and the gluteus maximus muscles as shown in **Figure 4.18**. Together, these muscles form the buttocks. The upper medial aspect of the buttocks and the lower back form a marked "V" shape right over the sacrum.

The Lower Limb

The lower limb is composed of the thigh, the leg, and the foot. In more common terms, the entire lower limb is usually referred to as the leg. Many of the muscles that form the surface anatomy of the thigh begin somewhere on the pelvis and then end at the femur, tibia, or fibula. For example, the origin of the rectus femoris muscle (the large muscle at the front of the thigh) is at the anterior spine of the iliac crest and inserts at the patella and the patellar ligament, which inserts into the tibia (**Figure 4.19**).

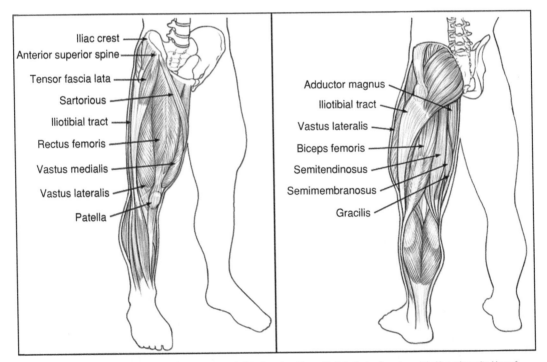

FIG 4.19 The Surface Anatomy of the Anterior Thigh Is Composed of the Sartorious, Vastus Medialis, Rectus Femoris, and the Vastus Lateralis. Most of These Muscles Originate on the Anterior Iliac Crest of the Pelvis.

The lower limb is cylindrical in shape, so many of the muscles that form the surface anatomy wrap around the thigh or leg. For instance, the huge vastus lateralis muscle wraps around from front to back, thus shaping much of the thigh. However, to keep things organized, you will sculpt anterior, lateral, posterior, and medial sections of the thigh, and anterior and posterior sections of the leg. But remember that, when sculpting, you should work on several areas almost simultaneously, constantly balancing the changes made in one area with those made in another.

The main sculpting tools you will use to build up muscle masses are Sculpt, Wax, and Bulge. The Grab tool is also useful for pulling out or repositioning masses. Remember that you may use the Freeze tool to protect certain areas while working on other areas. Always use the Smooth tool to smooth and blend shapes. An inverted Bulge tool is good for sculpting the grooves, depressions, and folds that form the separations among the muscle groups. Use the Contrast tool to further separate muscle groups and use the Pinch tool to delineate the separations between the muscle groups. Press Shift + D to subdivide the model to level 3, and create a new layer. The added geometry will make it possible to sculpt the details of the thigh, leg, and foot. However, remember to focus on sculpting the large masses created by the muscles and other anatomy of the thigh, leg, and foot, and don't worry about small details yet.

The Anterior Thigh

The surface anatomy of the front thigh is formed by the sartorious, the vastus medialis, the rectus femoris, and the vastus lateralis (Figure 4.19). The rectus and vastus muscles are part of what is commonly referred to as the quadriceps. The fourth muscle of the quadriceps group is the vastus intermedius, but it is a deep muscle and is not part of the surface anatomy.

Start by shaping the long sartorious muscle with the Wax tool as shown in Figure 4.20. The sartorious runs diagonally originating at the anterior superior iliac spine and inserts at the medial tibia. Next, sculpt the vastus medialis with the Bulge and Wax tools on the medial aspect of the lower thigh. Between the vastus muscles is the rectus femoris. This large muscle originates at the anterior inferior iliac spine and runs down to the knee. On the outside of the thigh is the very large vastus lateralis muscle (Figure 4.20). As you sculpt the muscle groups, notice the natural masses and furrows that are formed by the muscles. It is important that these masses are shaped correctly. The best way to check the shapes is to study the figure from life, but because the creature is very muscular, try finding photos of muscular men or even body builders and study how muscles grow in response to exercise. When you are finished with sculpting the muscle groups, use the Bulge tool to rough in the patella (knee cap).

FIG 4.20 Sculpt the Sartorious as It Courses from the Anterior Pelvis to the Medial Tibia, and Then Build Up the Masses of the Rectus Femoris and Vastus Muscles.

The Lateral Thigh

Starting at the iliac crest of the pelvis the lateral thigh is formed by tensor fascia lata muscle, its long iliotibial tract, and the lateral aspects of the gluteus medius and the gluteus maximus muscles. The massive vastus lateralis forms the bulk of the mid-to-lower lateral thigh as it wraps around from the front. Use a combination of the Wax and Bulge tools to shape the surface anatomy as in Figure 4.21. It is important to note that there is a marked fossa (dip) at the upper lateral thigh formed by the gluteus maximus, gluteus medius as they insert at the femur. Use a combination of the Wax and Bulge tools to shape the surface anatomy as in the first panel of Figure 4.21.

The Posterior Thigh

The back of the thigh may be sculpted as four groups of muscles that run along the vertical length of the thigh. The most lateral group is composed of the bulky vastus lateralis as it continues its course to the back of the thigh. The second group is made up of the biceps femoris muscle, and the third group is made up of the semitendinosus muscle. The proximal aspects of the large biceps femoris and semitendinosus muscles originate deep in the pelvis and emerge from underneath the gluteus maximus. The semitendinosus, then, courses along the medial aspect of

FIG 4.21 Because the Thigh Is Cylindrical, Much of Its Lateral Aspects Are Composed of the Anterior Muscles. True Lateral Structures Include the Tensor Fascia Lata, Iliotibial Tract, and the Gluteus Medius. Some of the Posterior Muscles Are Also Visible from the Side.

the femur and inserts at the medial tibia while the biceps femoris runs laterally along the femur and inserts at the head of the fibula. The fourth and most medial group is composed of the semimembranosus, adductor magnus, and the gracilis muscles. Sculpt these muscle groups as shown in **Figure 4.21**.

The Anterior Leg

Compared with the muscular thigh, the leg looks hilariously skinny at this point, but that will change once you sculpt some of the leg muscles. The anterior leg may be sculpted as three groups of anatomical structures. The lateral group is composed of two muscles, the largest of which is the fibularis longus. The middle group is primarily made up of the tibialis anterior muscle and the tibia. If you touch the front of your leg, you can feel the anterior border of the tibia immediately under the skin. Finally, the gastrocnemius and soleus make up the third and most medial group (**Figure 4.22**). Pull out the sides of the leg with the Grab tool to rough in the lateral and medial groups (**Figure 4.23**). It is important to do this when looking at the leg from the front to get the right shapes. The bulk of the lateral group should be proximal (higher up) and have a shallower curve than the medial group. To sculpt the middle group, use the Wax tool to build up the mass created by the tibia as shown in **Figure 4.23**.

FIG 4.22 The Main Structures of the Leg Are the Gastrocnemius, Soleus, Tibia, and the Calcaneal Tendon.

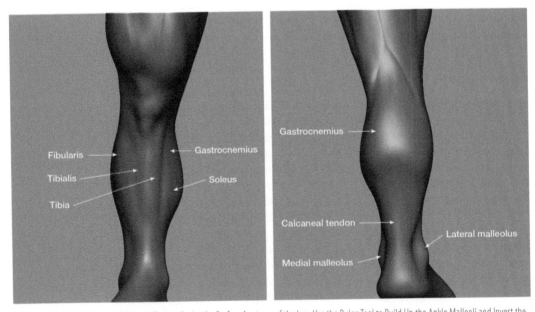

FIG 4.23 Use the Grab, Wax, and Smooth Tools to Sculpt the Surface Anatomy of the Leg. Use the Bulge Tool to Build Up the Ankle Malleoli and Invert the Bulge to Create the Sulcus Anterior to the Calcaneal Tendon.

The Posterior Leg

In this case, the lateral and medial aspects of the leg are combined with the posterior because of its cylindrical shape and the large size of the gastrocnemius and soleus muscles. Although the soleus is a deep muscle, its bulk shapes the back of the leg. The smaller gastrocnemius, composed of medial and lateral heads, drapes over the soleus to give the back of the leg its distinctive shape. The soleus originates at the proximal tibia and fibula, while the gastrocnemius originates at the distal femur. However, both muscles form the large calcaneal tendon (Achilles tendon), which inserts at the calcaneus (heel bone). Use the Grab tool to sculpt the general shape of the posterior leg. Then, switch to the Wax and Smooth tools to build up and blend the masses of the upper leg as shown in **Figure 4.23**.

The Ankle

The calcaneal tendon and the distal ends of the tibia and the fibula give the ankle its familiar shape. The distal end of the fibula forms the lateral malleolus and the distal end of the tibia forms the medial malleolus. The malleoli form the bony bumps that you can feel on either side of your ankle. Also note that the medial malleolus is higher than the lateral one. Behind each of the malleoli, but in front of the calcaneal tendon, is a deep sulcus or depression. Use the Wax tool and an inverted Bulge tool to shape the ankle as in **Figures 4.23** and **4.24**.

The Foot

Although, at first glance, sculpting the foot may appear similar to sculpting the hand, there are significant differences. For example, because the primary

FIG 4.24 The Foot Is a Weight-Bearing Structure Designed around Two Arches. To Get a General Feel for the Shape of the Foot, It May Be Broken Down into Planes.

111

function of the foot is weight bearing, it is formed around two arches: a longitudinal arch from the ball of the foot to the heel and a transverse arch at the instep (medial to lateral). These arches influence the overall shape of the foot. To get a handle on sculpting the foot and toes, they may be simplified into planes (Figure 4.24).

Because the model already has basic feet and toes, your task is to refine these shapes into a more detailed foot. Rotate the camera so that you can see the medial side and bottom of the foot, and using the Grab tool, push in the arch. Shape the heel, ball, and the sides of the foot as shown in Figure 4.25. Pay close attention to the appropriate shape of the sole of the foot as it seems from directly below. Notice that the heel is not as wide as the front of the foot. Check the ankle once you have roughed in the foot to make sure everything is in proportion.

Toes come in many shapes and sizes, and depending on what the foot is doing, the shape and position of the toes change. In this case, you will sculpt a generic "toe" shape. Sculpting the toes is one of those situations in which you have to quickly move from one part of the toe to another because changes in one area will influence the overall shape of the toe. Also note that the size of the sculpting tools will be set to very small size and strength values (less than 5) while shaping the toe. Rotate the camera so that you are looking at the foot from the front, and use the Grab tool to pull up on the first knuckle of each toe, then push down on the tip of each toe. Rotate so that you can see the bottom of the toes, and using the Bulge tool, add mass to each tip. Use the Grab tool to shape the bottom of each toe. When the toes are about finished, flatten the dorsal tip of each toe where the toenail will be eventually sculpted.

FIG 4.25 Use the Grab and Smooth Tools to Shape the Foot. The Toes May Be Sculpted with the Grab Tool Set to Very Small Strength Values and Refined with the Wax, Bulge, and Smooth Tools.

FIG 4.26 The Model Has All of the Major Muscle Groups Roughed In and the Hands and Feet Have Been Refined. Take Time to Inspect Your Work for Problems and Correct Anything You Find Before Moving on to the Next Section.

At this point, you have sculpted the general shapes and masses of the major superficial muscle groups, and you have refined the hands and feet. Your model should have a natural, recognizable physique, and look similar to the model in **Figure 4.26**. Take time to carefully inspect your model by looking for problem areas where the anatomy may look a bit off. A very useful technique in checking form, proportions, and anatomy is to move the scene light around the figure. Press L, left-click, and drag to move the scene light. As you move the light, the shadows cast on the surface of the figure change to reveal form and shape. This is a good time to save an incremental copy of your work. In the next section of this tutorial, you will work on the head and face and add details to refine the surface anatomy.

Sculpting the Head and Face

In this section of the tutorial, you may either sculpt the creature seen in the figures or sculpt a head and face of your own design. If you want to try the latter option, take time now to work out the design for your version of the head and face. There is plenty of opportunity to be creative; for instance, if you want your creature to appear thuggish, exaggerate the lower facial features by sculpting heavier jaws, minimize the size of the cranium, and emphasize the brows. Instead, if you want a cunning creature, make the size of the cranium larger, minimize the brows, enlarge the eyes, and make the jaws smaller. You may also incorporate animal features like an ape or a cat nose or a wolf-like snout – the possibilities are endless.

Facial expressions tell much about your character; is he angry, sad, afraid, or confident? For example, by moving both the brows and the corners of the mouth down, the creature will appear angry. Sculpt a snarl, and he will appear aggressive. The Grab tool is great for quickly changing facial expressions. You may experiment with different head and face designs without worry by using different layers in which to experiment. If you don't like the design, delete the layer and try again. Also remember to save incremental files as you hash out your design. If something goes wrong, you can start over without having to start from scratch.

Regardless of your design, it is important to anchor your creature in reality by starting from normal human anatomy and proportions. In this way, no matter how fantastical your creature becomes, viewers can still relate to it. Chapter 3 thoroughly covered sculpting the human head and face so you may review that chapter first if you have not already worked through it.

Use the Wax, Sculpt, and Bulge tools to initially build up the forms of the head and face. As always, use the Grab tool to reposition sections or to pull and push on the model, and use the Smooth tool to work out kinks and to blend shapes. When sculpting the face, use the Freeze to protect certain areas of the model while sculpting on other areas. Once the basic shapes are sculpted, you may use the Contrast and Pinch tools to refine the facial features. Remember to enable mirroring across the *x* axis to sculpt both sides of the head and face, simultaneously. Subdivision level 3 should provide enough polygons to sculpt the general shapes of the face as shown in **Figures 4.27** and **4.28**. Before sculpting, create a new layer and name it as Head and Face. As you sculpt, rotate around the model to see how your work looks from different directions and remember to inspect the model by moving the scene light.

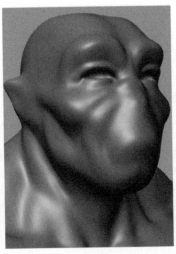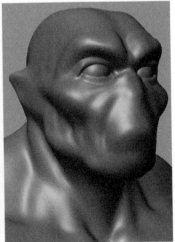

FIG 4.27 Use the Wax, Sculpt, and Bulge Tools to Sculpt the Basic Forms of the Head and Face on a New Layer. Rough In the Eyelids and Add the Eyes.

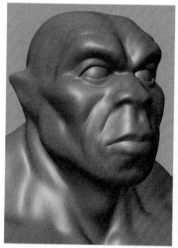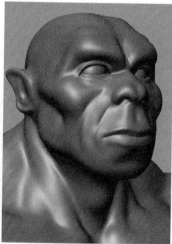

FIG 4.28 Sculpt the Nose and Mouth. Use the Smooth, Contrast, and Pinch Tools to Refine the Head and Face. Don't Forget to Work on the Back of the Head.

The model already has a rudimentary head and facial features, so you may use these as your starting point. Make sure that you are working in the new layer and begin by roughing in the basic shapes of the brows, nose, cheeks, and jaw line as in the first panel of Figure 4.27. Because the creature in the figures has pointed ears, use the Grab tool to begin pulling the helix of the ear back. Although it is not officially part of the head or face, sculpt the lateral head of the sternocleidomastoid muscle. Remember that, earlier, you had sculpted the main body and medial head of the sterno-cleidomastoid at subdivision level 2, but that subdivision level was not enough to sculpt the lateral head, so that is why you are doing it now as subdivision level 3.

Once the basic shapes are done, refine the face by connecting the bridge of the nose to the cheeks and sculpting the nasolabial folds around what will eventually be the mouth. Because the creature in the figures has an apish head and face, the cranium size is reduced, the brows are emphasized, the forehead is sloped back, the jaws are pulled forward, and the chin is pushed back. As you sculpt the head and face from the front and side views, remember to also view the model from the top down and the bottom up to make sure that the head is round and is not flattened.

Unlike the sculpture in Chapter 3, where the eyelids and eye are sculpted from the same mesh, in this case, the eyes will be created separately. First, rough in the eyelids with the Wax tool as shown in the second panel of Figure 4.27. Roughing in the eyelids may take some time. First, build up the masses for the lower eyelid and then build up the upper eyelid. Rotate the camera so that you can see the corners of the eyes. Use the Grab tool to push back the inner or medial corner of the eye so that it is not visible when the face is seen from the side.

To create the eyes, go to the Create menu, choose Mesh, and then select Sphere. A relatively large sphere will appear in the scene. Locate the sphere object in the Object List and rename it as Right_Eye. Select the right eye and scale it down until the values in the Scale fields in the Properties window are about 0.02. Once you have scaled the eye, use the Translate tool to position it in the eye socket. At this point, there is a pretty good chance that the eye will not fit well in the eye socket. Sculpt the eyelids so that they drape over the eyeball. However, eyelids have thickness so make sure to leave space between the eye and the outer edge of the eyelids. Mudbox does not have Copy and Paste or Duplicate commands. So, to quickly create the left eye, select the right eye in the Object List, and then, from the File menu, choose Export Selection. In the export dialog, name the file, and select OBJ from the "Save as type" menu, and click Save. Then, go back to the File menu, select Import, browse to the file that you had just exported, and click on Open. If you look at the Object List, a second eye object is listed; rename it as Left_Eye. Select the left eye and use the Translate tool to move it along the x axis to the left eye socket (Figure 4.27).

If you are sculpting the creature in the figures, either sculpt the nose and mouth as in Figure 4.28, or continue with your own design. Remember to extrapolate your design from basic human anatomy and proportions. In addition to the Wax and Sculpt tools, the Grab tool is useful for sculpting the basic shapes of the nose and mouth. Use an inverted Bulge tool to push in the nostrils and to create details like the dip created by the philtral columns under the nose. Use the Bulge tool to sculpt the laryngeal prominence (commonly known as the Adam's apple). The Freeze tool is very useful when sculpting the details around the nose and mouth. Use a combination of the Wax, Sculpt, and Bulge tools to rough in the lips. Once the basic shapes are in, refine your work with the Smooth, Contrast, and Pinch tools. At this subdivision level, there is not much you can do with ear details, but you should be able to indicate the helix, lobe, and antihelix. Don't ignore the back of the head; take time to sculpt the muscle attachments at the base of the neck and to shape the back of the skull (Figure 4.28). Remember to move the scene light (press L + LMB and drag) around the head and face to study forms. Experiment with your design by adding features like extra skin folds or mixing in animal features. For instance, the creature in the figures has noticeable bulges on the top of the skull, which humans do not have. You can even try sculpting horns or spikes to give your version of the creature a fearsome look.

Refining the Model

The main muscle masses of the torso, upper body, the upper limbs, and hands were sculpted at subdivision level 2. The model was then subdivided to level 3 and the muscle masses of the lower limb and feet and then the head and face were sculpted. Now that the model is at a higher resolution, revisit the torso, upper body, and upper limbs to add details. However, as you sculpt, make sure that the fundamental proportions remain unaltered and always check how changes in one area affect another. It is a good idea to create new layers

for the details you are about to sculpt. For instance, for new torso details, you may add a layer named Torso Details; for new upper arm details, add a new layer named Upper Arm Details; and so on. This way, if something goes wrong or you want to try something different, you have not altered your original work. Also remember to save incremental files as you progress.

Refining the Torso and Upper Limbs

Using the Wax tool, build up the serratus anterior and the superior aspects of the external oblique muscles. Then, use the Contrast tool to make the intersections between these muscles more distinct as shown in **Figure 4.29**. Use the Pinch tool to define the insertion of the External oblique at the iliac crest. Refine the pectoralis major muscles by adding striations created by the muscle bundles at the origin and insertion points. Because the creature is very muscular, the clavicle is not as pronounced as it would be in someone with less bulk. Nonetheless, suggest the head and superior aspects of the clavicle (**Figure 4.29**).

Add detail to the deltoid by sculpting the separations between the anterior, lateral, and posterior bundles. Work down to the upper arm and refine the muscle groups using the Contrast and Pinch tools, and do the same with the forearm. Remember that the three groups that you sculpted for the forearm are composed of many muscles. You may suggest some of these muscles by emphasizing the separations between them. However, don't arbitrarily add muscle details but instead use references to correctly indicate where the muscles are located. As you work your way to hand, emphasize details such as tendons and bony prominences (**Figure 4.29**).

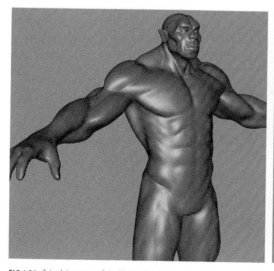 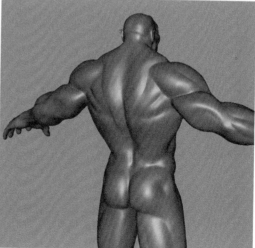

FIG 4.29 Take Advantage of the Higher Subdivision Level to Sculpt Details on the Torso, Upper Body, and Upper Limbs.

Refining the Hands

Because hands are a source of expression and are an area of focus in the human figure, they should have a moderate-to-high level detail. In this section, you will sculpt the skin creases and folds on the fingers and palm, refine the knuckles and tendons, and sculpt the fingernails. To sculpt these details, subdivide the model twice to subdivision level 5. At this subdivision level, the model has 2,673,664 polygons. Before moving on, create a new layer to sculpt the hand details.

To sculpt the skin creases on the dorsal side of the knuckles, select the Wax tool, and from the Stamp tray, choose the bw-fiber.tif stamp. With the stamp loaded, the Wax tool will sculpt using the pattern in the stamp. Rotate the camera so you can see the knuckles on the four fingers and sculpt the creases as shown in **Figure 4.30**. When you are done with the fingers, sculpt the creases on the thumb knuckle. You may make these creases as deep or as shallow as you like because there is much variability to the pattern of creases from person to person. You may also use an inverted Bulge tool set to a very small size (about 0.3) to break up the pattern created by the stamp. Rotate the camera so you that can see the ventral side (palm side) of the fingers. Use the Wax tool without the stamp to build up the fleshy sections between each joint. Use an inverted Bulge tool to sculpt the creases at each knuckle bend, and then use the Wax tool with the bw-fiber.tif stamp to break up the creases a bit. Don't forget to sculpt the creases on the ventral side of the thumb also. Once the creases on both sides of the fingers and thumb are sculpted, use the Contrast tool to make these features stand out.

FIG 4.30 Detailed Hands Add to the Overall Realism and Character of the Creature.

To sculpt the skin creases on the palm, use an inverted Bulge tool. Then, use the Smooth tool to smooth out any unwanted artifacts, and then, use the Pinch tool to cinch up the crease. Use the Wax tool to sculpt subtle folds of skin that follow the contours of the palm. To sculpt the creases on the wrist, use the same techniques that you used to sculpt the creases on the palm. Rotate the camera so that you can see the dorsum of the hand and refine the large knuckles and tendons leading to the forearm.

Sculpting the fingernails is challenging, but it can be accomplished fast with a stamp shortcut. First, take time to study the appearance of fingernails. Take a look at your own fingernails, and look at pictures of various types of fingernails. You will find that there is a wide range of variability to human fingernails. However, healthy fingernails fall within a spectrum that is considered normal, so unless you are going to sculpt diseased fingernails, nonhuman fingernails, or claws, make sure that you have good references for typical fingernails. Download the file fingernail-stamp.tif from www.digitalsculpting .net/mudbox_book. In the Stamp tray, click on the menu button and select Add Stamp, then browse to the file that you had just downloaded, and add it to the Stamp tray (Figure 4.31).

The fingernail stamp is a custom gray scale image that will displace the mesh in the general shape of a fingernail. This provides a starting point from which each fingernail may be refined, thus saving time because each fingernail doesn't have to be started from scratch. Create a new layer and name it as Fingernails. Rotate the camera until you can clearly see the fingertips of either hand up close. Select the Imprint tool and turn off Mirroring, then select the fingernail stamp from the Stamp tray. Set the Imprint tool strength to about 40

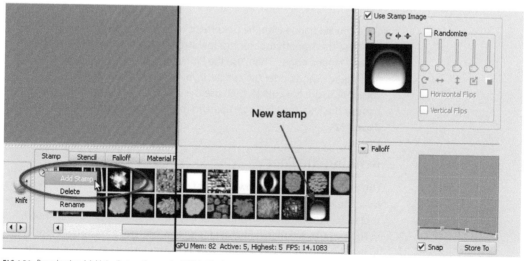

FIG 4.31 Download and Add the Custom Stamp that Will Be Used to Sculpt the Fingernails to the Stamp Tray. Customize the Falloff Profile for the Imprint Tool to Get a Good Displacement.

119

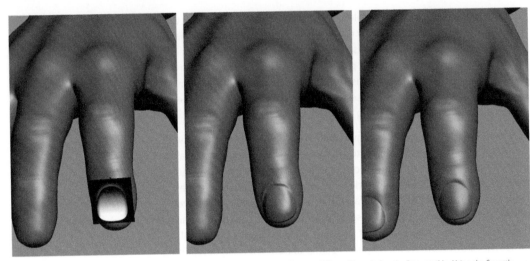

FIG 4.32 Apply the Imprint with a Custom Fingernail Stamp to Rough In the Basic Fingernail Shape. Then, Refine the Fingernail by Using the Smooth, Wax, Contrast, and Pinch Tools.

(the size value does not matter) and adjust the Falloff as shown in the last panel of **Figure 4.31**. To customize the falloff profile, click and drag on the control points. The falloff profile tapers so that the edges of the fingernail will also taper. Now, select one of the fingertips on which you will create the first fingernail. Rotate the camera so that you are looking directly at one of the fingertips. Place the mouse over the tip of the finger and left-click (you should see the stamp), then drag to set the size of the fingernail and then release the left mouse button to create imprint. It may take a few attempts to imprint the nail in the correct position on the fingertip, but with a bit of practice, you will learn it.

Once you are happy with the placement of the fingernail, you need to refine it a bit. Use the Smooth tool set to a low strength value (about 10) and smooth out any jagged edges. Then, use the Pinch tool and run it along the edges of the fingernail and under the cuticle. If you smooth out details, for instance, you smooth out the cuticle, then use the Wax tool to sculpt it back in. If parts of the fingernail or fingertip need to be repositioned, use the Grab tool (**Figure 4.32**).

Refining the Feet

Use the Wax tool with the bw_fibers.tif stamp and the Bulge tool to create the creases on the toe knuckles just like you did for the fingers. Use the Bulge tool to sculpt the tendons running along the dorsum of the foot as shown in **Figure 4.33**. To emphasize the details on the foot, use the Contrast tool. The toenails are sculpted in the same way as the fingernails. However, you may use mirroring across the *x* axis so that you only have to sculpt five toenails instead of ten. The trick to sculpting natural toenails is, first, to study what

FIG 4.33 Details on the Foot and the Toenails Are Sculpted the Same Way as with the Hands.

toenails look like and then prepare the nail bed on each toe by making it flat on top and making room for the toenail.

You have probably noticed that no sculpting is being done on the soles of the feet. This is because the soles of the feet are rarely seen. There is a cardinal rule in modeling and that says never sculpt anything that is not necessary. First, adding unnecessary details adds to computing overhead in terms of memory usage and file size. Second, sculpting details to a part of the model that will not be seen takes time, and in a production setting, you typically don't have time to waste. However, if you like, you may sculpt details on the soles of the feet, and try the same techniques used to add details to the palms of the hands.

Refining the Face and Ear

At subdivision level 5, it is possible to sculpt more details in the face and to finish the ear. Depending on your head and face design, you may add details such as skin creases, folds, wrinkles, and even scars. The Wax tool is great for adding larger skin folds, while a small inverted Bulge tool can create nice wrinkles. Remember that you may use Stamps or Stencils to add some details. Use the Contrast and Pinch tools to make details stand out. Very fine skin details like pores or exceptionally small wrinkles may be beyond the mesh resolution at subdivision level 5. But, in the next chapter, you will use bump maps to simulate small details without having to sculpt them. The creature in the figures has a somewhat elfin human-like ear. It is close enough to a human ear that you can refer to Chapter 3 for thorough instructions on sculpting the ear (Figure 4.34).

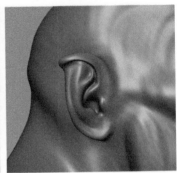

FIG 4.34 At Subdivision Level 5, It Is Possible to Add More Details to the Face and to Finish the Ear.

Final Details

At this point, the figure is almost complete, and the last few things to be done are adding final details such as surface veins and more skin details. An important decision has to be made as to whether some of these fine details should be sculpted or instead be simulated with bump maps. As you already know, the sculpting tools displace the surface of the mesh, whereas bump maps create the illusion of displacement or depth. Some of the factors in making this decision include the final output of the model. In other words, what is the model going to be used for? If the model is going to be exported for animation, then it is best to leave many of these finer details for bump maps. If the model is going to be printed, many of the very fine details may not print. In this case, smaller details like the nipples and umbilicus (navel) will be sculpted, as well as some veins and skin details, but very fine details like skin textures will be created with bump maps in the next chapter.

Nipples and Umbilicus

Create a new layer for the nipples and umbilicus. Using the Bulge tool create the nipples as shown in **Figure 4.35**. Now, using an inverted Bulge tool, push in the umbilicus along the linia alba at the intersection between the third and fourth rectus abdominis muscles. Umbilici come in different shapes and sizes, so you have some variability to experiment with. Once the initial cavity for the umbilicus is created, use the Grab tool to make it somewhat oval, horizontally. Then, use the Wax tool to create a fold of skin at the superior edge of the umbilicus (**Figure 4.35**).

Sculpting Veins

A feature commonly seen on the surface anatomy of muscular figures is blood vessels. The blood vessels visible on the surface are almost always veins. Arteries, which carry oxygenated blood and are under higher

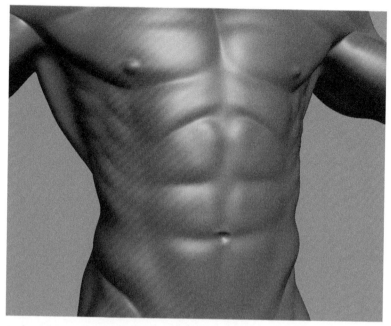

FIG 4.35 Suggest the Nipples with the Bulge Tool and Push In the Umbilicus with an Inverted Bulge Tool and Use the Wax Tool to Add Details.

pressures, are usually found deeper inside the arms and legs and the body. The number and size of veins seen on professional bodybuilders is not normal because these individuals have extremely large muscles and very little body fat. However, the creature you sculpted is muscular but still has some fat, so its veins will be on its arms and legs only. Veins on the arms and legs follow a general pattern that can vary somewhat from person to person. However, like most other anatomical features, you have to be to sculpt veins in places only where they occur.

Create a new layer for the vein details. Select the Bulge tool and set its size and strength values less than 5. In the Falloff tray, select the Falloff preset number 6. Hold the mouse over the Falloff presets to see their number. Now, depending on how hard you press on the graphics tablet as you sculpt, you will get different results. The goal is to sculpt subtle veins along the paths seen in Figure 4.36. The veins should not end abruptly but instead emerge gradually and taper gradually.

Asymmetry

As you have discovered, one of the great time-saving features in Mudbox is sculpting with mirroring across the x axis to sculpt both sides of the body, simultaneously. Through out most of this tutorial, you have been sculpting with mirroring enabled resulting in a model that is almost perfectly

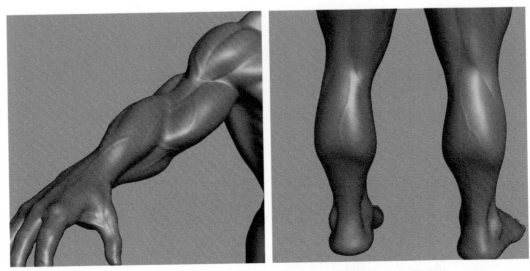

FIG 4.36 Surface Veins Add a Touch of Realism to the Sculpture. Use the Bulge Tool to Sculpt the Veins on the Arms and Legs.

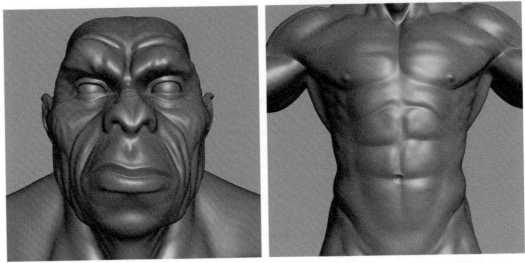

FIG 4.37 Living Things Including Humans Are Not Perfectly Symmetrical. Add Asymmetry to the Face and Body to Give the Sculpture a More Natural Appearance.

symmetrical. However, because human figures are not symmetrical, leaving the model as it is may cause it to look stiff and unnatural.

Take the time to study the subtle asymmetries that occur naturally in facial features and in the rest of the body. For instance, on the face, one brow may be higher, one eyelid may droop lower, or the nose may be a bit off center. Introducing some asymmetry will go a long way to enhancing the realism of your sculpture. In the body, asymmetry should be introduced in the torso.

For example, the Rectus abdominis muscles and the intersections between the muscles are almost never symmetrical. The same is true of the muscle groups on either side of the body. To add asymmetry, use the Grab tool with Mirroring disabled and lower its strength value so that any changes are subtle (Figure 4.37).

Summary

If you are reading this paragraph then you probably have made it all the way through sculpting an entire figure (Figure 4.38). Congratulations are in order because it's no small task to sculpt a figure from head to toe. By now, you should have a confident understanding of sculpting in Mudbox, digital sculpting concepts in general, and basic knowledge of human anatomy as applied to art. In the next chapter, you will work with Mudbox's 3D painting tools.

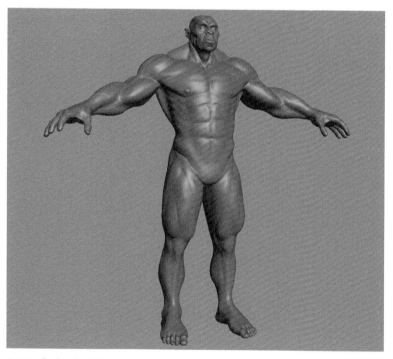

FIG 4.38 The Completed Creature.

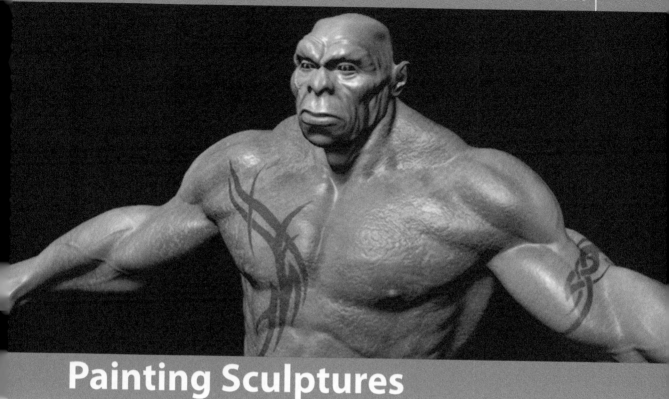

Painting Sculptures

In addition to a comprehensive sculpting toolset, Mudbox also features a professional three-dimensional (3D) paint system. In 3D painting, colors and textures are directly applied to the surface of a 3D model in real time. 3D painting in Mudbox is intuitive, easy to use, and analogous to how real-word objects are painted. In this chapter, you will review UV mapping, the Paint tools, Paint layers, and gain experience with Mudbox's 3D paint system by painting textures for the creature sculpted in Chapter 4.

UV Mapping

It is important to understand UV mapping because Mudbox relies on UV coordinates to paint textures on the surface of a model and also to extract displacement maps (reviewed in the next chapter). So, it goes without saying that to paint textures on a model in Mudbox, the model must first be UV mapped. *UV mapping* is a modeling process whereby the pixels in a 2D image are assigned to the geometry of a 3D model using UV coordinates. Much like a poster is tacked onto a wall, where the poster is the 2D image, the UV is the tack, and the wall is the 3D model. In essence, UV mapping tells the painting or modeling program where to place a 2D image on the surface of a 3D model (Figure 5.1).

Digital Sculpting with Mudbox. DOI: 10.1016/B978-0-240-81203-8.00005-2

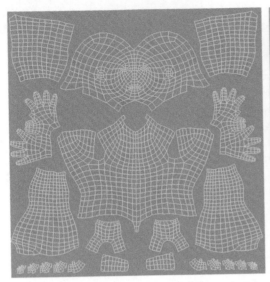

FIG 5.1 Models to Be Painted In Mudbox Must Be UV Mapped. In This Figure, You Can See the Correlation of the Model's UV Map and the Diffuse or Color Textures Painted in Mudbox (Diffuse Maps Are Shown as One Layer for Clarity).

The models that come with Mudbox like the Basic Head or the Human Body are already UV mapped, so they are ready to be painted. However, models that are imported into Mudbox must be UV mapped in a separate program like 3ds Max, modo, or Deep UV. The process of UV mapping or UV editing involves cutting and unfolding (also referred to as unwrapping) a repre-sentation of the 3D model into 2D UV space – which is an art unto itself. As mentioned earlier, in the tutorial that follows, you will paint texture for the creature sculpted in Chapter 4. The model used in Chapter 4 has been UV mapped for you, so it is ready for painting in Mudbox.

There are a few guidelines you should know when UV mapping a model for painting in Mudbox:

- UVs should be arranged (referred to as packing) to fill the UV tile as much as possible to improve the texture resolution.
- UV faces should be about the same size relative to each other and to the size of the polygons on the model, so that most UV faces are allotted about the same number of pixels in the 2D image. In some cases, such as painting textures for a character, certain areas like the head and hands will take up more room in the UV tile because of the greater detail required for these areas.
- In general, UVs should not overlap. The exception occurs when the UVs of a symmetrical model that uses the same texture on opposite halves are purposely overlapped to save UV space.
- UVs should have a four- to six-pixel space from the tile edge and from other UVs to make room for edge bleeding. UV mapping on a model may be visually checked by applying a checkered texture (Figure 5.2). On a well

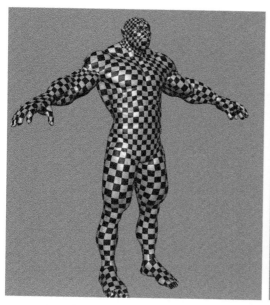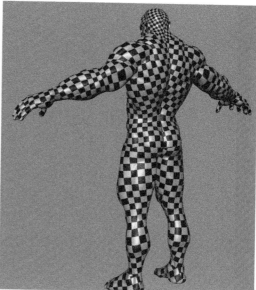

FIG 5.2 A Checkered Pattern May Be Used to Visually Check for Distortions, Seams, and Properly Proportioned UVs. The Checkers Are Smaller on the Head because the Head Takes Up More UV Space.

UV-mapped model, the checkers should appear about the same size and should be as square as possible.

Mudbox supports UV mapping on multiple UV tiles. When multiple UV tiles are used, sections of the model are UV mapped in adjacent tiles. For instance, the head and torso could be packed in one tile, and the legs, arms, hands, and feet could be packed in an adjacent tile (Figure 5.3). Using multiple UV tiles reduces some of the problems introduced by UV mapping on one tile such as having UVs of varying sizes, and it improves texture resolution. However, when UV mapping on multiple UV tiles, you must make sure that all applications in your pipeline support multiple-tile UV mapping. The model in the tutorial that follows is UV mapped using one UV tile.

The Paint Tools

The Mudbox paint tools consist of eight brushes (Figure 5.4). The Paint Brush, Airbrush, Pencil, and Dry Brush comprise the brushes that apply colors or textures by directly brushing on the model. The Paint Brush and the Airbrush are similar but the Airbrush applies a feathered and less opaque brush stroke. The Pencil applies an opaque, sharp, brush stroke, and the Dry Brush is a specialized brush that applies paint either to the raised or depressed areas of a model.

The Clone Brush, Paint Erase, and the Color Picker are utilities more than analogs for real-world brushes. The Clone Brush samples color or textures on one part of the model and applies it to another part of the model. The Color Picker

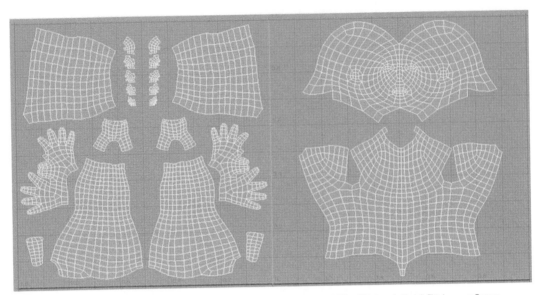

FIG 5.3 When Multiple UV Tiles Are Used, Parts of the Model May Be UV Mapped In Adjacent UV Tiles (UVs Seen In Modo). This Improves Texture Resolution and Reduces Distortions Caused by UVs of Varying Sizes.

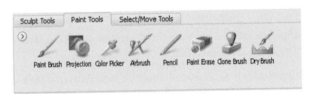

FIG 5.4 With Mudbox's Paint Brushes, Just About Any Texture Imaginable Can Easily Be Created.

samples color from the model and loads sampled color as the color for the active brush. The Paint Erase tool erases paint or textures in the active paint layer. If there are multiple layers, then erasing on one layer reveals the color or texture from visible paint layers below.

The paint brushes described thus far apply color on to the model based on brush properties. However, in stencil projection with the Projection brush, a 2D image is applied to the model. The advantage of stencil projection is that very complex textures may be easily created by applying real-world textures onto the model. For example, if you wanted to create a texture of scales, you could use the Paint Brush to draw the scales or even load a stamp to facilitate the process. However, with stencil projection, all you have to do is load an image of scales as a stencil and apply the details of the image to the model, using the Projection brush.

Like the sculpting tools, the paint brushes are designed to be used with a pressure-sensitive graphics tablet. The higher the pressure applied, the more paint is applied and the wider the brush stroke becomes. The paint brushes have

the same properties as the sculpting tools except that the paint brushes have a color property. To change the color of the active brush, click on the color swatch and select a new color. To control a brush's opacity, adjust the Strength value; to control its set size, adjust the Size property. The keyboard shortcut for brush size is B + LMB and drag, and for brush strength, it is M + LMB and drag. It is important to note that the paint brushes including the Projection brush may be used, with mirroring enabled, to paint symmetrically. For fine control, enable the Steady Stroke option. Also different Falloff presets will influence the shape and feathering of the brush stroke.

The versatility of Mudbox's paint brushes makes it possible to create an endless variety of textures. Although certain brushes are designed to be used in specific ways, such as stencils with the Projection brush, it is possible to mix brush properties to create novel textures. For example, if you use a stencil while using the Paint Brush with a stamp, then gray scale data in the stencil image will be used as an alpha mask. Viola! You have just created a new texture by mixing a stamp and stencil. Now add paint layers, the next topic in this chapter, and the possibilities become mind-boggling.

Paint Layers

In Mudbox, painting is done in paint layers, much the same way as in image-editing programs like Photoshop or Painter. Layers, sometimes referred to as channels, organize and manage paint and texture data in several ways. First, different types of texture data is organized in distinct layer types. For instance, color information is maintained in Diffuse layers, whereas reflection data is maintained in Reflection Mask layers. There are additional layer types for Gloss, Specular, and Bump Value data. Second, layers are grouped by type, so that all bump layers are in the Bump Value group, all diffuse color layers are in the Diffuse group, and so on. Third, layers may be used to organize the painted details of a model. For example, wrinkles may be painted in one layer while skin tones are painted on another layer. Also, if you want to try out an idea but are unsure how it may affect your work, you may create a new layer in which to experiment, leaving the previous work untouched in other layers (Figure 5.5).

Until the paint is applied, layers are transparent like traditional animation cels. Areas of a layer that are not painted allow paint in underlying layers to show through. Even if a layer is opaque with paint, it is possible to mix the contents of layers by varying the layer's opacities. It is the combination of the contents of the paint layers that produce the surface properties of model. Layers may be duplicated, merged, moved, hidden, deleted, and exported to Photoshop. If a layer is exported and edited in Photoshop, the edited data may be reimported by simply refreshing the layer. It is important to know that different types of layers (i.e., Bump or Diffuse) may be moved from group to group. For example, if a color layer is moved from the Diffuse group to the Bump Value group, the data in the color layer will be displayed as a bump map. New layers may be added as needed, limited only by the amount of graphics memory.

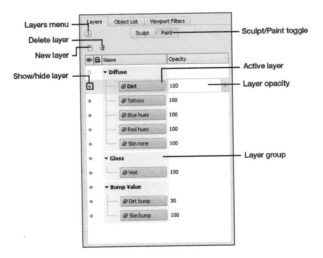

Layers menu

Delete layer

New layer

Show/hide layer

Sculpt/Paint toggle

Active layer

Layer opacity

Layer group

FIG 5.5 Mudbox's Layers Organize Different Layer Types and the Painted Details.

Once paint layers have been created, they are automatically saved in a local subdirectory, every time the Mudbox file is saved. In other words, the data in paint layers is not saved internally as part of the Mudbox file like the data in sculpt layers. Instead, each layer is saved as a separate image document that is linked to a specific layer in Mudbox and is loaded when the Mudbox file is opened. The image documents are saved in standard image file formats and may be edited in image-editing programs like Photoshop.

Because the data in a paint layer is actually linked to an image document, when a new paint layer is created in Mudbox, the file type, size, and bit depth must be selected. File types include, PNG, TIFF, Photoshop, TARGA, and OpenEXR. File size, also referred to as resolution, ranges from 256 × 256 to 4096 × 4096 pixels, and TIFF, TARGA, and OpenEXR files can be created in 16-bit and 32-bit depths. In general, the higher the resolution and bit depths, the better the quality of textures produced. However, the higher settings require more memory, so you will have to balance quality with performance. Unlike other 3D paint programs, Mudbox allows you to mix paint layers composed of different file formats, sizes, and bit depths. This important feature means that you can allocate higher resolution settings to specific textures while using lower resolution for others – thus, optimizing available graphics memory.

Painting the Creature

In the following tutorial, you will use Mudbox's paint brushes, paint layers, and interoperability with Photoshop (or similar image-editing program) to create the skin textures for the creature you modeled in Chapter 4. The instructions in the tutorial are a general guide to painting the textures. As with the sculpting tutorials, once you feel comfortable working with those paint tools and

paint layers, you are encouraged to experiment with brush and layer settings and to develop your own texture designs.

Getting Started

Go to www.digitalsculpting.net/mudbox_book and download the following files needed for this tutorial: skin_tone.tif, skin_bump.tga, dirt.bmp, chest_tatto.png, arm_tattoo.png, and eye_texture.tif. It may be a good idea to put the files in the same folder that contains your model from Chapter 4. Open the model you sculpted in Chapter 4 and save a new incremental copy. Go to the Sculpt Layers and merge as many sculpt layers as possible. Reducing the number of sculpt layers frees up memory for painting. Remember that you will be painting on a copy, so all the sculpt data is saved in the previous incremental files.

The textures in this tutorial will be 2048 pixels (2k) in size and 8 bits in depth because these settings work best on most computers and are usually sufficient for most applications. The 4096-pixel (4k) textures require considerable graphics memory, especially if there are several layers of large textures. With that said, if your computer hardware can handle 2048-pixel, 16-bit textures, we recommend that you use those settings instead because Mudbox's paint brushes work better with 16-bit textures.

Creating a New Mudbox Material

At this point, the creature and the spheres that represent the creature's eyes are all sharing the Default material. To avoid problems later, you will create a new Mudbox material and assign it to the eyes. Go to the Create menu in the menu bar, select Materials, and then choose Mudbox material. The new materials properties will display in a dialog box and in the Object list, you should see a new material object. You may close the material properties dialog box. Right-click on the new material, choose Rename Material and rename it as Eyes. To assign the new material to the eyes in the Object List, right-click on the l_eye object, select Assign Existing Material, and choose the Eye material. Repeat the process for the r_eye object.

Creating Basic Skin

Although it is possible to paint all of the textures for the creature using only Mudbox's paint tools, sometimes it is more efficient to take advantage of Mudbox's ability to import standard image files as paint layers to establish a starting point. In this case, you will use the files skin_tone.tif and skin_bump.tga to quickly create a basic skin for the creature. If it is not already open, open the incremental copy of your creature from Chapter 4, and click on the Paint button in the Layers window. The Layers window should be empty. To import the file skin_tone.tif as a paint layer, click anywhere in the Paint Layers window, select Import Layer from the contextual menu, and browse to the file skin_tone.tif. The file is automatically imported as a diffuse layer (Figure 5.6).

FIG 5.6 Importing an Image Document as a Diffuse Paint Layer.

When the skin_tone.tif file is imported, the color of the model should have changed slightly, although not as much as you had probably expected. This happens because the brown color in the diffuse channel of Default material is being multiplied with the texture in the Diffuse layer. There are several ways to fix the problem, but the quickest is to click on the Material Presets tray and click on the Porcelain material preset (the white preset in the second row) to apply it to the model. At this point, the color of the model should be lighter. Now, go to the Object List and select the Default Material. In the Properties tray, adjust the Fresnel Scattering Strength to about 0.7, the Reflection Strength to about 0.17. The model should now have a skin tone similar to Figure 5.7.

In the next step, you will add a bump map to the entire figure to simulate fine skin wrinkles. Unlike sculpting or displacement mapping, bump mapping does not change the geometry of an object but only simulates perturbations on the surface. It is, often, more efficient to simulate details like wrinkles or skin pores than to actually sculpt them.

Click on the New Layer icon in the Layers window to create a new bump layer. In the Create New Paint Layer dialog, name the layer Skin Bump, choose 2048 for Size, TIFF 8 bit for the file type, and Bump Value for the Channel. A new Bump Value group should appear in the Layers window with one layer. Now, right-click on the Bump Value group and select the Import Layer. Browse to the file skin_bump.tga to import it. When the file skin_bump.tga is initially imported, the model will appear to have serious skin problems. To reduce the effect of the bump map, click on the Opacity field of the new bump layer, and set the value to about 15. If you zoom in on the model, you should see a base skin tone with a skin texture (Figure 5.8). The details on skin bump texture applied is larger or more coarse than normal human skin, but then again, the creature is only human-like, so there is room for artistic license. Select Paint Erase and erase the bump texture from the fingernails and the toenails. Reduce the Paint Erase strength and remove some of the bump texture from the lips and eyelids.

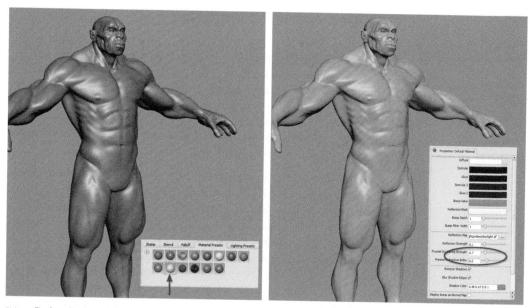

FIG 5.7 The Basic Skin Tone Is Quickly Created by Importing an Image Document as Paint Layer and Adjusting the Materials Properties.

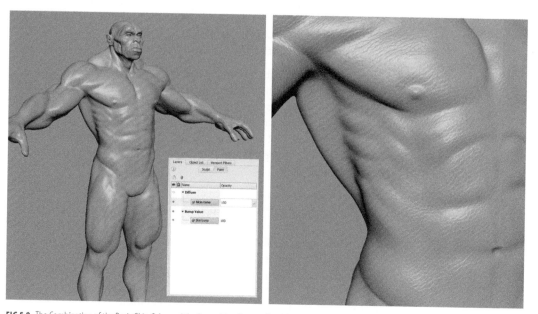

FIG 5.8 The Combination of the Basic Skin Color and the Bump Map Create a Good Starting Point for the Creature's Skin.

Adding Depth and Color to Skin

Human skin is never just one color. The optical properties of skin, arteries, veins, and oxygenated and deoxygenated blood near the skin surface absorb, reflect, and scatter light to create a myriad of colors that we see as subtle shades of red, blue, and even green. Human skin is complex in that its color and texture varies from ethnic group to ethnic group, varies between individuals in the same ethnic group, and even varies on one individual. So, to add depth and realism to the creature's basic skin texture, you will paint red and blue hues on separate paint layers.

First, you will paint the red skin hues created by exposure to the sun or oxygenated blood vessels close to the skin surface. Specific places like the fingers, toes, shoulders, elbows, knees, areas on the chest and back, and the parts of the face like the nose and lips often have subtle reddish hues. Create a new Diffuse layer and name it as Red Hues. Select the Paint Brush and set the following properties: enable Mirroring across the x axis, set the Size to about 8 and Strength to about 5. Once you gain experience with painting in Mudbox, you may change the Size and Strength to suite your painting style. Click on the Color swatch in the Properties tray, and from the Color Picker, choose deep red color. The red used in the tutorial is R: 149, G: 42, B: 51. Once you have a red you like, save it in the Color Picker, so that you can use it again later. Finally, from the Stamp tray, select the bw_leafVein.tif. In the Paint Brush properties, check the Randomize option for the stamp and move the Randomize sliders a bit, so that the stamp is randomly applied. The stamp will break up the brush stroke to achieve a more organic feel.

The goal is to apply a subtle layer of paint that suggests a red hue. Press lightly on the pen as you apply the brush strokes and don't linger too long in one place. If you press too hard or stay too long on one area, the color will be too saturated. If you apply too much color, select the Paint Erase brush, set its Strength to about 10, load the bw_leafVein.tif as a stamp, and check Randomize, so that the eraser will remove paint with the same pattern as the Paint Brush applied.

Take a look at Figure 5.9 to get an idea of where to apply the red hue. As mentioned earlier, important areas to apply red are the hands, specifically the finger tips. As you move up the arms, apply a light coat of red to the outside of the arms and give the elbow a healthy red glow. Apply a more saturated coat of the red to the shoulders and the upper back. As you move around to the front, apply red to the upper chest as seen in Figure 5.9. On the lower extremities, apply color to the thighs, knees, and bridge of the feet. On the face, apply red to the lips, tip of the nose, cheeks, and tips of the ears. Try not to make the creature look like it is wearing makeup but instead only suggest the red tones. The red hue may also be used to emphasize surface details by making natural depressions caused by muscles or skin folds a bit darker, much like an ambient occlusion map would do. Use Paint Erase to remove some of the red from the fingernails and toenails.

FIG 5.9 Skin Is Never Just One Color so to Make the Skin More Natural Red Hues Are Painted In Specific Areas of the Body.

Create another new diffuse layer and name it as Blue Hues. Blue skin hues are often created by veins and deoxygenated blood near the skin surface. Use the Paint Brush with the same properties including the stamp. Load a gray blue color (R: 100, B: 100, G: 140). Then mix in some of the blue hue into the red areas. If the paint application makes the skin appear bruised, you have gone too far. Use the Paint Erase tool to remove some color. As you did with the red hue, apply the blue hue into the depressions caused by muscles and skin folds. On the face, apply a bit of blue around the eyes especially where the dark circles usually appear. You may also suggest stubble by painting the blue hue where the beard and mustache would grow. Finally, turn off the stamp, enable the Steady Stroke option, and apply the blue hue to the veins on the arms and legs (Figure 5.10).

The combination of the base skin tone texture, the bump map, and the red and blue hues should produce an organic and natural skin texture. However, because you painted the red and blue hues with Mirroring enabled, both sides of the model have been painted symmetrically. To break up the symmetry, use the Paint Erase tool with Mirroring disable, and randomly remove some of the color in the red and blue hue layers. You may also use the Paint Brush with Mirroring disabled to asymmetrically reapply the color. You may experiment with the skin texture by adjusting the layer opacities, by adding more skin details like a layer of green hues or a layer with skin blemishes.

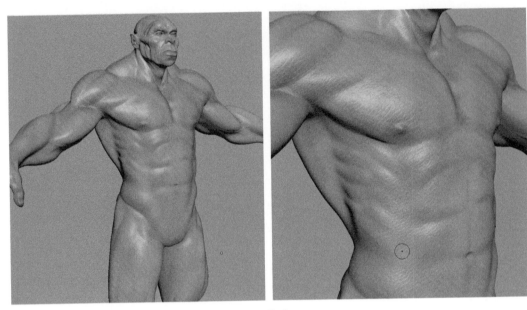

FIG 5.10 Blue Hues Mixed into the Red Areas Add Realism and Depth to the Skin Textures.

Adding Details

Creating Dirt

Most creatures probably don't have a very good hygiene, so in the next few steps, you will add dirt to the creature's skin. Create a new Diffuse layer and name it as Dirt. Switch to the Image Browser and navigate to the file dirt.bmp. Once you have located the file, click once on it to display it in the Image Browser. Next, click on the Set Stencil button to use the image as a stencil with the Paint Brush, and then switch back to the 3D view. In the 3D view, the image will appear as a stencil in the scene (see Figure 5.11). Make sure that the Paint Brush is selected and load a gray-green color (we used R: 90, G: 80, B: 100).

Stencils may be moved, scaled, and rotated by pressing the S key and then LMB to rotate, MMB to move, and RMB to scale. Position the stencil over the model similar to Figure 5.12 and begin to paint. The green color will be applied using the gray scale levels in the stencil to create an organic distribution of dirt (Figure 5.12). Once you have applied some dirt, disable mirroring to introduce some asymmetry. Although the painted dirt looks good, you can make it more realistic by simulating depth with a bump map. To do this, simply select the Dirt layer, right-click, and choose Duplicate Layer. Then move the copy to the Bump Value group (Figure 5.13). The data in the Diffuse layer will be used to create a quick and dirty bump map (no pun intended).

If you want to make a better dirt bump map, select the Dirt layer in the Diffuse group right-click, and choose Export Selected, and save the layer as a

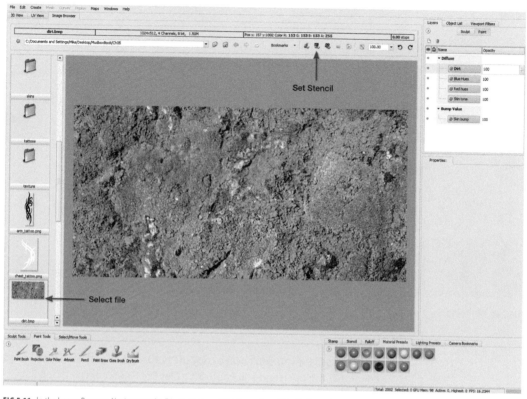

FIG 5.11 In the Image Browser, Navigate to the File dirt.bmp and Set It as a Stencil for the Paint Brush.

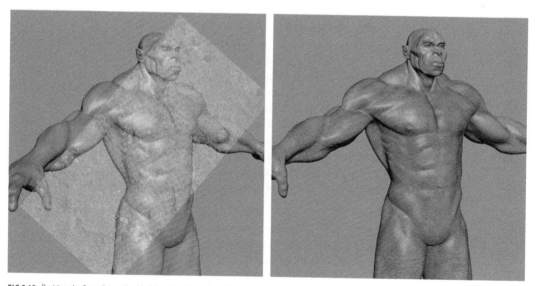

FIG 5.12 Position the Stencil over the Model, and with the Paint Brush, Paint Dirt Where You Want It on the Model.

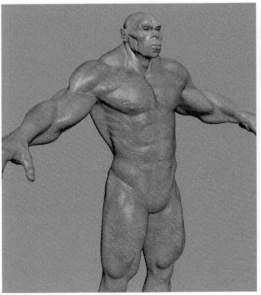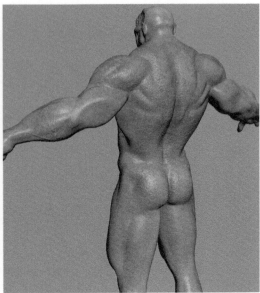

FIG 5.13 Add Depth to the Dirt with a Bump Map.

Photoshop file. If you don't own a copy of Photoshop, all you need is an image editor that can open and edit Photoshop files like Painter or PaintShop Pro. Open the exported Mudbox layer in Photoshop, then desaturate and adjust the levels to increase the contrast, and save the file. Back in Mudbox, go to the Bump Value group and import the edited Dirt layer as a bump map. The edited version of the Dirt layer should produce better bump results.

Adding Tattoos

In the steps that follow, you will use a stencil and the Paint Brush to paint a tattoo on the creature's chest, and once again, you will use Mudbox's interoperability with Photoshop to add a tattoo armband on the left arm. Create a new diffuse layer and name it as Tattoos. Switch to the Image Browser and locate the file chest_tattoo.tif and select it by clicking once on it. Then click on the Set Stencil button to set the image as a Stencil. Now, switch back to the 3D View and position the stencil as seen in **Figure 5.14**. Select the Paint Brush and set its Strength to about 85, set its color to black (or any color you'd like for the tattoo), and turn off Mirroring. Start applying brush strokes over the stencil to transfer the tattoo to the creature's chest (**Figure 5.14**).

Accurately placing an armband tattoo using a stencil is difficult because the arm is cylindrical. However, this task can be easily accomplished by exporting the Tattoo layer as a Photoshop file and placing the tattoo in the correct place using the UV map. In Mudbox, select the Tattoo layer, right-click, select Export Selected, and name and save the layer as a Photoshop file. Open the file in Photoshop; notice that the there are two layers, one named UV mesh and the

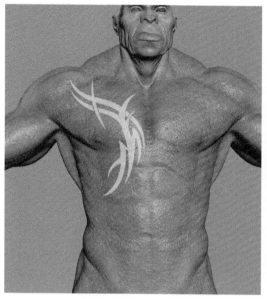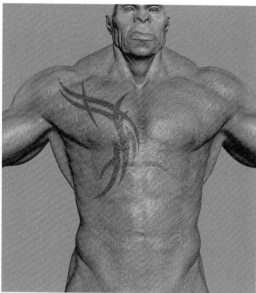

FIG 5.14 Use a Stencil and the Paint Brush to Apply the Chest Tattoo.

other named Mudbox layer. The UV mesh layer displays the models UV map and the other layer is the color data of the Mudbox Layer.

Next, open the file arm_tattoo.png in Photoshop. Then either copy and paste or drag the tattoo image into the Mudbox layer file. Scale and position the arm tattoo as seen in Figure 5.15. In this case, the tattoo is being placed on the left upper arm. Reduce the opacity of the tattoo layer to about 80 and merge the tattoo and Mudbox layers, so that there are only two layers once again and save the file. Back in Mudbox, select the Tattoo layer, right-click, and choose Refresh Selected. The armband should appear on left arm if you had placed as shown in Figure 5.15.

Texturing the Eyes

Although Mudbox materials do not support transparency, it is still possible to paint convincing eyes. Texturing the eyes requires positioning the pupils in the center of each eyeball. If the pupil is off by even a little bit the creature's eyes will appear unnatural. To facilitate positioning and painting of the eye texture, switch to the Front Camera to remove any distortion caused by perspective. Next, select the Eye material you created earlier from the Object List. If you look at the Paint Layers window, you will notice that there is no paint layers associated with the Eye material. All of the layers painted so far have been associated with the Default material assigned to the creature. Create a new 1024 (1k) 8-bit diffuse layer. Then in the Image Browser, locate the file eye_texture.tif and set it as a stencil. Switch back to the 3D view and select the Projection brush; make sure its Strength is set

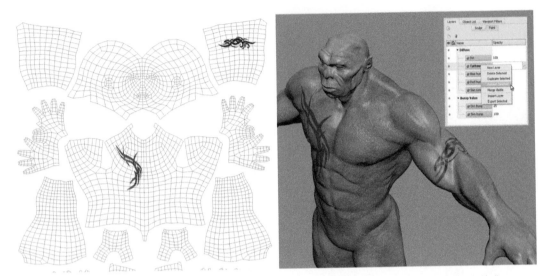

FIG 5.15 Copy and Paste or Drag the Tattoo Image into the Mudbox Layer Photoshop File and Position It over the UVs for the Left Arms. In Mudbox, Refresh the Tattoo Layer. The Tattoo Should Appear on the Upper Left Arm. (Photoshop File Shown with White Background for Clarity.)

to 100. Position the Stencil over one of eyes and begin painting. To make the eyes shinier and more reflective, try an alternate material presets like Porcelain, Chrome, or Shiny Red. The result should look something like Figure 5.16.

Adding Glossiness

The Default material assigned to the creature has some level of specularity and glossiness, and that's why there is some sheen to the skin, but wet or oily skin may look shinier. However, because the creature is dirty, shininess is not going to be an important issue. Nevertheless, you can add realism to the face by making the lips and nostrils appear a bit wet. Open the Paint Layer menu, select Add New Paint layer, and for the Channel, choose Glossiness. Select the Paint Brush and set its color to white and Strength to about 35. Now brush along the lips and inner aspects of the nostrils. Sharp highlights should appear making those surfaces appear wet (see lips on Figure 5.17).

Adding a Scar

At any time while working in the Paint Layers, you may switch back to the Sculpt layers to continue sculpting. In these next few steps, you will add a scar to the battle hardened creature's face. Click on the Sculpt button in the Layers window. Create a new Sculpt layer and name it as Scar. Use your favorite sculpting tool to add a scar similar to Figure 5.17, or you may place scars at any place you like on the creatures body. Make sure that the scar has lots of height differences like folds and wrinkles – it's a nasty scar. Now, switch back to the Paint Layers and create a new Diffuse layer named as Scar.

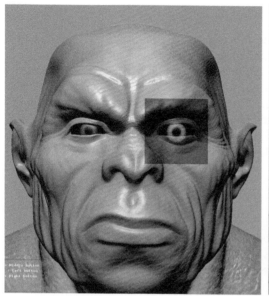

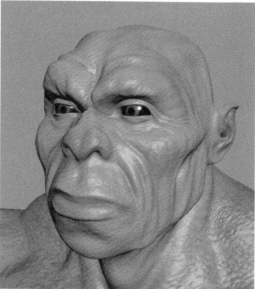

FIG 5.16 The Creature's Eyes Are Textured Using a Custom Stencil and the Projection Brush.

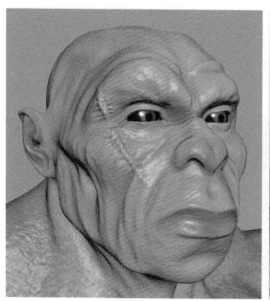

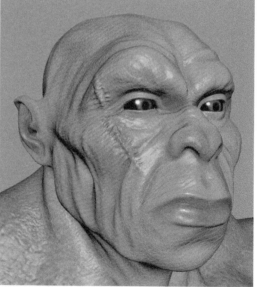

FIG 5.17 At Any Time While Painting, You May Switch Back to Sculpting. Sculpt a Scar on the Creature's Face and Use the Dry Brush to Paint Only on the Raised or Depressed Areas of the Scar.

Select the Dry Brush, click on the color swatch in the Property window, and load the red color used earlier, and begin to paint over the scar. Notice that only the raised areas of the scar are painted. Now, load the blue color, press Ctrl while painting with the Dry Brush, and this time, only the depressed areas of the scar are painted (Figure 5.17).

143

Viewport Rendering

Mudbox features real-time view port rendering, which previews models under different lighting and rendering conditions. To experiment with Mudbox's viewport rendering, click on the Viewport Filters tab. Click on the box next to the Tonemapper to turn it on. The Tonemapper manages the brightness in the scene, the tonal range, and glare effects. Adjust the Gamma slider to brighten or darken the scene. Next, turn on the Depth of Field and adjust the Depth of Field and the Focus Distance sliders until the areas of the scene you want are in focus. Turn on and adjust Ambient Occlusion to simulate global illumination (Figure 5.18).

Summary

In this chapter, you learned that it is important to efficiently UV map a model to get the most of Mudbox's paint tools. You have probably figured out that painting with Mudbox is a straightforward process that allows you to be creative, and you can create textures for just about anything you can imagine with ease. However, there are some considerations to take into account when painting in Mudbox. At this point, the shaders in Mudbox are basic tools compared with shaders and materials in programs like Maya or 3ds Max. As a result, if you want transparency or advanced options like subsurface scattering, you have to export the model along with its textures and build custom shaders in your favorite 3D program. In the next chapter, you will learn to extract displacement maps, export models from Mudbox, and then apply the displacement maps to the model in various 3D programs.

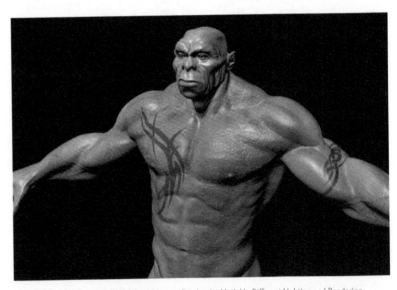

FIG 5.18 Experiment with the Viewport Filters to Render the Model In Different Lighting and Rendering Conditions.

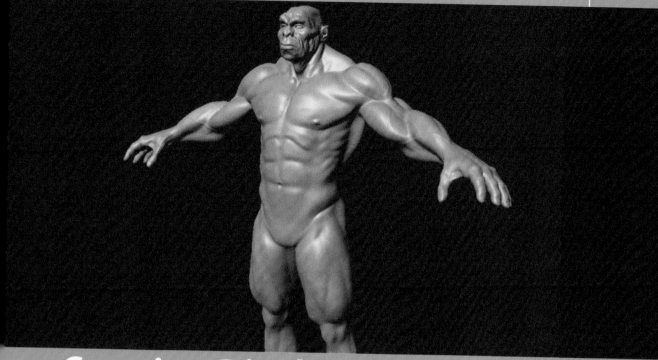

Creating Displacement Maps

By working through the tutorials in previous chapters, you have learned that it is simple to create very detailed sculptures in Mudbox. However, to achieve high-resolution detail, sculptures may consist of millions, if not tens of millions, of polygons. And while it is possible to export the high-resolution sculptures through Mudbox's FBX and OBJ exporters, there isn't much that can be done with models made of millions of polygons in other three-dimensional (3D) programs – certainly not in terms of animation.

To preserve sculpted detail and at the same time have a model that can be efficiently managed or animated, the recommended workflow is to extract normal or displacement maps (sometimes both) that represent the high-resolution details and assign the maps to a low-resolution model in the target 3D program using shaders. The effects of the normal or displacement maps are then applied to the model during the rendering process.

This chapter provides a brief overview of normal and displacement maps generated by Mudbox. In the tutorial that follows, you will extract a displacement map from the model sculpted in Chapter 4. The rest of the chapter features step-by-step tutorials on how to apply the extracted displacement map to a low-resolution model in 3ds max, Maya, modo, Cinema 4D, and Carrara.

Digital Sculpting with Mudbox. DOI: 10.1016/B978-0-240-81203-8.00006-4

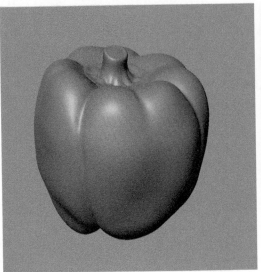

FIG 6.1 Normal Maps Use RGB Color Data to Simulate Depth on the Surface of a 3D Model. However, Normal Maps Do Not Actually Change the Surface Geometry of a Model.

Normal Maps

Normal maps are similar to bump maps in that they simulate depth or bumps on the surface of a model at render time. However, unlike bump maps that use gray scale data, normal maps use RGB color data. As a result, normal maps can simulate depth along the *x, y,* and *z* axes instead of just up and down, producing better depth simulations. Like bump maps, normal maps do not change the geometry of a model. So, the normal map must be applied to a model that already has the appropriate shape. Also like bump maps, when a model with a normal map is viewed in silhouette, the illusion of depth disappears. The advantage of bump and normal maps is that the depth simulations they produce are calculated very fast and require few computer resources. Bump maps and normal maps are used in real-time applications like games because of their efficiency. **Figure 6.1** shows the model from Chapter 2 and the normal map produced by Mudbox. The step up from bump or normal maps is the true displacement maps.

Displacement Maps

Unlike bump and normal maps, displacement maps actually change the geometry of a model. So, the silhouette of a model with a displacement map reflects that data in the displacement map. The amount of displacement is modulated by the gray scale data in the displacement map in which black and dark grays represent low areas and white and lighter areas represent high areas. Although displacement maps closely reproduce sculpted details

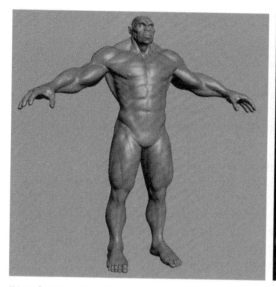

FIG 6.2 Displacement Maps Displace or Change the Surface of a 3D Model, According to the Gray Scale Data in the Map. This Figure Shows the Displacement Map Generated from the Sculpture In Chapter 4.

at render time, they take much longer to process than bump and normal maps (**Figure 6.2**). So at this time, displacement maps are typically used in film, broadcast, and for still renders. At this time, Mudbox uses a ray-tracing operation to produce a displacement map. Simply put, a ray is traced from the target to the source model and the differences are recorded as a displacement map. This method has some inherent limits. For example, if the section of sculpted geometry closely overhangs another section of sculptured geometry, then the ray will intersect several surfaces, possibly causing artifacts in the displacement map. Fortunately, this is not a common problem, but you should be aware of it, in case you encounter problems. The only way to fix the problem is to sculpt the problem area in a different way.

Like the textures produced by Mudbox's paint tools, the quality of a bump, normal, or displacement map depends on the image size or resolution and bit depth. Mudbox can produce maps from 256 × 256 to 4096 × 4096 resolutions with bit depths available in a range from 8 to 32 bits. File formats for displacement maps include BMP, TIFF, TARGA, PSD, and OpenEXR. Large displacement maps with high bit depths produce better results. However, the trade off is in performance because larger maps with higher bit depths require more memory. Also the same UV mapping rules that applied to producing good paint textures apply to producing good displacement maps. Mudbox can produce a variety of black and white and RGBA displacement maps for various applications. When extracting displacement maps, it is important to know in advance which type of file format works best in the target 3D program.

Extracting Displacement Maps

In the immediate steps that follow, you will extract a displacement map and then export a low-resolution version of the model in OBJ format. To get started, launch Mudbox and open an incremental copy of the creature you sculpted in Chapter 4. In the menu bar, go to Maps, select Extract Texture Maps, and choose New Operation. In the Extract Texture Maps dialog box, check Displacement Map (Figure 6.3). The options for extracting a displacement map will be displayed.

Because Mudbox saves the settings of extraction operations, you are asked to name the current extraction operation. You may rename the operation or leave the default name. In the Maps to Generate section, Displacement Map should be checked. In the Target Models field, click Add All to list the objects in the scene. Then click and drag over the left and right eye objects, and click Remove. The only object listed should be the creature, and its level should be 0. Repeat the process for the Source Models field as its level should be 5 (Figure 6.4).

In the Choose Samples menu, leave the Closest to Target Model option selected. This option will work for most extraction operations. The next option is the search distance. The *search distance* is the distance (in centimeters by default) that the extraction process searches for sculpt details on the source model. To set the search distance, click on Best Guess; more often than not, the best guess will work. However, round up the best guess value to the next whole number. For example, the Best Guess value for the model we created is 2.31, so we rounded up to 3. Because your model is different than ours, the Best Guess value for your model will be different. Rounding up the Best Guess value ensures that the search for differences between the source and target encompasses all of the details on the source model.

FIG 6.3 Check Displacement Map In the Extract Texture Maps Dialog Box.

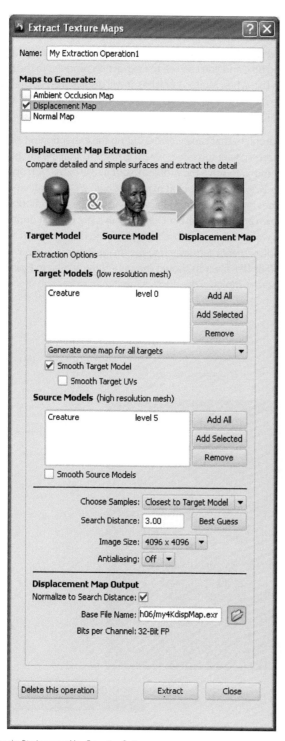

FIG 6.4 Setting the Displacement Map Extraction Options.

149

Set the Image Size to 4096 × 4096. Click on the folder icon next to the Base File Name field, select OpenEXR [32-bit Floating Point, RGBA], name the file, and click Save. Finally, click on Extract. Mudbox will display the Map extraction results dialog box, and you can see the extraction progress in the left corner of the status bar. When Mudbox finishes, it will display the Finished dialog box with the message "Map extraction finished without errors." If any other message is displayed, the extraction process probably did not work.

A common problem that causes errors during the extraction process is choosing image sizes that are too large or with bit depths that are too high for the available memory. To solve the problem, start a new extraction operation, and in the Image Size, choose the next map size down 2048 × 2048 and try again. If that still does not work, then while selecting the file type, choose the next bit depth down and try again. For OpenEXR files, the only bit depth available is 32, so you would have to choose a 16-bit TIFF to reduce the bit depth. To view the displacement map, switch to the Image Browser and navigate to the OpenEXR or TIFF file. You should see something similar to **Figure 6.5**. At this point, you have completed the displacement map extraction process.

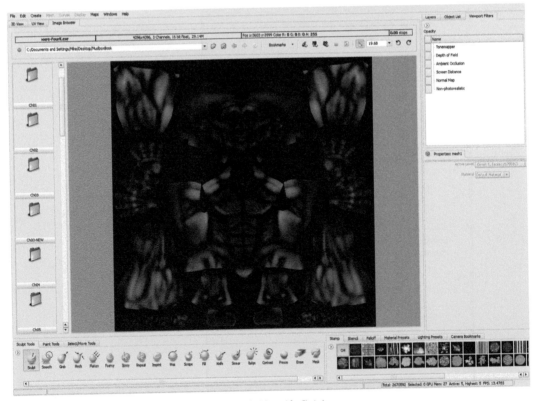

FIG 6.5 The Displacement Map In Mudbox's Image Browser (Map Levels Adjusted for Clarity).

Exporting a Low-Resolution Model

The next step is to produce and export a low-resolution model that will be imported into the target 3D program. During the sculpting process, the model was subdivided five times to level 5 and contains more than two million polygons – a modest amount for Mudbox, but too much for most 3D programs. So to be used in an external 3D application, a low-resolution or low-level version of the model needs to be exported. Press the Page Down key five times until you have reached level 0. As you press the Page Down key, the model's lower subdivision levels are displayed. Next, select the model in the scene or in the Object List, and from the File menu, choose Export Selection. Name and save the file in OBJ format (Figure 6.6).

Troubleshooting In Advance

Because everyone's model will be different in some way, the displacement map extraction settings described thus far may not produce the desired results for your model or your external 3D program. We suggest that while you are still in Mudbox and before you fire up your favorite 3D program, that you extract additional displacement maps in which the target is set to level 1 and export a level 1 OBJ model. If you know that your 3D program does not accept OpenEXR files, then choose a different file format during the extraction set up. Most 3D programs will accept the TIFF format.

The reason a level 1 target may produce better results is that often the level 0 target is too different from the level 5 source. The sculpture in Chapter 4 started at level 0, but it was subdivided five times during the sculpting

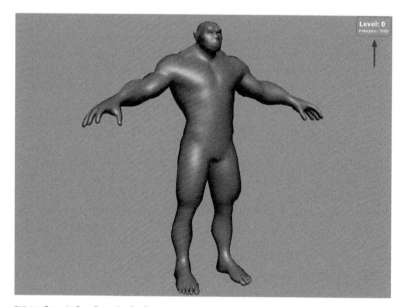

FIG 6.6 Press the Page Down Key Five Times to Get to the Lowest Subdivision Level and Export the Model as an OBJ File.

process and its surface significantly changed with the sculpting tools. If a displacement map is generated from the level 5 source and applied to the level 0 target, then there may not be enough data in the displacement map to displace the level 0 target to look like the level 5 source. The deciding factor is the amount of difference between the two models and the displacement features in target 3D application.

If you feel confident that you have the displacement map required for your 3D program, you may skip this step and move on to the next section. If not, then once again in Mudbox, go to Maps, select Extract Texture Maps, and choose New Operation. This time in the Target Models, right-click on the Creature object in the list, and select level 1 from the contextual menu. Leave all other settings the same as the first extraction operation – unless you are selecting a different file format for the map. Remember to name this displacement map something different than the first one, and when ready, click Extract.

Next, use the Page Up or Page Down keys to get to subdivision level 1. Select the model in the scene once again, and from the File menu, choose Export Selection. In the Save As dialog box, name this model something different than the first OBJ model that you exported a moment ago. At this point, you should have two displacement maps and two OBJ models.

Applying Mudbox Displacement Maps

The following section contains brief tutorials on how to apply the displacement maps generated in Mudbox to models in 3ds max, Maya, modo, Cinema 4D, and Carrara. The tutorials are written with the assumption that you are familiar with your 3D program of choice, and the tutorials are meant to take you to the point where the displacement maps have been applied successfully. If your 3D program is not covered, the tutorials should give you enough information, so that you can determine the workflow from Mudbox to your favorite 3D program.

3ds Max

This was written using 3ds max 2010, but this workflow should also work for recent versions of 3ds max. Open 3ds max and import the level 0 OBJ model exported from Mudbox as an Editable Poly (Figure 6.7). Add a TurboSmooth modifier to the stack. In the Main section of the TurboSmooth rollout, check Render Iters and set its value to 4. The Render Iters value is determined by the number of subdivision levels from the target model to the source model, and it is limited by the amount of memory in your computer. Recall that, in this case, the target is at level 0 and the source is at level 5, so a Render Iters of 4 should work, but if your computer can handle it, try a Render Iters of 5. You may leave the Iterations value at 1 (Figure 6.8).

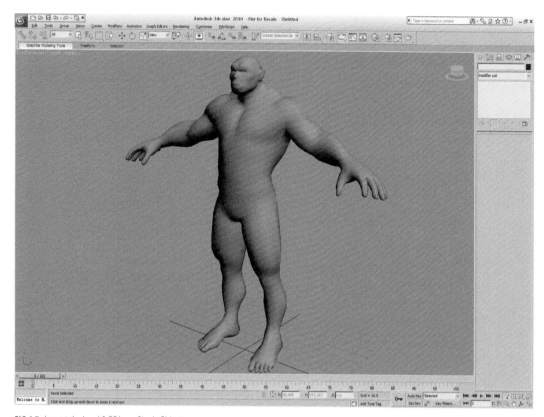

FIG 6.7 Import the Level 0 OBJ as a Single Object.

Add a Displace modifier to the stack. In the Map rollout of the Displace modifier, check Use Existing Mapping. In the Image section of the Paramers rollout, click on the button labeled "None under Map:" (not the button under Bitmap:); in the Material/Map Browser select Bitmap, browse to the displacement map Mudbox created, and load the file. In the Displacement section of the Displace rollout, set the Strength to about 10 (Figure 6.9). Press F9 to render the window, and your model should look similar to Figure 6.10. The strength value for your model may need to be adjusted up or down to get the appropriate displacement.

Tip

📖 Mudbox and 3ds max manage the smoothed and linear UVs differently. This difference may cause seams and artifacts. If this occurs, add an UnwrapUVW modifier to stack before the TurboSmooth or Displace modifiers. Select the UnwrapUVW modifier, and in the Parameters rollout, click on Edit to display the UV Editor, select all UVs, and then from the Tools menu, choose Break. This is not an elegant fix, but it works.

FIG 6.8 Add a TurboSmooth Modifier to Subdivide the Model at Render Time.

FIG 6.9 Apply the Displacement File with a Displace Modifier.

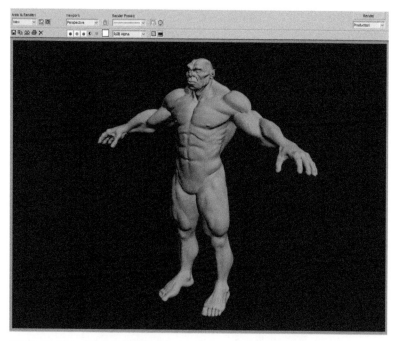

FIG 6.10 The Displaced Model Rendered with the Scanline Renderer in 3ds Max.

Maya and Mental Ray

This tutorial was written using Maya 2010 and Maya 2009. Import the level 0 OBJ model you exported from Mudbox into Maya as a single object (Figure 6.11). To set up render preferences, go to Window > Settings/Preferences > Preferences. In the Categories list, click on Rendering to display the rendering preferences. In Preferred Renderer, choose mental ray. In mental ray Preferences, check "Use Maya-style alpha detection on file textures" (Figure 6.12).

Open the Hypershade Editor (Window > Rendering Editors > Hypershade). Create a new Blinn material node and a new file node. Now, click MMB and drag from the file node to the Blinn material node and release the MMB. From the pop-up menu, choose displacement map (Figure 6.12). To assign the shader to the model, select the model in the scene, in the Hypershade Editor, right-click and hold on the Blinn node, and from the contextual menu, choose Assign Material to Selection.

Select the file node in the Hypershade Editor and open its Attribute Editor (Ctrl + A). In the Filter Type menu, choose Off. Then, click on the folder icon next to the Image Name field, browse to the displacement map generated by Mudbox and load it, and close the Attribute Editor (Figure 6.13). If you load the 4k OpenEXR file generated by Mudbox, Maya may display a warning. Ignore the warning – the file has probably loaded and will be used as the displacement map with no problems. However, if when your attempt to render the rendering fails, close Maya and go through the steps once more, but this time try a 2k OpenEXR file.

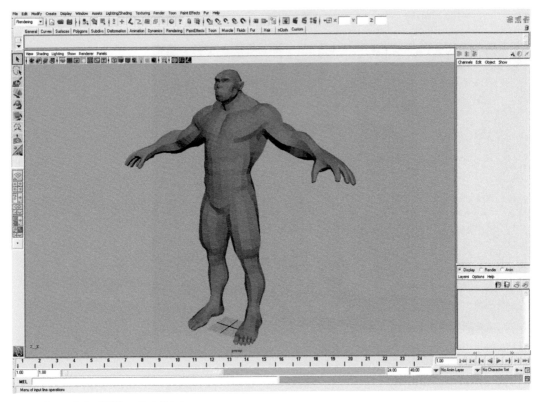

FIG 6.11 Import the Level 0 OBJ as a Single Object.

FIG 6.12 Setting Up Render Options.

FIG 6.13 Turn Filtering Off and Load the Displacement Map.

Make sure the model in the scene is selected and go to Window > Rendering Editors > mental ray > Approximation Editor (Figure 6.14). Under the heading Subdivisions (Polygon and Subd. Surfaces), click on Create to make the ghosted buttons active. Click on Edit to bring up the mentalray SubDivApprox1 Attribute Editor. In the Subdivision Surface Quality menu, choose Parametric for the Approx Method, set the N Subdivisions value to 4, and check Fine (Figure 6.15). Remember that the subdivision level is approximately the difference in levels between the level 0 or level 1 model and the highest level (in this case, 5) in Mudbox. Parametric is the simplest choice, but with the least control over subdivision properties. For better control, choose Spatial in the Approx Method menu. Choosing Spatial will allow you to set the minimum and maximum number of divisions (values of 2 for minimum and for maximum 5 are a good place to start), and set the Length that determines how long an edge has to be before mental

FIG 6.14 Open the Mental Ray Approximation Editor.

FIG 6.15 Set the Subdivision Method and Level In the Mentalray SubDivApprox1 Attribute Editor.

ray divides it (smaller values equals more polygons). Usually, it is best to start with the Length value at 0.01 and then decrease it as needed. When finished, close the Attribute editor and close the mental ray Approximation Editor.

To set the amount of displacement, click on the file node in the Hypershade Editor, open its Attribute Editor, and open the Color Balance menu. Set the Alpha Gain to about 10, leave the Alpha Offset at 0, and check Alpha Luminance. A good starting estimate for the Alpha Gain is about two and half times the Best Guess value in the Mudbox Extract Texture Map dialog box (Figure 6.16).

There are just a few more details left. Select the model in the scene, open its Attribute Editor, and click on the Shape tab (Figure 6.17). In the Displacement Map menu, uncheck Feature Displacement because this option is used in the native Maya renderer not mental ray. Render the current frame, and your model should look similar to Figure 6.18.

FIG 6.16 Adjusting the Alpha Gain In the Color Balance Menu.

FIG 6.17 Turn off the Feature Displacement Box In the Model's Attribute Editor.

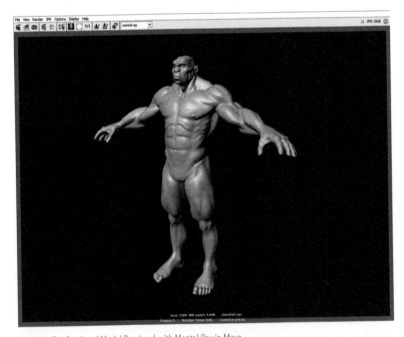

FIG 6.18 The Displaced Model Rendered with Mental Ray in Maya.

If the displacement amount is not sufficient, click on the file node in the Hypershade Editor, bring up its Attribute Editor and increase the Alpha Gain and render again. There are a couple of issues you need to know if you are using earlier versions of Maya, specifically Maya 8. Maya 8 prefers to use the MAP format for displacement files. Also there may be problems with seams and artifacts when subdividing the model. The fixes for these issues can be found at www.digitalsculpting.net/mudbox_book.

Modo

The workflow from Mudbox to modo 401 is clear-cut, and should also work for latest versions of modo. Import the level 0 OBJ into the scene (File > Import). Convert the model to a Sub-D model by pressing the Tab key on the key board (Figure 6.19).

With the model still selected, assign a new material to the model (Texture > Assign Material Group). Assigning a new material to the model will display the Polygon Set Material dialog box. If you like, name the new material group, and click OK. We named the material CreatureDisp to make it easier to see the material in the Shader Tree.

In the Clip Name column of the Images tab, click on "(load image)", browse to the displacement map, and open it (Figure 6.20). This loads the displacement map as an asset modo can use. In the Name column of the Shader Tree tab, click on the Render item to select it. In the Properties tab, click on Settings, in the Geometry section, check Adaptive Subdivision and make sure that Micropoly Displacement is checked. Set the Mircropoly Displacement value to about 0.3 and leave everything else in its default settings (Figure 6.21).

FIG 6.19 Import the Level 0 OBJ and Convert It to a Sub-D Model.

FIG 6.20 Load the Displacement Map as an Asset Modo Can Use.

FIG 6.21 Select the Render Item and In the Properties Tab Check Adaptive Subdivision and Micropoly Displacement.

Go back to the Shader Tree tab, open the Render item, and select the Matr: CreatureDisp item, and in the Add Layer menu, select Image Map (**Figure 6.22**). From the list of thumbnails displayed, double-click on the displacement map. A new Image item is now listed under Matr: CreatureDisp. The displacement map may be displayed as a diffuse color map on the model in the scene. To change it to displacement, select the Image item and in the Effect column, right-click on the words Diffuse Color, and from the pop-up menu, choose Displacement (**Figure 6.23**).

FIG 6.22 Load the Displacement Map into the Matr: CreatureDisp Item.

FIG 6.23 Switch the Effect Mode from Displace Color to Displacement.

To make sure that the appropriate UV map is being used in the correct manner, click on the Images tab and in the Properties tab, click Texture Locator. Under the Projection section, set the Projection Type menu to UV Map and set the UV Map menu to Texture. "Texture" is the default UV map name used by the OBJ format (Figure 6.24).

Back in the Shader Tree tab under the Matr: CreatureDisp item, select the Material item (not the Base Material Item). In the Properties tab, click on Material Ref and in the Displacement Distance start off with a value of about 6 m (Figure 6.25). Click on the Render Layout tab to view the results (Figure 6.26). The Displacement Distance value may be different for your mode, so if the displacement results don't look correct, accordingly adjust the value.

FIG 6.24 Make Sure the Projection Type Is UV Map and the UV Map Is Texture.

FIG 6.25 Set the Displacement Distance.

FIG 6.26 The Displaced Model Rendered in Modo.

Cinema 4D

This tutorial was written with Cinema 4D R11, but this workflow should also work with latest versions. Cinema 4D features one of simplest workflows for importing and applying Mudbox displacement maps to models. Open the level 0 OBJ file, in the Wavefront Import make sure the scale is 1. Create a new material in the Materials tray, and assign the material to the model in the scene by clicking and dragging the material from the tray to the model (Figure 6.27).

Open the Material Editor by double-clicking on the new material in the Materials tray. Check the Displacement channel, and in the Texture field, browse to the displacement map. Although the 32-bit version of Cinema 4D supports OpenEXR files in our experience, we got better results from TIFF files. In the Sub-Polygon Displacement section, check Sub-Polygon Displacement, set the Subdivision Level to 4, and check Round Geometry. Rounded geometry eliminates edge creasing (Figure 6.28).

Press Ctrl + R to render the window (Figure 6.29). If the amount of the displacement is not what you had expected, then increase the Height value in the Material Editor. With Mudbox's TIFF files, it may be necessary to considerably

FIG 6.27 Open the Level 0 OBJ Model, Create a New Material, and Apply It to the Model.

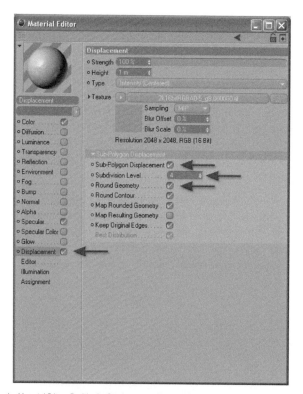

FIG 6.28 In the Material Editor, Enable the Displacement Channel, Browse to the Displacement Map, and Set the Subdivision Levels.

FIG 6.29 The Displaced Model Rendered In Cinema 4D.

increase the Height value. Alternatively, you could open the TIFF file in an image-editing program and adjust the levels to increase contrast and reimport the displacement file.

Carrara

This tutorial was written using Carrara 7 Pro. Open a new Carrara scene, go to File > Import, and browse to the level 0 OBJ file. In the OBJ Import dialog box, check Disable Auto-Scaling in the "Create Carrara Object As:" section, select Vertex Primitives, and in the "Grouping:" section, select Create Only One Object (Figure 6.30).

Select the model in the scene and jump into the Texture room. In Shader Tree Editor, click on the Displacement tab, open the Displacement sub-shader menu, and select Texture Map. Next, in the right side of the Shader Tree Editor, click on the Load button (it's the button with the open folder icon) and browse to the displacement map (Figure 6.31). Carrara accepts 16-bit RGBA TIFF displacement maps.

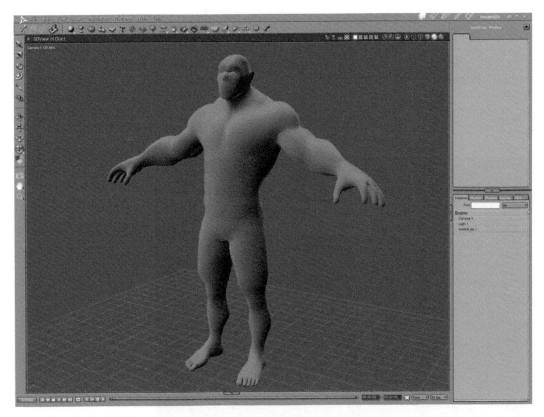

FIG 6.30 Import the Level 0 OBJ Model.

FIG 6.31 Load the Displacement Map into the Displacement Sub-Shader.

Tip

📖 Sometimes, Mudbox's 16-bit TIFF displacement maps produce a little displacement in Carrara, even when the Amplitude and Offset are adjusted. However, because the displacement maps are image files, they may be edited in image-editing programs like Photoshop. If the displacement map from Mudbox does not produce enough displacement, open the file in Photoshop and adjust the levels, so that there is more contrast between the lighter areas and the darker areas. Save the edited map under a new file name and load it into Carrara.

While still in the Displacement tab, click on the Top Shader, check Enable Displacement, set the "Amplitude:" to about 0.6, and adjust the Offset slider to 0.5, and the Smoothing Angle to 65° (Figure 6.32). Do not enable Subdivisions; the subdivisions will be managed in the Vertex Modeler. The "Amplitude:" value determines the height or amount of displacement while Offset sets the value for no displacement. The Smoothing angle sets the angle at which smoothing or creasing occurs.

FIG 6.32 Adjust the Displacement Settings.

FIG 6.33 Setting the Subdivision Levels.

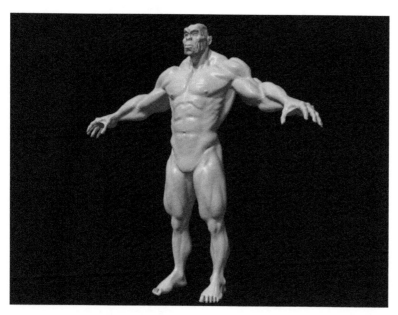

FIG 6.34 The Displaced Model Rendered In Carrara.

Next jump into the Vertex Modeler and select the model. Under Subdivision in the Model tab, select Smooth; set the Modeling Level to 0 and the Rendering Level to 4 (Figure 6.33). Displacement should be enabled in the Displacement section (Figure 6.33). When finished, press Ctrl + R to do a quick render – it should look similar to Figure 6.34. If you get a Memory Allocation error, reduce the number of subdivisions to 3 in the Vertex Modeler.

Summary

The process of extracting displacement maps from a model in Mudbox is uncomplicated. But as you have learned, there is an element of trial and error to find out which displacement map settings work best for a specific model and for a particular 3D program. Nonetheless, Mudbox has sufficient versatility in its displacement map extraction process so that you can, with a bit of work, extract the perfect displacement for any application.

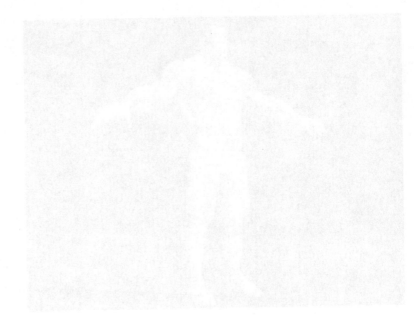

Scanning, Printing, and Milling

When working in Mudbox, you will need to work with a polygonal model. Polygonal models can be the template models offered in Mudbox or models that have been created in other three-dimensional (3D) modeling programs such as 3ds Max, Maya, Carrara, Houdini, or Blender. In the "Scanning" section of this chapter, we will explore alternative methods of bringing models into Mudbox.

In many instances, once the works of art created in Mudbox are complete, they leave the Mudbox program and enter into another virtual environment for animation or rendering. These digital models are created for movies, video games, and applications in which the Mudbox creation is exported from one virtual environment to another. But what if you want to realize your work in a physical form? In the "Digital Printing and Milling" section of this chapter, we will discuss the different types of output available and the process of getting your virtual image out of your computer and onto your physical desk!

While exploring these alternative methods of both input and output, this chapter will also demonstrate the entire process of input of a traditional clay maquette of a mother and her baby that is scanned and retopologized. After it is modified in Mudbox, it is output in different materials.

Digital Sculpting with Mudbox. DOI: 10.1016/B978-0-240-81203-8.00007-6

Digital Scanning

An alternative way of getting a 3D model into the computer is through digital scanning. *Digital scanning* is the process of taking an existing physical object and creating a digital representation of it as a 3D model, using the data the scanner has collected.

There are two types of scanners, contact and noncontact digital scanners. The difference between the two is that contact scanners are scanners that collect information through the physical touch of the object, and noncontact scanners do not physically touch the object being digitized. Noncontact digital scanners use light or a laser to obtain the information. The light or laser is projected onto the surface of the object, and the *xyz* coordinates are collected as data. Noncontact scanners are important to those who record information on objects where retaining the integrity of the object is vital, so that it is never compromised or damaged; for example, scanning of priceless historical artifacts, archeological finds, or forensic samples.

The most popular types of scanners in use are noncontact scanners, which include both laser scanners and structured light scanners. For fine artists who are entering a digital world and don't want to model in another program, it is feasible that the artists could rough in a sculpture in traditional clay such as the mother and baby shown in our demonstration. The clay can be scanned, and then after some manipulation of the scan, it can be brought into Mudbox to add details and refinement. Combining both traditional and digital tools creates traditional and digital (tra-digi) art that is referred to in this chapter.

Laser scanning can be expensive. A list of resources for digital scanning will be included in the resource guide and website; however, digital scanners are becoming more readily available and affordable for the average user. For example, the NextEngine desktop scanner that is used to scan the mother and the baby for our demonstration is very affordable for the office or studio.

Objects of all sizes can be digitally scanned from jewelry to jets (**Figure 7.1**). It is important to pick the proper scanner or service bureau for your job. When working with scanning your own project with your own scanner or with scanning companies such as Direct Dimensions or Synappsys, here is some important information to remember.

Copyrights

It is important to understand copyrights and copyright infringement. As digital scanners and digital printing become more commonplace, individuals must be informed that they can't legally scan anything that they would like, using a 3D scanner. According to the copyright law of 1989, having a copyright notice (©) on your design or art is optional. The copyright symbol helps others to identify you as the copyright holder, but your work is copyrighted

FIG 7.1 Scans Can Be Created of Very Large or Very Small Objects. Nasa F-15b Jet Prototype Scan and Model Scanned with Direct Dimensions Spherical Laser Scanner. *Reproduced with Permission of Direct Dimensions.*

the moment it is created, even without a copyright symbol on it. The exception to this is when your work is work made for hire, when you are an employee of a company, or your work is special ordered. A copyright is viable until 70 years after the death of the creator. That is good news for artist, but it also means that the objects you may put in the scanner and copy could be copyrighted, and by reproducing them, you are infringing on someone else's copyrights.

The argument might be, what if I am going to change the 3D model made from a scan and use it only as a base or armature for a design? It will be necessary for you to change the object considerably so that you are not breaking the law. There is no magical number or percentage of change that must be done to the art. It is not in the "differences" that judges will look at in a courtroom; it is in the "similarities" of the work. If a judge can look at your work and state that it is "substantially similar" then you have infringed on someone's copyrights.

Right of ownership becomes increasingly unclear when it comes to original items and scans or models. You may own the artwork, but if someone else does a scan, do you own that scan as well? It is important to protect yourself when working with 3D scanning and 3D printing companies. If their paperwork does not state that you own the model, scan, and file, then you should ensure that your purchase order states that you retain all rights to the art, scan, model, and file. Also, ask for the policy of your service bureau as it pertains to file deletion, storage, and security. Do they delete all files once the job is complete? How do they protect the customer files that they have? Should their files get hacked, your work could be compromised, sent halfway around the world and digitally reproduced, without your consent or compensation. The files are as important as your original artwork, and the

compromising of the files could eventually affect the value of the artwork. Protect yourself and your copyrights, and be sure that the inspiration that is found in other people's artwork, when used to inspire your own creation, is not "substantially similar."

Resolution

Digital scanners can scan using many different resolutions. It is important to use only the resolution and scanning system that is necessary to obtain the information that you need in your workflow. If you are going to retopologize a rough maquette and then bring it into Mudbox, a high-resolution scan will not be necessary.

Multiple Scans and Undercuts

Undercuts are areas where an object has deep crevices that go under something or around an area. For example, an arm, as the hand is resting on the hip, creates an area that must go around and through. You need to be able to scan around and under the entire object. In some cases, this may be impossible. Appendages can be cut off in the clay maquette and scanned separately. For example, the hand and arm can be cut apart from the clay body. Then, the scans are aligned and spliced together in the scanning program. Digital scanning is rarely done with just one scan. Instead, multiple scans are taken from all directions and once again aligned and spliced together.

Size and Color

The size of the object does not matter. Depending on your scanning company, they can scan a jet or a piece of jewelry. The NextEngine digital scanner that we will be using in our demonstration has the ability to scan both micro and macro objects. But with patience, you could scan a larger object and splice together the pieces within a computer. When sending your work to a scanning service bureau, be sure to ask them what size object they prefer to scan. You may also want your scanned object to be the size that you are working on in the computer. Otherwise, you will have to enlarge or reduce your model within another program to bring it into Mudbox. Dark, shiny, or transparent objects are difficult to scan. Applying powder to shiny surfaces or paint to a transparent object will assist with obtaining a good scan. Some scanners not only scan the object itself, they can also retain the color information. When scanning, knowing your final output of the project will help you decide which scanner or scanning service will fit your needs.

File Formats

Scanners can produce files in different formats. To bring your work back into Mudbox, you will have to save it in an .OBJ file format.

Demonstration – Scanning the Mother and Baby

Scanning

An art nouveau, mom and baby, was roughed in with traditional clay and was scanned using the NextEngine digital scanner. The NextEngine scanner is a noncontact laser scanner. The scanning process consists of setting the object on the rotating scanning bed, and scanning the object from different angles to gather digital information from all angles and sides. All the individual scans are aligned and seamed together within the Rapidform software that comes with the scanner (Figure 7.2). Holes are sometimes created when the scanner misses information while scanning. Having a watertight image with no holes will be important when printing in 3D, but it is just as important to get a good mesh for the next step of sculpting in Mudbox. The Rapidform software can fix holes in the mesh or in the scan (Figure 7.3). Then, the scan can be exported from the scanner in the following formats, .OBJ, .PLY, .STL, .VRML, .U3D, and .SCN. The mother and baby scan is saved in the universal .OBJ file format. There is, however, one more thing that needs to be done to this file before it can be worked on in Mudbox. The topology created by most scanners is in points or triangles. It must be changed into a format that can be used with Mudbox. It must be retopologized.

FIG 7.2 Clay Mother and Baby Was Scanned Using a Laser Scanner, and Then the Scanned Pieces Were Seamed Together.

FIG 7.3 Scan Displays Point Cloud or Mesh Views. Holes In the Mesh Must Be Filled.

Retopologizing

The mesh that is created by scanning the sculpture is not a suitable mesh to work on in Mudbox. The scanned mesh created from scanning with the NextEngine scanner is made up of triangles and is very dense. A mesh used in Mudbox must be made up of four-sided faces or quads. When using a model that has geometry other than quads, it is difficult to sculpt, and topological artifacts or bumps can be created on the Mudbox model. Before working in Mudbox, the object must be retopologized. Retopologizing programs such as 3D Coat or Topogun allow you to change the mesh or topology. Another program worth mentioning is MeshLab, which is an open source software that is used to edit a triangular mesh before sending it to print. It can inspect and clean up a file that is being prepared for printing and can work on both Mac and Windows platforms. However, MeshLab is also adding a new Triangle-to-Quad conversion algorithm that will simplify the process of changing a mesh or scan that is triangles to a mesh of quads. This will come in handy when working with scanned objects to be used in Mudbox. Another addition to the MeshLab program will be an algorithm that improves the quality of the mesh with quad simplification.

These additions to MeshLab are a new addition and were not available at the writing of this book, and so the .OBJ file was imported into 3D Coat and the topology was changed using large quads. There is a slight learning curve in using the retopology tools, but incorporating a retopology tool with the scanned images can open up a world of creative possibilities. Good topology

FIG 7.4 The Scanned Mesh Made of Triangles Must Be Retopologized into a Simple Mesh of Quads.

will be important if you are sculpting, or if you are taking your model into an animation program, good topology is essential. Bad topology can cause problems down the road. Subdividing the mesh in the retopologizing program before importing it into Mudbox may provide a smoother model. For those who are new to 3D modeling and who desire to learn more of the basics such as subdivisions and subdivision artifact or topology, a good resource for basic free instruction on topology is "The Guerilla CG" project at www. Guerrillacg.org (Figure 7.4).

Using the Retopologized Model In Mudbox

There are several things to be careful of when uploading the scanned/retopologized model into Mudbox. First is the size. If you bring an object into Mudbox that is too small or too big, there can be problems. Tools react differently, depending on the size of the model. There are several ways to check the size of your object. The grid inside of Mudbox is made up of 50 cm squares. Also the brush radius is depicted in centimeters. That would mean if the brush size measures 50 cm, it would also have a radius of 50 cm in real-world space. The size of the brush can be seen in the Properties: Sculpt window. If you prefer to work in inches instead of centimeters, you can change the linear units of measurement from centimeters to inches in the user Interface menu, found in the Preferences (Figure 7.5). If you find that your model is too small or two big, you can either resize your model outside of Mudbox before importing it in, or scale the model in Mudbox by using the Scale tool in the Select/ Move Tools tray.

The Mudbox tools are great for sculpting on the imported retopologized model. By using the grab tool on a large size and strength, it is much easier to change the shape and flow of the mother and baby sculpture in Mudbox

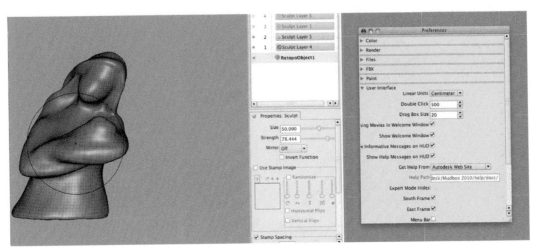

FIG 7.5 The Size of the Brush Can Help Determine Physical Size of Model. The Linear Units Can Be Changed In the Preferences.

than it would be with traditional clay. It is easy to experiment, making her taller and skinnier, tilting the head, or making other modifications. If these types of modification were done in traditional clay and traditional sculpting, you would have to resculpt the mom and baby each time. This basic model, once scanned and retopologized, can also be used as the armature for a more detailed creation in Mudbox. Working in real clay, creating shape and gesture, scanning and retopologizing to make a digital model to add detail, may be a good workflow for the traditional artist entering the digital world and creating tra-digi art.

In the final version of the mother and baby shown in this demonstration, several experiments were conducted for shape and form before creating minor revisions and smoothing in preparation for digital printing. Let's take a closer look at the different aspects of digital printing and milling before sending the mother and baby through the process.

Digital Printing and Milling

The technology for output is growing rapidly, and with this growth comes new ways of creating your work into a physical form. These processes were originally created for manufacturing and were very expensive; however, the costs of 3D printers are becoming more affordable and now outsourcing from service bureaus such as Shapeways, Wicked Resin, and others are available. And for those hobbyist who want to have their own 3D printer, there are several open source 3D printers available such as Fab@Home, MakerBot,

RepRap, and DIY. As creative individuals push the boundaries of the technology and try to make the technology fit their creative needs, and as they share their own processes and the advancements, the technology and its uses will grow.

As people experiment with the technology, a growing number of mediums of output are now available. In additive manufacturing, it is possible to create your artwork in a variety of plastics, acrylics, resin, wax, glass, ceramic, chocolate, sugar, sand, paper, even metal including gold. And subtractive manufacturing can be milled out in wood, stone, foam, metal, and other substances. Each material and each process, of course, has its own limitations and tolerances.

When trying to get your artwork from the computer to the physical desktop, there are many different options available for output. These can be divided into two categories, additive and subtractive. Additive fabrication technology is known by many different names – 3D printing, rapid prototyping, solid freeform fabrication, layered manufacturing, and so on. It can be quite confusing. The industry has not settled on a single name as of the printing of this book, but committees are trying to agree on one encompassing definition. Within additive manufacturing, there are several processes to choose from. Some that will be covered in this chapter are fused deposition modeling (FDM), inkjet and multijet modeling, selective laser sintering (SLS), and stereolithography (SL or SLA). The subtractive manufacturing technologies that we will look at consist of milling on computer numerical controlled (CNC) milling machines. At first, it can be a bit confusing to understand the nuances of each process, but understanding the details of each of these forms of output will help to determine the best output for your art. In addition to the information in this chapter, be sure to review the website, www.digitalsculpting.net, where we will include videos of some of the processes and a list of service providers.

Additive Manufacturing

Fused Deposition Modeling

In FDM a machine digitally prints small layers of plastic by extruding plastic filament through a heated nozzle. Each layer is bonded to the other and hardens. Think of a glue gun, but on a smaller scale. The nozzle is moved over the object as it deposits the material (Figure 7.6).

For fragile overhanging parts in a design, support structures are created that are removed later. Your service bureau may add these structures for you in the prefab process. Some support structures are water soluble, and removing support structures is simply a matter of washing them away. Others are created with a break away material.

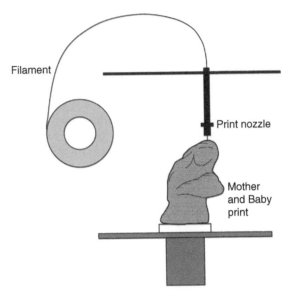

FIG 7.6 Fused Deposition Modeling Deposits Layers of Filament.

FIG 7.7 "Indian" Created in Mudbox by Steven Guevara and Printed Out on an InVision Multijet™ Printer at Wicked Resin. The Thinner Filament on the Left Side of the Printed Sculpture Was Printed as a Seam for Making a Mold.

Inkjet or MultiJet Modeling

Inkjet is very similar to FDM, but, instead, the material is in a liquid state before being deposited on the build platform. It solidifies as it cools. A second softer support material may also be dispensed from another print head. MultiJet is similar to Inkjet; however, there are multiple nozzles that distribute the material (Figure 7.7).

Selective Laser Sintering

In selective laser sintering (SLS), a laser passes over a bed of deposited powder. This powder can be plastic, metal, glass, or even ceramic. The laser fuses the powdered material together. The build bed is lowered and another layer of powder is added on top. The process continues through the building of the product. Once it is complete, the powder is brushed or blown off the object. Some applications may need a further process of baking or curing. The advantage of SLS is that support structures do not need to be incorporated in the design because the powder that creates the object during printings supports the object and overhangs (Figure 7.8).

Stereolithography

In SL or SLA, your design is again divided up into layers. A laser beam passes over a photocurable liquid resin. The build table is lowered to the thickness of each layer, allowing more resin to accumulate over the top of the object, where a laser once again cures the resin. Support structures for overhangs may need to be built into the design. Once your product is printed, it is raised up on the build bed out of the liquid (Figure 7.9).

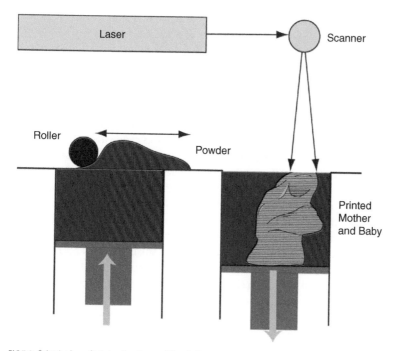

FIG 7.8 Selective Laser Sintering Uses Layers of Powder Fused by a Laser.

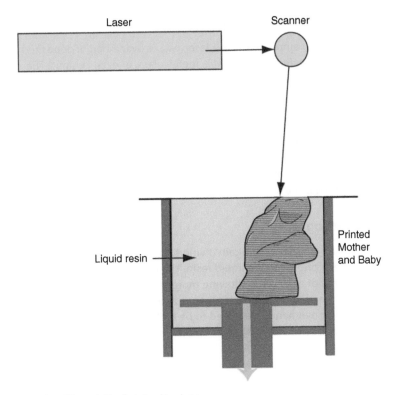

FIG 7.9 Stereolithography Uses Resin Fused by a Laser.

Subtractive Manufacturing

CNC Milling

The material to be milled, whether metal, stone, wood, or foam is stationary, and a cutting tool that rotates on one or more axes carves away the unwanted material. Depending on the amount of detail required, several passes may be needed with several different size bits, each removing layers of material. CNC milling machines are classified by the number of axes that they can move. Some CNC machines can have as many as six axes. The additional axes come into play with moving the object, as well as cutting the object using the cutting tool. Traditional artists have been incorporating CNC milling in foam for enlargements of the maquettes. A maquette or small version of a sculpture is created, scanned, and then enlarged and milled out in foam. Foam is easy to use and can be covered in clay to add fine details. This new process in technology replaces both the pointing up system of enlargements that traditional sculptors have used for years and the tedious process of welding large armatures (Figure 7.10).

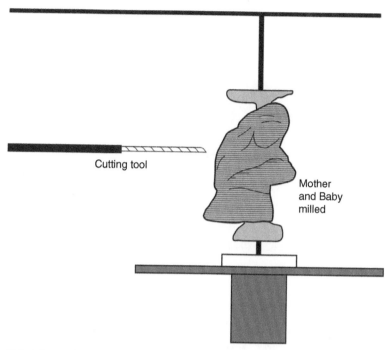

Cutting tool

Mother
and Baby
milled

FIG 7.10 Computer Numerical Controlled Printing Is a Subtractive Process Involving Milling of Different Substances.

Many Processes Expand the Creative Possibilities

New processes as well as combined processes (additive and subtractive) are being created and used daily. Although some of the following are created in other programs, let's take a look at the creative output. For example, Synappsys Digital Service designed a process called Data Direct to Mold or Digital Direct to Mold (DDTM) that will be used in place of the lost wax method of bronze casting to create the monumental sculpture called *The American* by Shan Gray. In the DDTM process, the monumental sculpture is divided up into many 4-foot sections. Instead of milling a positive, a negative two-piece mold is milled out of resin-bonded sand. Bronze will be poured into these mold sections and welded together. Then the 3,600 panels needed to create this work of art will be welded together to create the final sculpture (Figure 7.11).

Another creative example of CNC milling is milling your digital file into stone. The Digital Stone Project, formerly the Johnson Atelier, works with artists to realize their creation in such mediums as marble, onyx, granite, and aggregate (Figure 7.12).

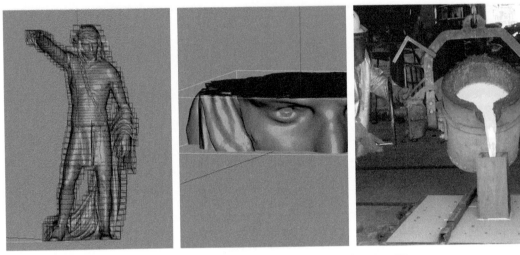

FIG 7.11 Data Direct to Mold Uses Milling to Carve a Two-Piece Mold In Sand/Resin for Bronze Casting from a Digital File.

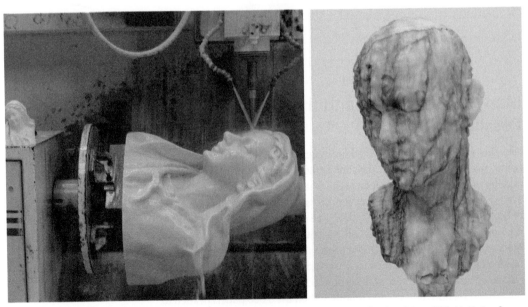

FIG 7.12 Rob Neilson's "Monument to St. Elizabeth of Hungary" Milled In Marble and Barry X Ball's "Jeanne Greenberg Rohatyn" Milled In Mexican Onyx by The Digital Stone Project.

Creating digitally printed work does not have to be limited to printing in wax or plastic. ExOne can reproduce your 3D model by printing in metal **(Figure 7.13)**.

Some 3D printing machines can even print in ceramic or a ceramic substitute **(Figure 7.14)**.

FIG 7.13 Gil Bruvel's Chess Pieces Are Printed Using ExOne's Metal Printing Process.

FIG 7.14 Paul R. Effinger Printed "Artifice" with a ZCrop 510 In a Ceramic Powder That Was Dipped In a Resin Binder – Infiltrate.

These are just a few samples of some of the new technology and its relation to digital art. The creative applications of these new technologies are endless. Understanding the process and knowing how to prepare your artwork for the journey from virtual to real world is the beginning of this new adventure.

Preparing Your Mudbox Model for Output

It can be difficult to think about your virtual art in a physical form. Unlike the virtual world that your sculpture was created in, in the real world your art that is printed in 3D is subject to physical forces. It must be designed so that it can function in the real world. The first step in preparing your creation for 3D printing is to visualize it and revise it with the real world and natural forces in mind.

Creating a piece for digital printing or milling means preparing the model and file. Some service bureaus will assist you in preparing the file; others expect it to be complete upon the receipt of your printable file. There is a plug-in for Mudbox that is being created to assist with preparation and output of files for 3D printing. It is important to know this process and to also know the expectations of your service bureau. There may be additional costs acquired when using their services to prepare your files, and time is money, so the more you can prepare your file in advance, the less expensive it will be. However, there is something to be said about paying for the service bureau to prepare or look over your files because you may not know if there are problems with your printing until you have printed, paid for, and received your piece, and without being sure of the output, you may end up paying for your errors. Your service bureau can review the design to tell you how you can avoid problems, such as parts that are too thin to print or how to modify parts that are supporting other parts. As you continue with your service bureau and become familiar with the process and the expectations for proper files, as well as the tolerances within the specific additive or subtractive manufacturing process, you will be more confident in the process and your creations. It is essential to have communication with your 3D printing company before printing your art, as it will assure a better printing and can save your money in the process.

It is also important to plan your design of your Mudbox creation and its file with 3D printing or milling in mind. There are several errors that can be made in creating a file that is intended for printing. Your service bureau will detect these, but you can also take your file through a simple check with the open source MeshLab software to help find and fix any problems with your files.

Here are some of the warnings and preparation suggestions for both design and file preparation.

Save Your Work

As you create your file in Mudbox, be sure to save your files at increments. Saving incremental files have been expressed repeatedly in this book; however, in creating a model for printing, you may find that you have to modify

something for printing that can only be done in an earlier incremental file. Saving incremental files affords you the opportunity to correct errors without having to recreate the model.

Appropriate Detail for Output and Size

It is easy to become so involved with your computer model that you continue to work it over and beyond the capabilities of what can be seen, when printed or milled. Some detail could even be lost because of the resolution of the output process or the postprinting processes of cleaning.

Remember How Your Final Creation Will Be Viewed

Many traditional sculptors know that you need to adjust your artwork for how it will be viewed or displayed. If a computer model is to be milled into a monumental stone sculpture or through other processes where it will be larger than life or stand on top of a tall pedestal, you will need to pay close attention to creating it with the viewer and their vantage point in mind. Some distortions may be necessary for a sculpture to look right from where it is viewed. It may also be important to modify models intended for creation as miniatures or jewelry. As you are creating your model, you are used to being able to navigate your camera to look from all different angles. While creating the model, continually view it from the angle and size that your viewer will see it. Use their vantage point. This will help you to make necessary adjustments to the design. When creating the design, you should have the final output in mind, as well as the viewer who will be observing the completed work.

Stability In the Real World

If you want your artwork to stand on its own in the physical world, it is important that you plan this in your design. Is there enough mass in the appropriate places to hold your object upright? In Mudbox's virtual world it can stand, but can it stand in real gravity? Is the mass within the design distributed properly? In the example of a bird, if it has a large hindquarter, it will not be able to balance, once printed. In some designs, it might be better to incorporate a flat base that distributes the weight and helps the model to stand.

Modifications

It takes some trial and error to learn the different modifications that you can make to a design to facilitate a good print. One modification is avoiding knife edges. For example, the rim of a cowboy hat is very thin; however, it can be designed so that only the edge is seen as thin, and instead, the brim starts thicker and tapers off at the edge. This modification of thickness assists in the stability of the object, but the eye will read the brim as thin. Check with your service bureau to find the minimum tolerances for your material and process of printing, and look for modifications that can be made in your design to ensure a good print.

Thickness

Objects must have thickness. Paper-thin parts will not print properly. Some service bureaus recommend a thickness that is no smaller than 2–3 mm thick. Minimum thickness will depend on the 3D printer and the type of material you are printing; however, the larger your final printed piece is going to be, the thicker the walls should be, so that the object can support its own weight. You can make wall thickness outside of Mudbox in programs such as 3ds Max, Blender, 3D Coat, and so on. It is possible to create an offset shell, although you will have to reverse the normals to make them face in the correct direction and to connect the two shells. This is a time-consuming process. And, of course, SL or SLA, SLS, and FDM-additive manufacturing all have their own limitations, so your design modifications may be dependant on your output process. Subtractive manufacturing such as milling does not require thickness in files but instead requires a solid surface structure. Other areas to be aware of concerning thickness are those that support large volumes – for example, the legs of a bird supporting the weight of the body. Thickening the legs to support the bird would look unnatural, but putting reeds or other material of mass next to the legs will give support to the physical object.

A Way to Remove Powder or Support Material

In some additive manufacturing processes, creating thickness and making an object hollow is important because you don't have to have excess waste material trapped in the internal cavity. Less material equals less cost. But if you are printing in additive manufacturing – SLS or SLA – and have created it hollow and enclosed, you will need a way to get the excess material out of the enclosure. This will need to be incorporated in your design. If your service provider is creating this escape area, be sure that it does not interfere with a signature or copyright notice that may be included in your design (Figure 7.15).

Expansion, Contraction, Warping, and Breaking

Once again, depending on the process and the final material expansion, contraction, warping, and breaking are all factors. Your service bureau can assist you in deciding if this will be a problem with your design and the final material that you have chosen. Contraction should be a big concern if you are creating pieces that are to fit one into another.

Watertight

Before a mesh can be printed, it must be watertight or without holes, just as the mother and baby had to be watertight to bring it into Mudbox. Before sending your file to be printed, first check to ensure that you have a water-tight mesh and fix any holes created by missing polygons.

FIG 7.15 Creating a Way for Excess Material to Escape Will Lower Your Cost, But You Must Be Sure That It Does Not Interfere with the Design.

Avoid Files with Transparent Surfaces

Be sure that your object is not transparent and that it contains 100% opacity, otherwise the printer may not know how to print the faces.

Extrude Planes

Flat surfaces or planes will not print without thickness, or even if they print, they will break when the object is being handled. Extrude a surface with a minimum thickness (**Figure 7.16**).

Remove Unnecessary Geometry

Having additional, unnecessary geometry on your mesh will take more time for the printer to print your object. Often geometry in some areas can be simplified to aid in printing.

No Reversed Normals

You must check for reversed normals. A *normal* is a vector perpendicular to the surface of a polygon. With 3D printing, a reversed normal means that the normal is pointed inside the model. Nothing will print in the area of a reversed normal.

FIG 7.16 A Plane Needs Thickness to Print. Check with Your Service Provider to Know Minimal Thickness Allowances.

Polygon Count Check

Depending on which service bureau you use, they may have requirements for a maximum polygon count. They may suggest you to reduce your polygon count, depending on the type of manufacturing you are doing, as well as the resolution of their equipment.

Nonmanifold Errors

It is important to check your object for nonmanifold errors. Nonmanifold errors can refer to your object not being watertight, but your model may also have additional faces or edges that may go undetected. Also look for overlapping vertices.

Merge Overlapping Meshes

Some 3D printing companies will ask you to merge overlapping meshes. Fuse them together using Boolean operation in another 3D program and be sure to check the meshes before uploading files. For example, if you have a sphere for eyeballs inside a head, these must be merged together.

Physical Size

The build envelope is the size that the digital printing machine can print. The technology is advancing, and the build envelope size is growing. It is possible to create objects larger than the build envelope if they are seamed together or printed in pieces. Maximum build envelope size on the ExOne's printing in metal for the mother and baby is 39" × 18" × 8.5", whereas some SL or SLA machines such as those by Materialise (http://www.materialise.com) have a

larger build envelope around 82" × 27" × 31". The average 3D printer build envelope seems to be in the neighborhood of 12" × 12" × 12". Because subtractive manufacturing or milling is often done in pieces, a build box is not an issue.

Material

There are a wide variety of materials with each process of 3D printing, both additive and subtractive manufacturing. Each has its own characteristics. Just as in traditional sculpture, the material that the sculpture is going to be printed in and the type of 3D printing process chosen can also determine the design. Digitally printing in metal is, of course, stronger than something printed in a softer plastic. More information about the different digital materials is listed on the website at www.digitalsculpting.net.

Stair Stepping and Fluting

With additive manufacturing, mass is added in layers. Each process may leave a stair-stepping effect created by this additive layer process. Layers that are farther apart (0.10") will have heavier stepping than layers that are closer together (0.004"). Fluting happens in subtractive manufacturing, and those are the areas that the milling bit grooves out. Stair stepping and fluting can often be minimized by postprinting processes that include smoothing the object, although if you have a texture on your digital model, it may have been compromised by the printing and further compromised by smoothing. Finding the perfect process for your final creation may take some experimentation. However, remember that you can also take advantage of the boundaries of the technology. For example, encourage your service bureau to put the model into the build box, so that the stair stepping or grain look becomes a part of the creation. The same can be done when milling. Consider using the texture of the fluting as part of your design (Figure 7.17).

Faceting and File Size

Your final file type for output is .STL. The .STL files are triangles. Faceting happens when you have flat spots on curved surfaces. This usually happens because the resolution is too low; however, the finer the .STL file, the larger the file will be in size. This will then mean more on computer and output time, making your object more costly. The key is to reduce faceting with a lower resolution without sacrificing the quality of design.

Uploading File and File Types

Most service bureaus have a File Transfer Protocol site, where your files can be uploaded. Some can accept .OBJ files but most want .STL files. To export your file in Mudbox into an .OBJ file, in the Select Moves Tools tray, select the object. In the File menu, select Export Selection. Your options of saving

FIG 7.17 The Stair Stepping Effect Became Part of the Design of the Printing of the Skull Created by ExOne.

your Mudbox file are .MUD, .OBJ, and .FBX. Mesh Lab or 3D Coat, as well as other 3D programs, can change your .OBJ file into a .STL file. It is possible that Mudbox will offer this as part of the plug-in that is being developed. If you want your object printed in color then a .VRML (the file extension is .WRL) will be necessary.

Pricing

The price of a piece, whether created as additive manufacturing or subtractive manufacturing is based on the material used and the time it takes to render the piece. Additional charges may be incurred if work needs to be done on the file to prepare it for printing. A way to cut down on cost is to create hollow objects, when the design allows, and doing everything that you can to properly prepare your own files.

Mother and Baby Printed

With the use of 3D scanning of a traditional roughed in clay maquette and preparation of that file from triangle into quads, the mother and baby model could be worked on in Mudbox. With proper knowledge of the different resources for output and proper preparation of the file for 3D printing, a digital model could be realized in the real world. There are many different options

FIG 7.18 The Mother and Baby Was Printed as Jewelry and as a Bronze Figurine by ExOne, and Printed In Acrylic Polymer Plastic by Wicked Resin.

for milling and printing of this model. For this demonstration, the mother and baby model was reduced down and printed out for jewelry by ExOne and also printed in metal as a smaller metal figurine. Wicked Resin printed the mother and baby in an acrylic polymer plastic. A combination of traditional sculpture and digital technology of 3D scanning, Mudbox, and 3D printing or tra-digi art is used to transform art into a physical form.

Summary

Digital scanning offers another way to bring models into Mudbox for sculpting, and there is a wide variety of materials and processes available to the artist that would like to create art in a physical form. Resources for scanning, printing, or milling are advancing and changing rapidly. More information and advances, as well as further definitions, will be available at the website. This chapter is only a primer to sample the possibilities and hopefully to inspire readers to create differently and push the boundaries of the technology and their own creativity.

Appendix A: Gallery

We would like to thank the artists who generously contributed their artwork to these galleries.

Mudbox Gallery

© Brad Meyers. www.bradm3d.com. All Rights Reserved

© Brad Meyers. www.bradm3d.com. All Rights Reserved

Digital Sculpting with Mudbox. DOI: 10.1016/B978-0-240-81203-8.00012-X
Copyright © 2010 Taylor & Francis. All rights of reproduction in any form reserved.

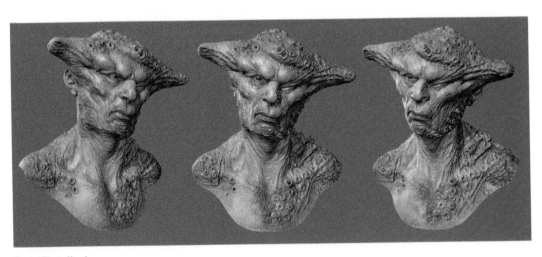

Cursed Pirate Head.

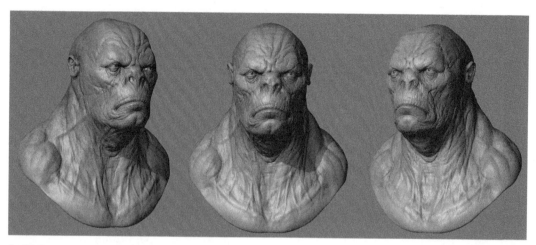

Orc Head.
© Howard Swindell. www.howardswindell.com. All Rights Reserved

Forest Elf.
© Howard Swindell. www.howardswindell.com. All Rights Reserved

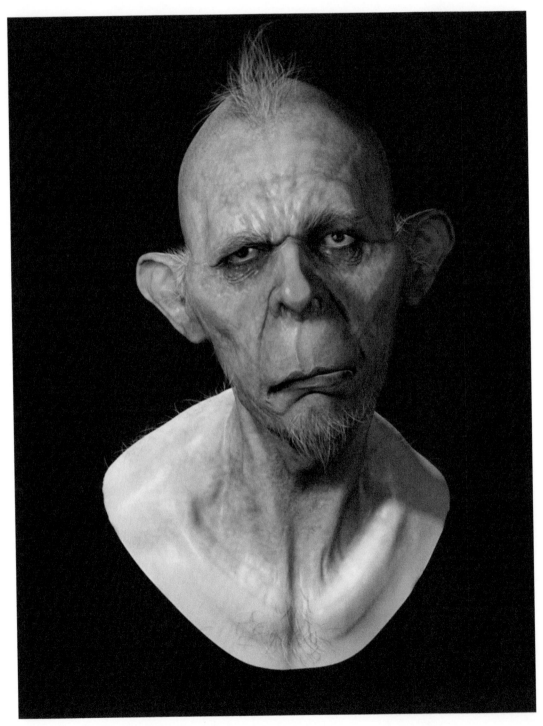

Dumb.

© *Howard Swindell. www.howardswindell.com. All Rights Reserved*

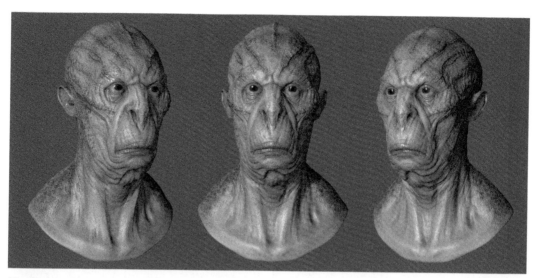

Alien Head.

Aged Waiting.

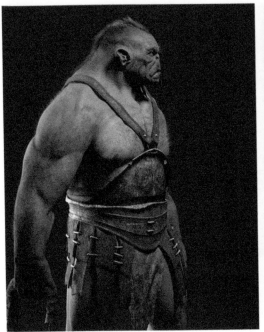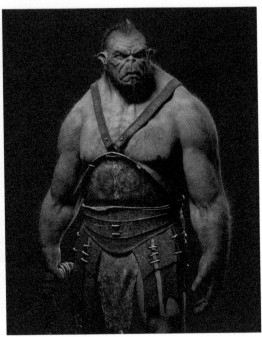

Orc.

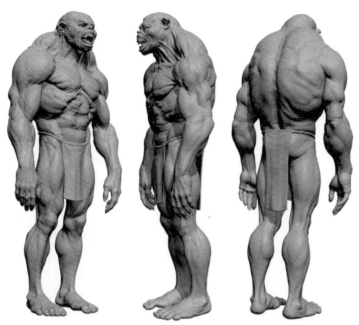

Freak.
© Mashru Mishu. www.fx81.com. All Rights Reserved

Jellyfish Girl.
© Pascal Raimbault. www.cgfeedback.com. All Rights Reserved

Amazon and Beast.

Amazon.

Print Gallery

The artwork in this gallery was created using a variety of three-dimensional (3D) scanning, printing, and milling technologies and various applications, including Mudbox. This gallery is included to show what can be produced by combining applications like Mudbox with current 3D scanning, printing, and milling technologies.

George's Horse.
© Gil Bruvel. www.bruvel.com. All Rights Reserved

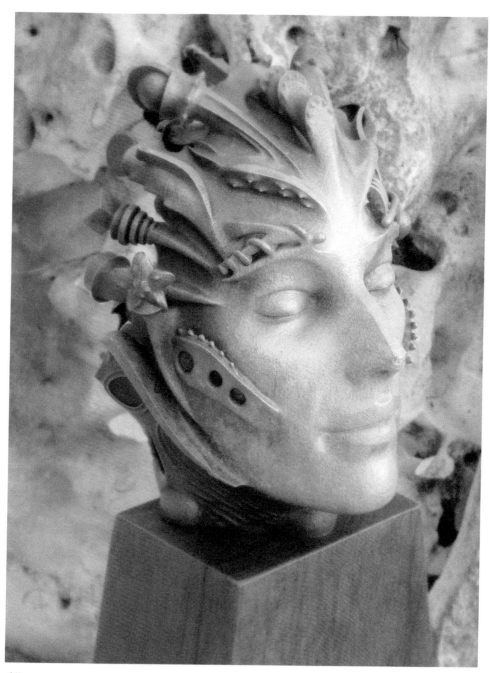

Mask of Sleep.
© Gil Bruvel. www.bruvel.com. All Rights Reserved

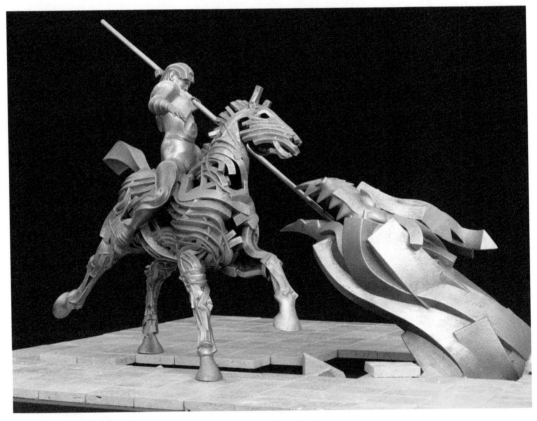

St. George and the Dragon.

© Gil Bruvel. www.bruvel.com. All Rights Reserved

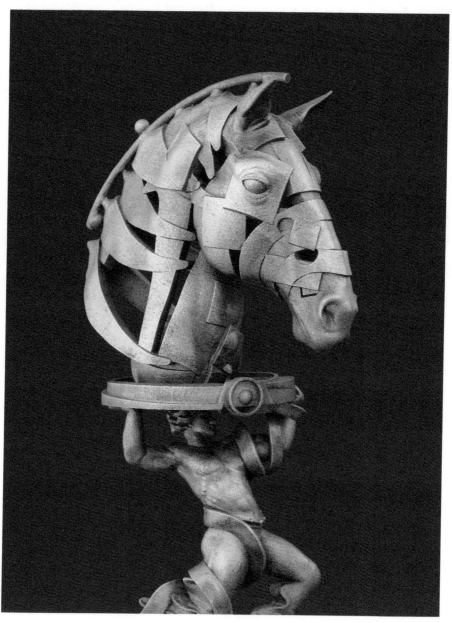

The Builder.
© Gil Bruvel. www.bruvel.com. All Rights Reserved

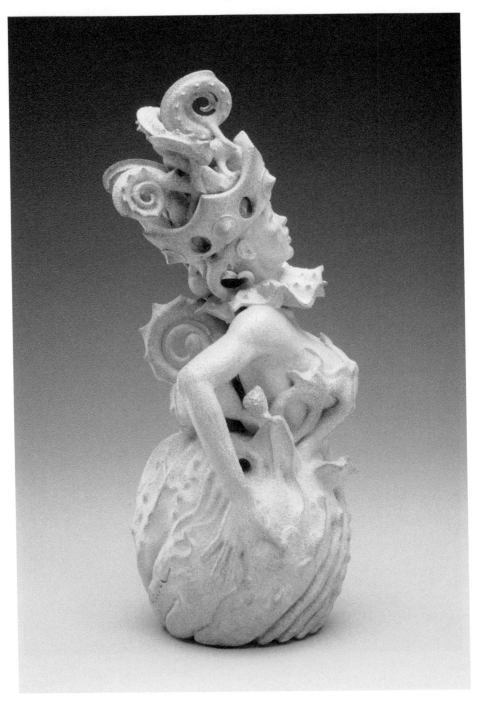

White Queen.
© Gil Bruvel. www.bruvel.com. All Rights Reserved

Dirty Laundry – Milled In Marble.

Dirty Laundry – Clothes to Be Scanned.

Dirty Laundry – Scan of Dirty Laundry.

Dirty Laundry – Milling Dirty Laundry.

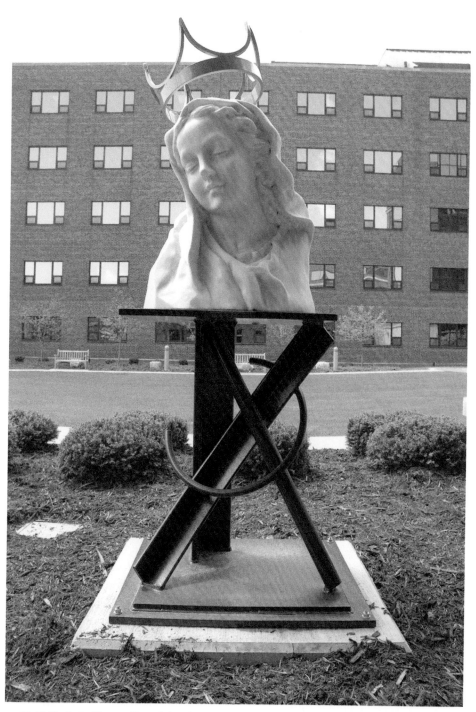

"Monument to St. Elizabeth of Hungary" Commissioned for St. Elizabeth's Hospital, Appleton WI, Milled In Marble.

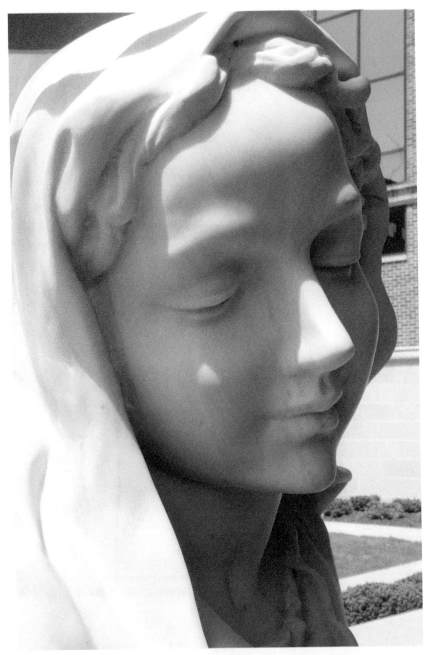

"Monument to St. Elizabeth of Hungary" Commissioned for St. Elizabeth's Hospital, Appleton WI, Milled In Marble.

"About Place, About Face" Commissioned for the Los Angeles Metro Transit Authority. Scanned Portraits, Cast In Cast Iron.

"Jeanne Greenberg Rohatyn" Milled In Mexican Onyx.

"Laura Mattioli" Milled Belgian Black Marble.

"Amaranthe" Polyurethane Skin over Computer Numeric Controlled Foam.

© Robert Michael Smith. http://iris.nyit.edu/~rsmith. All Rights Reserved

"GoldenGeminiGyneRapture" Rapid Prototype Printed Gold-Leaf Painted.

© Robert Michael Smith. http://iris.nyit.edu/~rsmith. All Rights Reserved

"Gynefleuroceraptor" Milled In Marble.

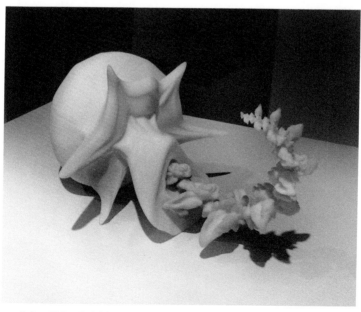

"Virtuaclabiabyte Tongue Twister" Printed with Dimension Printer by Stratasys.

Appendix B: 3D Resources

3D Printing

Shapeways

www.shapeways.com

Shapeways is a company in The Netherlands that offers affordable three-dimensional (3D) printing, including printing in color.

Wicked Resin*

www.wickedresin.com

Wicked Resin prints in photopolymer acrylic plastic using 3D Systems InVision si2 printers.

ProMetal Ex One*

www.exone.com/eng/technology/x1-prometal/index.html

ProMetal Ex One offers 3D printing in various metals.

ProMetal Ex One RCT*

www.exone.com/eng/technology/x1-prometal-rct/index.html

ProMetal Ex One RCT digitally prints sand casts, and it can also create sand cast molds.

Thinglab

www.thinglab.co.uk

Thinglab uses ZCorp 450 printer (www.zcorp.com) to print in color, and it also uses 3D Systems HD 300 for printing high-quality plastic models.

3D Systems

www.3dsystems.com

3D Systems is a leading manufacturer of 3D printing systems.

* Highly recommended-Used by authors

Materialise

www.materialise.com/MGX

Materialise offers high-end 3D printing for designers.

3D Milling

Synappsys Digital Services*

www.synappsys.com

Synappsys provides several services including digital scanning, 3D milling of foam, Direct Data to Mold, and 3D printing with a thermo-jet printer in wax.

Blue Genie*

www.bluegenieart.com

Blue Genie provides digital scanning and 3D milling in foam.

Digital Stone Project*

www.digitalstoneproject.org

The Digital Stone Project is a high-tech stone sculpture fabrication studio.

3D Scanning

Direct Dimensions*

www.dirdim.com

Direct Dimensions is a full-service scanning, digitizing, modeling, 3D printing company.

Desktop 3D Scanners and Printers

NextEngine Scanner*

www.nextengine.com

NextEngine Scanner is an affordable desktop scanner for the studio.

Desktop Factory Printer

www.desktopfactory.com

Desktop Factory Printer is an affordable desktop printer for the studio.

* Highly recommended-Used by authors

Create Your Own 3D Printer or CNC Milling Machine

The following are open source rapid prototyping machines that you can buy as kits for 3D printing or milling.

Printing

RepRap

www.reprap.org

RepRap is an open source rapid prototyping machine that "prints itself." It was invented by Adrian Bowyer of the University of Bath in the United Kingdom. The RepRap prints in thermoplastic polymers. Bowyer is focusing on biodegradable printing products that will work with the RepRap. Recent additions to the open source provide extruders for printing in silicone and also ceramic mixtures.

MakerBot

www.makerbot.com

The MakerBot is another open source 3D printer similar to the RepRap project. MakerBot is the creator of the do it yourself kit known as The Cupcake.

Fab@Home

http://fabathome.org/wiki/index.php?title=Main_Page

Fab@Home is another open source system offering free hardware and software designs to create your own 3d printer.

CandyFab4000

www.evilmadscientist.com/article.php/candyfab

CandyFab4000 is a 3D printer that prints in sugar. It uses selective hot air sintering and melting (SHASAM).

Milling

BuildyourCNC

www.buildyourcnc.com

Commercial Software

The following is a brief list of commercial applications that may be used in conjunction with Mudbox for modeling, UV mapping, rendering, and other tasks.

3ds Max*

www.autodesk.com

3ds Max is a professional modeling, animation, special effects, and rendering application.

Maya*

www.autodesk.com

Maya is a high-end modeling, animation, special effects, and rendering application.

Cinema 4D*

www.maxon.net

Cinema 4D is a complete modeling, animation, special effects, and rendering application.

Modo*

www.luxology.com

modo is an advanced subdivision surfaces modeling, UV mapping, sculpting, 3D painting, and rendering application.

Photoshop*

www.adobe.com

The standard in image-editing software. Mudbox is designed to work closely with Photoshop.

3D Coat*

www.3d-coat.com

3D coat is a voxel sculpting, UV mapping, retopologizing, and texture painting software.

Topogun

www.topogun.com

Topgun is a retopologizing and baking software.

* Highly recommended-Used by authors

Open Source Software

The following is a brief list of no cost open source applications that may be used in conjunction with Mudbox for modeling, UV mapping, rendering, and other tasks.

MeshLab

www.meshlab.sourceforge.net

MeshLab is an open source software for editing, cleaning, healing and inspecting meshes before printing.

Blender

www.blender.org

Blender is an open source modeling, animation, special effects, and rendering application.

Wings3D

www.wings3D.com

Wings3D is an open source application for subdivision surfaces modeling.

Gimp

www.gimp.org

Gimp is an open source image-editing application.

Appendix C: Online Resources

Mudbox Forums

The Area

http://area.autodesk.com/forum/autodesk-mudbox

The Area is an Autodesk official Mudbox forum.

CGSOCIETY

http://forums.cgsociety.org/forumdisplay.php?f=221

CGSOCIETY is a busy Mudbox forum.

The Guerrilla CG Project

The Guerrilla CG project is a volunteer organization of CG (Computer Graphics) professionals, whose goal is to produce free tutorials to assist others in understanding the fundamentals of computer graphics. If you would like to get involved, then visit www.guerrillacg.org

Free videos to date include the following:

3D General

- Hierarchy Basics – Andrew Silke

3D Polygonal Modeling

- The Polygon – Andrew Silke
- Multi Sided and Intersection Polygons – Andrew Silke
- Smooth Shading – Andrew Silke
- Smooth Shading Examples – Andrew Silke
- Objects – Andrew Silke
- Subdivision surfaces: Overview – Glen Moyes
- Subdivision Surface Topology: Artifacts – Greg Petchkovsky

3D Rigging

- Hierarchy Basics
- Hierarchies: Building a Robot – Andrew Silke
- The Rotation Problem – Andrew Silke
- Euler Rotations Explained – Andrew Silke

Digital Sculpting with Mudbox. DOI: 10.1016/B978-0-240-81203-8.00010-6
Copyright © 2010 Taylor & Francis. All rights of reproduction in any form reserved.

3D Texturing

- Displacement and Bump: Overview – Paul McGrade

Free 3D Tutorials

Find more free tutorials at www.free3dtutorials.com

3D Printing and Scanning

Worldwide Guide to Rapid Prototyping

www.additive3d.com

Worldwide Guide to Rapid Prototyping is a comprehensive guide to all things dealing with rapid prototyping.

Wohlers Associates and Wohlers Report

www.wohlersassociates.com

Wohlers report shares regular updates to news that is happening in the world of rapid prototyping.

Emotion In Art

Dr Paul Ekman

www.paulekman.com

Paul Ekman is the psychologist who developed the Facial Action Coding System.

A Human Face

www.face-and-emotion.com/dataface/general/

A Human Face is a Facial Action Coding System resource.

Ed Ulbrich: How Benjamin Button Got His Face

www.ted.com/talks/ed_ulbrich_shows_how_benjamin_button_got_his_face .html

It is a lecture on how the Facial Action Coding System was used in the creation of Benjamin Button.

Appendix D: Traditional Sculpting Tools and Resources

Ceramic Store Inc

www.ceramicstoreinc.com

Ceramic Store sells clay, sculpting tools, and armatures.

Reynolds Advanced Materials

www.reynoldsam.com

Reynolds Advanced Materials sells mold-making materials, life-casting materials, and other supplies.

Smooth-On

www.smooth-on.com

Smooth-On sells mold-making materials, life-casting materials, and other supplies. They also offer seminars and free video tutorials.

Fine Arts Foundry of Texas, Inc

www.fineartsfoundrytexas.com

Fine Arts Foundry of Texas casts traditional bronzes using the lost wax method.

American Stonecast

www.americanstonecast.com/services

American Stonecast is a facility that makes molds and casts in simulated stone.

Anatomical Figures

www.anatomicalfigures.com

Anatomical Figures provides several different figures depicting human anatomy that can be used by artists and students.

Digital Sculpting with Mudbox. DOI: 10.1016/B978-0-240-81203-8.00011-8
Copyright © 2010 Taylor & Francis. All rights of reproduction in any form reserved.

Skulls Unlimited

www.skullsunlimited.com

Skulls Unlimited is a supplier of cast reproductions of many different types of skeletal parts.

Appendix E: Books

Drawing

Loomis, A. **Drawing the Head and Hands**. City: Viking Pr, 1956.

Pérard, B. **Anatomy and Drawing**. New York: Bonanza Books, 1989.

Rubins, David. **The Human Figure**. New York: Penguin Books, 1977.

Sculpture

Faraut, Philippe and Charisse Faraut. **Portrait Sculpting**. Honeoye: PCF Studios, 2004.

Langland, Tuck. **From Clay to Bronze**. New York: Watson-Guptill Publications, 1999.

Lanteri, Edouard. **Modelling and Sculpting Animals**. Mineola: Dover, 1985.

*Lanteri, Edouard. **Modelling and Sculpting the Human Figure**. Mineola: Dover, 1985.

*Lucchesi, Bruno and Margit Malmstrom. **Modeling the Figure in Clay**. New York: Watson-Guptill Publications, 1980.

Lucchesi, Bruno and Margit Malmstrom. **Terracotta**. New York: Watson-Guptill Publications, 1996.

Anatomy

Marsh, Reginald. **Anatomy for Artists**. New York: Dover Publications, 1970.

Richter, Jean and R. Bell. **The Notebooks of Leonardo Da Vinci**. New York: Dover Publications, 1970.

Taylor, Karen. **Forensic Art and Illustration**. Boca Raton: CRC Press, 2001.

*Thompson, Ernest and Ernest Seton. **Anatomy of Animals**. Avenel: Crescent books, 1990.

3D Printing

Grenda, Ed. **Printing The Future**. 3rd. Castle Island Co., 2009. Print.

*Highly recommended.

Digital Sculpting with Mudbox. DOI: 10.1016/B978-0-240-81203-8.00012-X
Copyright © 2010 Taylor & Francis. All rights of reproduction in any form reserved.

Appendix F: Figure List

Chapter 1

1.1
When working with Mudbox, the program's interface provides all the space and tools required for sculpting.

1.2
Traditional sculpting tools come in a variety of sizes and shapes.

1.3
Mudbox sculpting tools produce the same or similar sculpting effects as real sculpting tools.

1.4
Sculpting a natural sculpture begins with the understanding of anatomy.

1.5
When possible, it is advisable to take accurate measurements of your subject to assure correct proportions.

1.6
The interplay of light and shadows on the surface of a sculpture dictates its perceived form. Life-size clay sculpture by Bridgette Mongeon.

1.7
Negative space is useful in preventing problems with proportions and form.

1.8
Establishing gesture early in the process ensures an appealing sculpture that has motion and balance. In this photograph, you can see the lines that establish its gesture. Life-size bronze sculpture by Bridgette Mongeon.

Chapter 2

2.1
Mudbox has a standard, intuitive interface and straightforward sculpting and painting workflows.

2.2
Mudbox features a comprehensive set of sculpting and painting tools. The main selection tools are Faces and Objects, and the Translate, Rotate, and Scale tools comprise the select/move tools.

Digital Sculpting with Mudbox. DOI: 10.1016/B978-0-240-81203-8.00013-1

2.3
To effectively sculpt in Mudbox, you must learn to manage the sculpt layers.

2.4
Paint layers organize the different types of textures, such as diffuse, bump, and specular, that Mudbox can paint.

2.5
The Object List is the central hub where you can find information about any object in the scene.

2.6
The Properties window displays information about the active tool or selected object. The Strength, Size, and Mirror properties are highlighted because they are often used to adjust the Mudbox tools.

2.7
The HUD displays important information about current operations.

2.8
You can see the x, y, and z axes labeled in the Rotate manipulator. Also notice the x, y, and z coordinate input fields in the Properties window.

2.9
Polygons are composed of vertices and edges. Filled polygons interact with virtual light, and when many polygons share vertices and edges, a polygonal model is constructed.

2.10
The resolution of a model depends on how many polygons compose the model. The model on the left has a lower resolution than the model on the right.

2.11
UV mapping is a coordinate system that specifies how a 2D image is applied to a 3D model.

2.12
Digital images are composed of a pixel grid. Each pixel stores information like color and transparency. Mudbox use digital images as stencils and stamps and creates digital images when painting textures. Photography by Christina Sizemore.

2.13
The pepper will sculpted from Mudbox's stock sphere model. Insert a sphere into the scene and turn off the grid and gradient background.

2.14
Scale down the sphere by about 50%. You may scale a selected object by clicking and dragging the Scale manipulator or numerically by changing the values of the Rotate x, y, and z input fields.

2.15
Before starting to sculpt, create a new Sculpt layer and subdivide the sphere twice.

2.16

To begin shaping the sphere into a pepper, use the Grab tool to quickly flatten the top and bottom.

2.17

Use the Bulge tool to mark the sections of the pepper. However, in this case, you will invert the Bulge tool by pressing Ctrl while sculpting to sculpt indentions.

2.18

With the Grab tool, push in the sides of the sphere and then indent the top.

2.19

Use the Pinch tool to delineate or tighten the grooves between bumps and sections.

2.20

Use a combination of the Grab and Bulge tools to shape the bottom of the sphere. By this point, you should be getting a feel of how the sculpting tools work.

2.21

Use the Grab tool to give the pepper its characteristic bell shape.

2.22

Use the Freeze tool to paint the area where the stem will be sculpted. Then invert the Freeze tool to freeze the rest of the pepper and leave the stem spot unmasked.

2.23

Use the Grab tool to pull out the stem. Once finished, turn off the Freeze mask and shape the stem.

2.24

Use the Fill tool to fill in the area around the stem. This will give you a base to sculpt the floret. Then, use the Bulge and Wax tools to sculpt the lumpy leaves and, finally, use the Pinch tool around the edges to delineate the floret.

2.25

Use the Sculpt tool with a stencil to add a texture to the pepper's skin. When finished, the texture will appear very rough.

2.26

Use the opacity property of the Texture layer to reduce the skin roughness.

Chapter 3

3.1

It's important to take good reference photographs all the way around the subject on the same plane and from different angles.

3.2
In this project, the sculpture will have a subtle smile, but in the photo sitting, Amy exhibits quite a few expressions. Expressions noticeably change the shape of the face.

3.3
In traditional sculpture, measurements are taken with calipers. Many are taken from the notch in the ear.

3.4
Sculpt first in the neutral position to avoid time-consuming mistakes.

3.5
Select the Basic Head from the dialog box.

3.6
In the Object List, right-click on the Front Camera and choose Look Through. Then, expand the camera tree and select Image Plane. In the Properties window, click on Import to load the reference sketch.

3.7
Adjust the visibility of the reference sketch to see the model.

3.8
Align the model with front and side reference sketches.

3.9
Create camera bookmarks for the Front and Side cameras.

3.10
The proportions of a child are very different than an adult's proportions.

3.11
Changing the chest, back, and shoulders of the adult model to match Amy's smaller proportions.

3.12
Use the Grab tool to adjust the model's features as seen from the front.

3.13
Adjust the model's features as seen from the side.

3.14
Download all reference photographs.

3.15
Repositioning and roughing in the eye sockets and sculpting the forehead and cheeks.

3.16
Position the camera to match photo01.jpg and sculpt what you see. As you work, use camera bookmarks to save the views that match the reference photographs.

3.17
Roll the camera to match photo02.jpg and sculpt the sides of the head, face, and jawline.

3.18
Traditional sculpture roughed in.

3.19
The external anatomy of the nose.

3.20
Widen the bridge of the nose and sculpt the sides of the nose as they blend into the cheeks.

3.21
Comparing the width of the nose to the width of the cheek.

3.22
Roughing in the alae.

3.23
Refining the alae and the tip of the nose.

3.24
Use the Freeze tool to mask the area where the nostrils will be sculpted. Invert Freeze and then use an inverted Bulge tool to push in the nostrils. Use the Smooth tool to get rid of any unwanted artifacts.

3.25
Refining the alae.

3.26
Sculpt the negative space created by the nostrils and the S shape created by the alae and the columella to get the right shapes.

3.27
Sculpting the philtrum and philtral columns in Mudbox and the completed nose in a traditional sculpture.

3.28
Understanding the anatomy of the mouth as well as the masses of the face will help in properly sculpting the mouth.

3.29
Hiding part of the model in Mudbox and hiding part of the sculpture in traditional sculpting.

3.30
Sketching the parting line in the lips.

3.31
Sculpting the upper lip and blending it into the philtrum.

3.32
Sculpt the masses of the lower lip. Check with side reference sketch to make sure the lips line up.

3.33
Work with Freeze and Invert Freeze to adjust lips.

3.34
With the upper lip frozen, push back the corners of the mouth.

3.35
Defining the nasolabial folds will help in shaping the corners of the mouth.

3.36
Add small mass, tubercle of upper lip, to the middle of the upper lip and pull down over lower lip.

3.37
Add texture to the lips by sculpting subtle folds and furrows. The traditional sculpture in clay.

3.38
Defining cheeks and jawline will aid in blending the mouth to the rest of the face.

3.39
Anatomy of the eye and the masses of the upper face. Eyelids have thickness and come over the eye.

3.40
Outline the eyes to ensure correct placement.

3.41
Use the Bulge and/or Foamy tools to sculpt the eyeball.

3.42
Rough in the lower eyelid with the Wax and Bulge tools and then smooth.

3.43
Eyelids have thickness.

3.44
Use the Freeze tool to protect parts of the eye and then sculpt the thickness of the lower eyelid. Use the Flatten tool to define the eyelid thickness. Then, rotate the camera to view the model from underneath. Use the Grab tool to make sure that the eyelid is round.

3.45
Take a moment to inspect the model to make sure its proportions are correct. Inspect the shape of the face as seen from the front.

3.46
Rough in the upper eyelid using Freeze and Invert Freeze.

Chapter 4

4.1
Anatomical directional terms describe the locations and relationships between anatomical structures.

4.2
Understanding how skeletal muscles work, the different types of muscles, and their three-dimensional relationships will help you to sculpt more natural and organic figures.

4.3
Heroic or superhero proportions are different than average human proportions; however, normal human anatomy still applies.

4.4
Download the file ch04_01.mud from www.digitalsculpting.net/mudbox_book to get started.

4.5
Use various sculpting tools like the Sculpt and Wax tools to build shapes, then use the Smooth tool to blend, and finally the Contrast and Pinch tools to define edges and details.

4.6
In this section, you will shape the upper body by sculpting the trapezius, deltoid, and pectoralis major muscles.

4.7
Use the Sculpt and Wax tools to build up the masses created by the muscles of the upper torso. Sculpt the infraspinatus and teres muscles. Use the Pinch and Contrast tools to accentuate the separations between the muscle groups.

4.8
Use the Wax tool to sculpt the sternocleidomastoid muscle.

4.9
The upper arm is shaped by the large biceps brachii, triceps, and deltoid. However, the brachialis is also visible in the lateral upper arm.

4.10
Use the Wax and Sculpt tools to shape the upper arm. Remember to blend shapes with the Smooth tool and use the Contrast tool to make the groups distinct.

4.11
The forearm is composed of many muscles that move the arm, hand, and fingers.

4.12
To facilitate sculpting, the muscles of the forearm may be divided into three groups.

4.13
It is helpful to break down the shapes of the hand into simpler forms.

4.14
Add general details to the dorsum of the hand; shape the fingers and thumb.

4.15
The anterior and lateral torso is composed of the rectus abdominis, the latissimus dorsi, serratus anterior, and external oblique.

4.16
Build up the muscles of the torso with the Wax and Sculpt tools, blend with the Smooth tool. Then use the Contrast and Pinch tools to make the muscle groups distinct. Use the Grab tool to sculpt the latissimus dorsi.

4.17
The surface of posterior lower torso is made up of the inferior aspects of the trapezius, the latissimus dorsi, and the external oblique.

4.18
Sculpt the large latissimus dorsi muscle, define the furrow along the middle of the back, and then, shape the gluteus medius and gluteus maximus muscles.

4.19
The surface anatomy of the anterior thigh is composed of the sartorious, vastus medialis, rectus femoris, and the vastus lateralis. Most of these muscles originate on the anterior iliac crest of the pelvis.

4.20
Sculpt the sartorious as it courses from the anterior pelvis to the medial tibia, and then build up the masses of the rectus femoris and vastus muscles.

4.21
Because the thigh is cylindrical, much of its lateral aspects are composed of the anterior muscles. True lateral structures include the tensor fascia lata, iliotibial tract, and the gluteus medius. Some of the posterior muscles are also visible from the side.

4.22
The main structures of the leg are the gastrocnemius, soleus, tibia, and the calcaneal tendon.

4.23
Use the Grab, Wax, and Smooth tools to sculpt the surface anatomy of the leg. Use the Bulge tool to build up the ankle malleoli and invert the Bulge to create the sulcus anterior to the calcaneal tendon.

4.24
The foot is a weight-bearing structure designed around two arches. To get a general feel for the shape of the foot, it may be broken down into planes.

4.25
Use the Grab and smooth tools to shape the foot. The toes may be sculpted with the Grab tool set to very small strength values and refined with the Wax, Bulge, and Smooth tools.

4.26
The model has all of the major muscle groups roughed in and the hands and feet have been refined. Take time to inspect your work for problems and correct anything you find before moving on to the next section.

4.27
Use the Wax, Sculpt, and Bulge tools to sculpt the basic forms of the head and face on a new layer. Rough in the eyelids and add the eyes.

4.28
Sculpt the nose and mouth. Use the Smooth, Contrast, and Pinch tools to refine the head and face. Don't forget to work on the back of the head.

4.29
Take advantage of the higher subdivision level to sculpt details on the torso, upper body, and upper limbs.

4.30
Detailed hands add to the overall realism and character of the creature.

4.31
Download and add the custom stamp that will be used to sculpt the fingernails to the Stamp tray. Customize the Falloff profile for the Imprint tool to get a good displacement.

4.32
Apply the Imprint with a custom fingernail stamp to rough in the basic fingernail shape. Then, refine the fingernail by using the Smooth, Wax, Contrast, and Pinch tools.

4.33
Details on the foot and the toenails are sculpted in the same way as with the hands.

4.34
At subdivision level 5, it is possible to add more details to the face and to finish the ear.

4.35
Suggest the nipples with the Bulge tool and push in the umbilicus with an inverted Bulge tool and use the Wax tool to add details.

4.36
Surface veins add a touch of realism to the sculpture. Use the Bulge tool to sculpt the veins on the arms and legs.

4.37
Living things including humans are not perfectly symmetrical. Add asymmetry to the face and body to give the sculpture a more natural appearance.

4.38
The completed creature.

Chapter 5

5.1
Models to be painted in Mudbox must be UV mapped. In this figure, you can see the correlation of the model's UV map and the diffuse or color textures painted in Mudbox (diffuse maps are shown as one layer for clarity).

5.2
A checkered pattern may be used to visually check for distortions, seams, and properly proportioned UVs. The checkers are smaller on the head because the head takes up more UV space.

5.3
When multiple UV tiles are used, parts of the model may be UV mapped in adjacent UV tiles (UVs seen in modo). This improves texture resolution and reduces distortions caused by UVs of varying sizes.

5.4
With Mudbox's paint brushes, just about any texture imaginable can easily created.

5.5
Mudbox's layers organize different layer types and the painted details.

5.6
Importing an image document as a diffuse paint layer.

5.7
The basic skin tone is quickly created by importing an image document as paint layer and adjusting the materials properties.

5.8
The combination of the basic skin color and the bump map create a good starting point for the creature's skin.

5.9
Skin is never just one color, so to make the skin more natural, red hues are painted in specific areas of the body.

5.10
Blue hues mixed into the red areas add realism and depth to the skin textures.

5.11
In the Image Browser, navigate to the file dirt.bmp and set it as a stencil for the Paint brush.

5.12
Position the stencil over the model, and with the Paint brush, paint dirt where you want it on the model.

5.13
Add depth to the dirt with a bump map.

5.14
Use a stencil and the Paint brush to apply the chest tattoo.

5.15
Copy and paste or drag the tattoo image into the Mudbox layer Photoshop file and position it over the UVs for the left arms. In Mudbox, refresh the Tattoo layer. The tattoo should appear on the upper left arm. (Photoshop file shown with white background for clarity.)

5.16
The creature's eyes are textured using a custom stencil and the Projection brush.

5.17
At any time while painting, you may switch back to sculpting. Sculpt a scar on the creature's face and use the Dry brush to paint only on the raised or depressed areas of the scar.

5.18
Experiment with the Viewport Filters to render the model in different lighting and rendering conditions.

Chapter 6

6.1
Normal maps use RGB color data to simulate depth on the surface of a 3D model. However, normal maps do not actually change the surface geometry of a model.

6.2
Displacement maps displace or change the surface of a 3D model, according to the gray scale data in the map. This figure shows the displacement map generated from the sculpture in Chapter 4.

6.3
Check Displacement Map in the Extract Texture Maps dialog box.

6.4
Setting the Displacement map extraction options.

6.5
The displacement map in Mudbox's Image Browser (map levels adjusted for clarity).

6.6
Press the Page Down key five times to get to the lowest subdivision level and export the model as an OBJ file.

6.7

Import the level 0 OBJ as a single object.

6.8

Add a TurboSmooth modifier to subdivide the model at render time.

6.9

Apply the displacement file with a Displace modifier.

6.10

The displaced model rendered with the scanline renderer in 3ds Max.

6.11

Import the level 0 OBJ as a single object.

6.12

Setting up render options.

6.13

Turn filtering off and load the displacement map.

6.14

Open the mental ray Approximation Editor.

6.15

Set the subdivision method and level in the mentalray SubdivApprox1 Attribute Editor.

6.16

Adjusting the Alpha Gain in the Color Balance menu.

6.17

Turn off the Feature Displacement box in the model's Attribute Editor.

6.18

The displaced model rendered with mental ray in Maya.

6.19

Import the level 0 OBJ and convert it to a Sub-D model.

6.20

Load the displacement map as an asset modo can use.

6.21

Select the Render item, and in the Properties tab, check Adaptive Subdivision and Micropoly Displacement.

6.22

Load the displacement map into the Matr: CreatureDisp item.

6.23

Switch the Effect mode from Displace Color to Displacement.

6.24

Make sure the Projection Type is UV Map and the UVMap is Texture.

6.25
Set the Displacement Distance.

6.26
The displaced model rendered in modo.

6.27
Open the level 0 OBJ model, create a new material, and apply it to the model.

6.28
In the Material Editor, enable the Displacement channel, browse to the displacement map, and set the subdivision levels.

6.29
The displaced model rendered in Cinema 4D.

6.30
Import the level 0 OBJ model.

6.31
Load the displacement map into the Displacement sub-shader.

6.32
Adjust the displacement settings.

6.33
Setting the subdivision levels.

6.34
The displaced model rendered in Carrara.

Chapter 7

7.1
Scans can be created of very large or very small objects. NASA F-15b Jet prototype scan, and model scanned with Direct Dimensions spherical laser scanner. Reproduced with the permission of Direct Dimensions.

7.2
Clay mother and baby model was scanned using a laser scanner, and then, the scanned pieces were seamed together.

7.3
Scan display point cloud or mesh views. Holes in the mesh must be filled.

7.4
The scanned mesh made of triangles must be retopologized into a simple mesh of quads.

7.5
The size of the brush can help determine physical size of model. The linear units can be changed in the preferences.

7.6

Fused Deposition Modeling deposits layers of filament.

7.7

"Indian" created in Mudbox by Steven Guevara and printed out on an InVision multiJet™ printer at Wicked Resin. The thinner filament on the left side of the printed sculpture was printed as a seam for making a mold.

7.8

Selective Laser Sintering uses layers of powder fused by a laser.

7.9

Stereolithography uses resin fused by a laser.

7.10

Computer Numerical Controlled printing is a subtractive process involving milling of different substances.

7.11

Data Direct to Mold uses milling to carve a two-piece mold in sand/resin for bronze casting from a digital file.

7.12

Rob Neilson's "Monument to St. Elizabeth of Hungary" Milled in Marble and Barry X Ball's "Jeanne Greenberg Rohatyn" milled in Mexican Onyx by The Digital Stone Project.

7.13

Gil Bruvel's chess pieces are printed using ExOne's metal printing process.

7.14

Paul R. Effinger printed "Artifice" with a ZCrop 510 in a ceramic powder that was dipped in a resin binder – infiltrate.

7.15

Creating a way for excess material to escape will lower your cost, but you must be sure that it does not interfere with the design.

7.16

A plane needs thickness to print. Check with your service provider to know minimal thickness allowances.

7.17

The stair stepping effect became part of the design of the printing of the skull created by ExOne.

7.18

The mother and baby model was printed as jewelry and a bronze figurine by ExOne, and was printed in acrylic polymer plastic by Wicked Resin.

Glossary

Many of the terms in the following glossary were used in the book's chapters, but other relevant terms are also included because they are important to know if you are going to work in computer graphics. Although the glossary contains more than 220 terms, it is only a starting point from which you learn more about computer graphics.

2D Acronym for two dimensional. In computer graphics, a two-dimensional object such as a bitmap image has height and width but no physical depth.

3D Acronym for three dimensional. In computer graphics, a three-dimensional object such as a 3D model with x, y, and z coordinates has height, width, and depth that determine its physical properties and location.

3D Mill A device that uses cutting tools to manufacture specific 3D objects from solid materials. 3D milling machines may use data from sculpting programs to cut a sculpture from a solid material such as foam, metal, plastic, wood, and stone.

3D Painting The process of creating textures by directly painting on a 3D model in real time. Different types of textures such as diffuse color, specular, gloss, reflection, and bump may be created by 3D painting.

3D Printing The process in which 3D objects are produced in successive layers using different types of materials, such as plastics, ceramics, and metals.

3D Scanner A device that scans real-world objects or environments to produce digital 3D models and, sometimes, 2D textures. There are three main types of 3D scanners: contact, light, and laser.

3D Space In computer graphics, a 3D space is a virtual environment commonly described using x, y, and z coordinates, also referred to as Cartesian geometry.

A

Additive Manufacturing A process in which successive layers of specific materials are deposited and fused to manufacture 3D objects from computer data. Types of additive manufacturing include selective laser sintering, inkjet modeling, stereolithography, and fused deposition modeling.

Algorithm A sequence of instructions.

Align To arrange in relation to the physical properties of another object or an environment. For example, arranging six polygons perpendicular to each other to form a cube, or positioning objects in a scene so that they are parallel.

Digital Sculpting with Mudbox. DOI: 10.1016/B978-0-240-81203-8.00014-3

Alpha A channel that contains transparency information for an image, sometimes referred to as an opacity or transparency map. In RGBA images, pixels have an added channel for alpha data.

Ambient Occlusion A shading method that simulates the attenuation of reflected light on a model or an environment. Ambient occlusion adds realism without the computing overhead of calculating global illumination. Mudbox can display ambient occlusion effects in the viewport and can also produce ambient occlusion texture maps.

Angle The measure of rotation between two vectors that share a common vertex.

Anomaly An unexpected result, such as a computer bug.

Antialiasing A sampling process that makes the edges of objects in an image or display appear smooth.

Application A computer program or software.

Artifact Unwanted distortions usually in bitmap images caused by faulty processing or by some types of data compression.

Aspect Ratio The ratio of width to height in an image or display is expressed as $x{:}y$. The ratio stays the same no matter what units of measurement are applied. For instance, an image with an aspect ratio of 4:3 can be 800×600 pixels or 16×12 inches.

Attribute The value of a specific property of an object or element.

Averaged Normal The average of two or more normals used to produce smooth shading. In Mudbox, toggling the Smooth Shade command off causes normals to not be averaged, thus producing a faceted model.

Axes In 3D computer graphics, axes refers to the x, y, and z variables.

Axis The vector about which an object rotates.

B

Back Face In a two-sided polygon, the side that is pointing inward. Not to be confused with a backfacing polygon.

Backfacing Polygon A polygon with a normal that points away from the scene cameras and lights. Backfacing polygons do not render correctly and often produce holes in a model, and are also referred to as flipped polygons.

Bake The process of rendering lighting, shading, and texture, data to an image file that is mapped onto a model or an environment.

Banding An artifact that causes color or gray scale gradients to appear as stepped instead of a continuous smooth shade. Banding may be the result of data compression or insufficient bit depth.

Base Mesh The lowest subdivision level of a model (level 0).

Bit A computing variable that has two possible values.

Bit Depth The number of bits of computer memory used to represent color or gray scale in the pixels of a bitmapped image. Higher bit depths such as 16, 24, or 32 produce more colors but also require much more graphics memory.

Bitmap An array of bits used to store image information or simply a type of image file. The textures produced with Mudbox's paint tools are bitmaps.

Bookmark In Mudbox, a bookmark is used to store the position of camera.

Brush A general term used to refer to the painting tools in Mudbox.

Buildup A sculpting tool property that determines the rate at which the tool deforms the surface to reach the strength value.

Bump Map A technique where the surface of a model is made to appear bumpy using a texture map. Bump maps do not displace the surface of model but only simulate bumpiness.

C

Camera In Mudbox and other 3D applications, a camera is a virtual analog to a real-world camera and is used to view a virtual scene.

Cartesian Coordinate System In 3D computer graphics, the x, y, and z variables of Cartesian coordinate system are used to describe the physical properties of objects and environments.

Center A point that is equidistant from the boundaries of an object or group of objects. In computer graphics, the center is often analogous with the pivot of an object.

Central Processing Unit (CPU) The part of a computer system that processes and executes instructions from a computer program.

Clean Geometry A 3D model that is well organized and free of technical errors.

Color Depth See Bit Depth.

Component Parts of a polygon such as its vertices, edges, faces, or UVs, sometimes referred to as elements or subobjects.

Computer-Aided Design (CAD) The use of computers to design real-world or virtual objects.

Computer-Aided Manufacturing (CAM) The use of computers to control manufacturing tools as in 3D printing or milling.

Computer Graphics (CG) In general, computer graphics is a subfield of computer science concerned with the manipulation of visual data by a computer. Specifically, computer graphics refers to a class of technologies used to produce art.

Computer Numerical Controlled (CNC) A computer system used to automate CAM such as in 3D printing and milling.

Coordinates The values assigned to variables such as x, y, and z.

Cube One of the basic meshes available in Mudbox.

D

Data Direct To Mold (DDTM) A process of metal casting where a digitized sculpture is divided into sections. The section data is used to mill resin-bonded sand molds. A metal such as bronze is poured into the molds and then cast sections are welded.

Decimate In 3D computer graphics, decimation is the process of reducing the number of polygons in a model.

Default A predefined setting or value for a variable in computer applications.

Delete To remove an element or object. Delete functions can usually be reversed with the Undo command.

Depth of Field (DOF) The portion of an image that is in sharp focus. Mudbox features a viewport filter that simulates depth of field.

Diffuse Diffuse refers to the color an object reflects under pure white light.

Digital Sculpting A modeling method that uses specialized software to build 3D models in an intuitive and organic way similar to real-world clay modeling.

Digitizer A class of input devices that convert real-world data into digital data. 2D scanners, 3D scanners, graphics tablets, even a mouse are examples of digitizers.

Dimension Magnitude in a specific direction such as length, width, or height.

Directional Light A type of virtual light that emits parallel rays.

Displacement Map A computer graphics technique that uses a height map to cause the surface of a 3D model to be displaced or changed.

Distortion In image mapping, distortion refers to the misapplication of textures. For example, in UV mapping, a texture may become stretched or pinched if UVs are not properly mapped.

Dolly Moving the scene camera toward or away from the point of interest.

Dots per Inch (DPI) The number of pixels per linear inch. DPI is a measure of display or print resolution, the higher the DPI the better the display or print quality.

Duplicate To copy an element or object.

E

Edge A line that connects two vertices and serves as a boundary for polygons.

Edge Layout The orientation of edges in a mesh. Edges may connect vertices in various configurations, sometimes referred to as edge flow.

Element In 3D computer graphics, element usually refers to geometrical subobjects, such as vertices, edges, and faces.

Export Saving an object or environment to an external file. Usually, the exported file format is different than the native format saved by the application. For example, Mudbox's native file format is MUD, but it can export OBJ and FBX formats also.

Extract In Mudbox, an extraction operation produces displacement, normal, and ambient occlusion maps.

F

FBX A file format used to transfer data, such as models, UVs, shading, and textures, between 3D applications.

Face A filled or closed polygon, and also the side of the polygon that has the normal pointing outward.

Falloff In Mudbox, the falloff property determines the profile of a sculpt tool or paint brush from its center to its edge.

Filter In Mudbox, viewport filters apply effects such as ambient occlusion and depth of field to add realism to a scene.

Flat Lighting In Mudbox, the Flat Lighting toggle displays models as silhouettes filled with a solid color. Flat lighting makes it possible to inspect the contours of a model without the distractions of shading.

Flip To rotate a polygon 180° so that its normal faces outward.

Floating Point Practically, a floating point file such as a 32-bit TIFF stores color information beyond the range of what is possible with file that have lower bit depths.

Fluting The action of milling machine's cutting tool on the material being milled. This may also refer to the scallop texture left after milling.

Frames per Second (FPS) The frequency at which unique frames are produced by hardware or software. In Mudbox, the FPS refers to the frequency at which the scene is refreshed. Scenes with models composed of millions of polygons have a lower FPS.

Free Form Fabrication A group of additive manufacturing techniques in which a 3D model is divided into layers, and the layers are then printed.

Front Face In a two-sided polygon, the front face is the side of the polygon pointing outward.

Fused Deposition Modeling (FDM) An additive manufacturing process in which successive layers of a melted material such as thermoplastic and wax are built up into a specified 3D shape.

G

Gamma The overall brightness of an image.

Geometry In 3D computer graphics, geometry refers to a polygonal surface or volume.

Gloss In Mudbox, the gloss is a material channel or texture that specifies the size of a specular highlight.

Graphical User Interface (GUI) Pronounced as "gooey," a graphical user interface is a type of computer interface that allows individuals to interact with a computer, using graphical symbols and input devices such as a mouse or graphics tablet instead of typing with a command line interface.

Graphics Processing Unit (GPU) A specialized processing unit typically found on a video card but sometimes installed on a motherboard that processes images for display.

Graphics Tablet A pressure- and tilt-sensitive input device that allows the user to draw in a natural manner with a stylus or pen. Mudbox's sculpt tools and paint brushes require a Wacom graphics tablet.

Gray Scale A bitmap image or display composed of shades of gray. Gray scale images are often used for alpha maps, transparency or opacity maps, and displacement and bump maps.

Grid An arrangement of evenly spaced vertical and horizontal lines that help to orient the user in a 3D scene.

Grow Selection In Mudbox and Photoshop, it is a command to enlarge the area of a selection in specified increments.

H

HDRI Acronym for High Dynamic Range Image. A 32-bit image that stores a wider range of lighting and exposure information than it is possible with standard image files. HDRI files are used to produce realistic lighting in a 3D environment.

Hierarchy A nested organizational system of parent and children objects. Mudbox's Object List is hierarchical in that the parent objects such as cameras contain the nested child objects such as image planes.

Highlight The brightest area of reflected light on the surface of an object.

Hotkeys Keyboard shortcuts for common commands. In Mudbox, hotkeys make it possible to work more efficiently. Hotkeys may be customized through the Hotkey editor.

I

Interface The system by which a user interacts with a computer.

Image A picture or graphical file. In 3D computer graphics, images are often used as textures mapped onto the surface of 3D models.

Image-Based Lighting A lighting method that typically uses HDRI data to produce accurate lighting and reflections.

Image Plane A 2D object that has an image mapped on to it. Image planes are often used to place references in a scene for modeling or sculpting.

Import To bring in an object or environment from an external file. To open a file format different from the application's native file format. For instance, Mudbox's native file format is MUD, but it can import OBJ and FBX files.

Instance A unique representation of an object or element.

Intensity Typically, a parameter in virtual lighting that controls the amount of energy output by a light.

Invert A property or command that reverses or changes something into its opposite. In Mudbox, several of the sculpt tools can be inverted. For example, the result of inverting the Bulge tool causes it to dig into the mesh instead of adding to it.

L

Layer A system that separates and organizes elements in an image or file. Mudbox features Sculpt and Paint layers. Sculpt layers are used to organize sculpting information, while paint layers organize textures.

Level Refers to a subdivision level. A subdivision level displays the model at a specific subdivision point. Level 0 is the base mesh, which can be

subdivided as many times as permitted by hardware limitations, such as available RAM. Higher subdivision levels permit sculpting fine details, whereas lower subdivision levels are great for roughing in basic shapes.

Light A virtual object used to calculate the effects of rays (or photons) with specific properties and from a specific location.

Local Axis An axis defined by an object's attributes.

Local Space A space reference defined by an object's attributes instead of the attributes of world space.

Lock The act of locking an object or component so that it cannot be changed. Any item in the Object list, as well as sculpt or paint layers, may be locked (and unlocked).

M

Manipulator A graphical representation of transform operations, such as translate, rotate, and scale.

Mapping The process of matching points between distinct data models such as when UV mapping a 2D image to a 3D object.

Mask A Mudbox tool that is used in combination with sculpt layers to occlude a section of a model so that the sculpt tools have no effect in the masked section.

Material A set of surface properties that describe how a model appears when rendered.

Memory Physical computer data storage systems. Memory usually refers to the amount of RAM installed on a computer, but storage systems such as hard drives, CDs, and flash drives are also considered as types of computer memory.

Merge To join two or more objects or components into one. For example, in Mudbox, sculpt or paint layers may be merged.

Mesh A group of disjointed or contiguous polygons, also referred to as polyset or polygonal object.

Mirror Simultaneously, sculpting or painting on opposite halves of an object across a specified axis or tangent.

Model A representation of a 3D object. Mudbox works with polygonal models.

Modeling The process of building a model.

MUD Mudbox's native file format.

N

Navigation The process of moving the camera through a virtual environment.

n-gon Technically n-gon and polygon are interchangeable terms, but n-gon is usually applied to a polygon with more than four sides.

Non-Photorealistic Rendering (NPR) A type of rendering that produces painterly or artistic images as opposed to photorealistic images.

Normal A vector perpendicular to a geometrical component. Surface normals are used to determine the orientation of a polygon face, whereas vertex normals represent the averaged surface normals and are used to produce smooth shading.

Normal Map An RGB image map used to simulate depth on the surface of 3D object. Normal maps are used to represent high-resolution data on low-resolution models.

O

OBJ A standard file format for storing 3D geometry and UV datasets.

Object In Mudbox, objects may be polygonal models, cameras, lights, materials, selection sets, and extraction operations. Objects are organized in the Object List and object properties displayed in the Properties window.

Offset To translate or move from one point to another.

One-Sided A polygon with once face, usually a front face.

Opacity A degree of transparency. In Mudbox, Sculpt, and Paint layers have opacity properties so that it is possible to mix the contents of layers.

OpenEXR An open source high-dynamic range image file format.

Optimized In computer graphics, optimization refers to an efficient use of computer resources.

Origin See world origin.

Orthographic A camera view without perspective.

Overlapping UVs UVs that share the same UV space. In general, overlapping UVs are to be avoided because they may produce artifacts.

P

Pan Moving the camera vertically or horizontally, also known as "track."

Parameter A variable that defines a value in a system or formula. For instance, the x, y, and z variables are parameters for 3D world space.

Parametric Defined by parameters.

Perspective A system for reproducing a 3D scene onto a 2D surface. In Mudbox, a perspective camera reproduces the effects of linear perspective.

Photon A virtual light packet.

Photoshop A popular image-editing program made by Adobe. Mudbox is designed to work closely with Photoshop in texture creation and management.

Pipeline A term, borrowed from general computing, used to describe the tools and processes and the order in which those tools and processes are used by an artists or group of artists to produce computer graphics.

Pivot A point or coordinate around which the transform operations such as rotate or scale may occur. In Mudbox, an object's pivot may be moved and centered.

Pixel Acronym for picture element. The fundamental element of an image or display.

Plane One of the basic meshes available in Mudbox.

Point Light A virtual light that emits rays equally in all directions.

Poly Short for polygon.

Polybudget The number of polygons allotted for a specific task or the number of polygons permitted by software or hardware limitations.

Polycount The number of polygons in an object or scene.

Polygon A geometric primitive with a minimum of three vertices, three edges, and one face. Polygons may have *n* number of sides (n-gons). Mudbox can work with models composed of triangles or n-gons but works best with models composed of quadrangles or quads because quads subdivide predictably.

Polygonal Composed of polygons.

Polyset A group of polygons. The polygons in a polyset may be contiguous as in a model or disjointed as in shells.

Preset A predetermined set of attributes that can be quickly applied to an object, tool, or scene. For instance, Mudbox features lighting, falloff, and material presets.

Program Computer instructions designed to perform a specific task.

Properties A characteristic of tool or object. For example, some of the properties of the Sculpt tool are size and strength.

PSD The Photoshop file format.

Q

Quadrilateral A four-sided polygon, also known as "quad" in short.

R

RAM Acronym for Random Access Memory. A type of computer data storage. Considerable amounts of RAM are required to work with models composed of hundreds of thousand or tens of millions of polygons.

Rapid Prototyping (RP) A general term that encompasses different types of additive manufacturing processes.

Ray The path of a photon or virtual light.

Real Time Occurring immediately such as in real-time rendering, where a scene is rendered, instantly, to the screen.

Reflection A simulation of the reflective properties of certain materials like metals and glass. In Mudbox, reflections are controlled through a reflection mask channel in Mudbox materials and reflection maps.

Refresh In Mudbox, paint layers may be refreshed or reloaded after having been exported to Photoshop.

Render The process of producing a 2D image from a 3D scene. The properties of 3D objects such as color and transparency combined with scene properties such as lighting and atmospherics are used to calculate the color of each pixel in the 2D image.

Renderer Software or hardware that renders, also known as a "render engine."

Resolution A measure of the amount of detail in an image. Image resolution may be measured in terms of the size of an image such as 2048 × 2048 pixels, its bit depth, or as DPI. Resolution can also be used to describe the number of polygons in a 3D model. A high-resolution model has more polygons than a low-resolution model.

Retopologize Typically, the process of modeling a low-resolution model usually is made of quads from a dense high-resolution model.

Reversed Normal A polygon with normal is pointing inwards, also known as a "flipped normal." Reversed normals do not render properly.

RGB Acronym for red, green, and blue. A common color space where the three colors are mixed to produce new colors.

RGBA Acronym for red, green, blue, and alpha. The same as RGB, but with an added channel for alpha data.

Roll Rotating the camera along an axis parallel to its length.

Rotate To turn around an axis.

S

Scale The process of changing the physical size of an object.

Scene The 3D view as seen through various cameras.

Sculpt In Mudbox, it refers to the sculpting tools or the sculpting layers.

Seam An artifact produced when the edges of a nontiled image are adjacent to each other. Seams may appear while painting textures or UV mapping.

Select The process of choosing an object in the scene. In Mudbox, objects or the faces that make objects may be selected, as well as cameras, materials, and lights, among other objects and subobjects.

Selection Set A method for saving a collection of selected items.

Selective Laser Sintering (SLS) An additive manufacturing process that uses lasers to fuse particles of specific materials into the shape of a 3D object.

Shaded Display A representation of a 3D model in which the object is drawn as if it were a solid shaded surface.

Shadow Darkened areas that are produced on the surface of a model, when something gets in the way of a light source.

Size The physical dimensions of an object in the scene. The area in which a sculpt tool or paint brush has an affect.

Smoothing In Mudbox, the Smooth tool levels a surface by averaging vertex positions.

Solid Freeform Fabrication (SFF) See additive manufacturing.

Specular The highlights on the surface of an object produced by its shininess. In Mudbox, specularity is controlled through specular channels in a material or specular texture maps.

Sphere One of the basic meshes available in Mudbox.

Stair Stepping The visible edges of the layers deposited in a 3D printed object.

Stencil In Mudbox, a stencil is an image that is used in combination with the sculpt tools or paint brushes to produce complex effects.

Stereolithography An additive manufacturing process that uses a UV laser to cure layers of liquid resin to progressively build a 3D shape.

Strength In Mudbox, the strength of a sculpt tool or paint brush determines the intensity of its effect.

STL A widely supported file format used to store raw 3D datasets. STL files are common in rapid prototyping and CAM applications.

Stylus A hand-held device used in conjunction with a graphics tablet to draw, paint, or sculpt, also referred to as a pen.

Subdivide The process or adding polygons to a model. When a model is subdivided, its polygon count increases four times.

Subdivision Level When a model is subdivided, a new higher resolution version of the model is stored in a subdivision level.

Subtractive Manufacturing A process that removes material to manufacture objects from 3D data, such as in milling.

Stamp In Mudbox, a stamp is an image used in combination with the sculpt tools to produce intricate sculpting effects.

Symmetry In 3D computer graphics, symmetry typically refers to simultaneously modeling, editing, or painting on opposite halves of an object across a specified axis or tangent. In Mudbox, symmetry is referred to as mirror.

T

Tangent A line in contact with a curve that indicates its slope at any given point.

Tessellate The process of dividing polyset into smaller polygons.

Texture In 3D computer graphics, it is an image mapped onto the surface of a 3D model to describe its surface properties such as color.

TIFF (Tagged Information File Format) A widely supported file format for storing images. In Mudbox, TIFF files are used for displacement maps, ambient occlusion maps, and screen images.

Tolerance An acceptable range.

Track Moving the camera vertically or horizontally, also known as "pan."

Transform The processes of moving, scaling, or rotating an object.

Translate The action of moving an object along the x, y, and z axes, also known as "move."

Triangle Polygon made up of three vertices and edges.

Triangulate In polygonal modeling, it is the process of converting n-gons into triangles.

Two-Sided Polygon A polygon that consists of a front and back face.

U

Untriangulate In polygonal modeling, it is the process of converting triangles into quadrangles or n-gons.

UV A coordinate system used to correlate the pixels in an image with the geometry of a 3D model, when applying textures.

UV Map A 2D space that uses the UV coordinate system to arrange UVs.

UV Packing The process of efficiently arranging UVs so that they take up as much of the available UV space as possible.

UV Tile A single instance of UV space. A UV map may contain several UV tiles.

V

Vertex A point in 3D space defined by x, y, and z coordinates.

Vertex ID A unique number assigned to vertices in a model.

Vertex Normal A normal associated with a vertex. Averaged vertex normals are used to produce smooth shading.

Video Card An expansion card that processes and sends images to a display device such as a monitor. Video cards are an integral part of working with Mudbox because they facilitate the display of models consisting of millions of polygons in real time.

Viewport The interface window through which a scene is viewed.

Visibility In Mudbox, images, objects, and layers may be visible or invisible. Images in an image plane can be visible, partially visible, or completely invisible, while objects and layers have show/hide toggles.

W

Watertight A 3D polygonal model that has no holes. For most 3D printing applications, models must be watertight.

Weld The process of fusing two or more geometrical elements or objects into one.

Wireframe A display method that shows the edges of the polygons in a model.

Workflow A sequence of steps necessary to complete a task. For instance, the workflow to paint a model in Mudbox requires that the model be UV mapped, specific paint layers be created, specific brushes be selected, and their properties be adjusted.

World Origin The world origin occurs where the values of x, y, and z are zero.

World Space The coordinate system that contains all things in a virtual environment. The world origin is at the center of the world space.

Z

Zoom Moving the camera closer or farther away from an object in the scene.

Index

Page numbers followed by f indicates a figure.